Collecting the New

Museums and Contemporary Art

Collecting the New

Edited by Bruce Altshuler

PRINCETON UNIVERSITY PRESS

PRINCETON AND OXFORD

Front cover: "White Wall and Storage (Green)," 1989.
Louise Lawler (LL #249). Courtesy of the Artist and
Metro Pictures Gallery

Published by Princeton University Press,
41 William Street, Princeton, New Jersey 08540
In the United Kingdom: Princeton University Press,
3 Market Place, Woodstock, Oxfordshire OX20 1SY
pup.princeton.edu

Designed by Deborah Hodgdon
Composed by Bytheway Publishing Services
Printed by Friesens (Four Colour Imports Ltd.)

Printed and bound in Canada
10 9 8 7 6 5 4 3 2 1

Library of Congress Cataloguing-in-Publication Data
Collecting the new : museums and contemporary art /
edited by Bruce Altshuler.
 p. cm.
 Includes bibliographical references and index.
 ISBN-13: 978-0-691-11940-3 (CL: alk. paper)
 ISBN-10: 0-691-11940-6 (CL : alk. paper)
 1. Art, Modern 20th century Collectors and
collecting—United States. 2. Art, Modern—21st
century—Collectors and collecting—United States.
3. Art museums—Collection management—United
States. I. Altshuler, Bruce.

N6486.C65 2004
708.13'09'051—dc22 2004057051

Contents

Collecting the New:
A Historical Introduction

Bruce Altshuler

DIRECTOR, PROGRAM IN MUSEUM STUDIES, GRADUATE SCHOOL
OF ARTS AND SCIENCE, NEW YORK UNIVERSITY

T
he collecting and preserving of objects has traditionally been marked as
a—if not the—central function of the museum, but discussion of muse-
ums and contemporary art has focused almost entirely on issues of dis-
play and exhibition.[1] This is not surprising, as exhibitions are the public face of
the museum, being the primary attraction for visitors and the central object of
attention in the press and in the academy. But the collecting of contemporary
art by museums raises a wide range of issues, from challenges to the traditional
conception of the art museum to practical questions relating to the changing
character of contemporary art itself. The purpose of this volume is to investi-
gate these concerns, and to do so from the standpoint of those who deal with
them in the course of active museum work. To set the stage, it will be useful to
look at some of the critical moments in the history of, and conceptual tensions
occasioned by, museum collecting of contemporary art.

Gertrude Stein reportedly observed that something could either be modern
or it could be a museum, but it could not be both.[2] Stein's remark points to a
dilemma central to the museum's engagement with contemporary art: since the
eighteenth century the traditional view of the art museum has been that it is an
institution intended to preserve and display works that have withstood the test
of time. Given the fallibility of aesthetic judgment, this has seemed the most reli-
able way to identify artistic quality.[3] Thus the validation that artists and con-
temporary collectors seek from the display of their works in museums is based
on the association of the museum with the time-tested masterpiece, a normative
connection grounded in a convergence of historical opinion that seems to rule
out the new.[4]

Of course, curators make qualitative judgments all of the time—about new works as well as about old—but such assessment implicitly is done in the subjunctive mode. To designate artworks as museum-worthy is to mark them as objects that would deserve a particular place in what Philip Fisher has called "the future's past."[5] This past is that of art history, whether viewed as a linear narrative or, in tune with recent directions of inquiry, as a more variegated story. Contemporary works valorized by entering museum collections—and, to a lesser extent, by being exhibited in museums—are in a sense projected into the future, identified as playing a role in an anticipated history. This same kind of projection also connects with the art market for contemporary works, for putting a price on a recent work of art in part is to place a bet on how important this work will be in the art historical future.[6] These two aspects of anticipating the art historical future are closely related, and in fact they are two sides of the same coin. A familiar example is the influence of Clement Greenberg during the 1950s and '60s, when his critical writing and art world activity guided contemporary acquisitions by both American museums and private collectors. During this period Greenberg's view of artistic progress yielded expectations of future art historical significance, which in turn determined judgments of both museum-worthiness and market value.[7]

The connection between art history and the art museum makes the collecting of contemporary works just as much a matter of guesswork as are dealers' prices, and equally problematic. In addition to general skepticism concerning aesthetic judgment of the new, the pedagogical function of the museum—established in the eighteenth century alongside its moral purpose of developing taste through exposure to exemplary artworks—required that works brought into an institutional collection be located within a fixed art historical narrative. It is this narrative that was to be taught to visitors, making the museum, as Christian Mechel wrote in his 1781 catalog for the Habsburg imperial collection that he had installed in the Belvedere in Vienna, "a visible history of art."[8] Especially in the modern period, when artists pushed the boundary of what counts as a work of art—certainly one source of Stein's difficulty in conjoining "museum" and "modern"—problems of historical anticipation were pronounced. And with recent resistance to the modernist story of late-nineteenth and twentieth-century art, as well as the proliferation of alternative narratives and artistic practices, the very enterprise of constructing definitive accounts that situate new acquisitions in terms of historical place and importance has been called into question. So throughout the history of the museum, arguments have been available to steer the institution away from the art of its time.

Such reluctance, however, generally has existed alongside a fervent desire to embrace the new. The museum as exemplar of civic pride and national heritage

was established in eighteenth-century France and promulgated by the French. Initiated by the transformation of the Louvre in Paris into a museum and its opening as a public institution in 1793 after the Revolution, the conception of the public museum spread throughout Europe.[9] With the nation's artistic patrimony expanded through the confiscation of works from the aristocracy and the Church—and by Napoleon's looting of the Continent's artistic treasures— museums were created in other French cities, and a number of important European museums were established in the early years of the nineteenth century in territories occupied by Napoleonic forces. Although their primary displays were of works of the past, a rising sense of national identity often resulted in the exhibition of local artists, such as the room of contemporary paintings by Goya and other Spaniards that led toward the central gallery at the opening of the Museo Nacional del Prado in Madrid.[10] Such nationalism influenced the creation in the latter half of the nineteenth century of many public institutions dedicated to the display of contemporary art, from London's Gallery of British Art to Moscow's Tretyakov Gallery, and here the precedent also was French.[11]

In Paris in 1818, with the Louvre reserved for the masterpieces of the past, a place was made for contemporary French art when the Palais du Luxembourg was converted into a public museum, the Musée des Artistes Vivants (Museum of Living Artists).[12] (The name would be adapted by A.E. Gallatin when he established one of the first modern art museums in the United States at New York University in 1927, the Gallery of Living Art.)[13] With works by important French artists passing from the Luxembourg to the Louvre within five to ten years after the artists' deaths, room was freed in the Luxembourg for new art, and an institutional structure was created for an ongoing state commitment to the collecting and display of contemporary work. This commitment soon was expressed by large-scale state purchase of paintings at the annual Salons, works bought for the Luxembourg and, increasingly, for the expanding system of provincial museums. But it is important to note that these state purchases were primarily of academic art, and that "the new painting" would largely be excluded.[14] Only in 1896 did a significant number of important Impressionist works enter the Luxembourg, after a compromise was reached allowing the museum to accept a portion of Gustave Caillebotte's controversial bequest of his collection to the nation.[15]

The predominantly academic character of the French state collection during the nineteenth century raises an important question: What exactly do we mean by contemporary art? It might seem most natural to identify as "contemporary" those artworks created by living—or recently deceased—artists, but this is not how the term currently is employed. There is an additional filter, a presumption that "contemporary art"—the subset of present artistic production

that finds its way into significant galleries and museums—is more adventurous, more "cutting edge" than work made by traditional artists. Of course this distinction presupposes the historical break between the academic and the avant-garde—a break that first occurred in the nineteenth century in France. But the institutional identification of the contemporary with the up-to-date originated not in France but in Germany. For it was in Germany that such works were first brought into public collections in significant numbers and that museums first committed themselves to what we would call contemporary art.

A 1912 guidebook for Berlin's National Gallery stated that its "principal task . . . was to be for the art of the present what historical art museums are for the art of the past," but the collecting of modern art by German museums did not come easily.[16] With acquisition committees governed by establishment artists, it took radical purchases made by progressive museum directors to change the course of German museum collecting. Ironically, the greatest opposition came from artist organizations, pressed by competition from increasing numbers of artists and threatened both economically and aesthetically by the new French painting.[17] The exemplary figure here is Hugo von Tschudi, who was appointed director of the National Gallery in 1896. Tschudi was an expert on Italian and Flemish painting and senior assistant to the conservative Wilhelm Bode, head of the Prussian museums, but soon after his appointment he had a kind of conversion experience while looking at Impressionist paintings in Paris. Bode believed that museums should hold only work that represented time-tested aesthetic values, but Tschudi came to identify the role of a museum of contemporary art as facilitating the development of modernity.[18] Relying on funds provided by wealthy patrons, he was able to purchase progressive French and German art without the use of state money or the approval of the official acquisitions committee. His purchases and his reorganization of the galleries, especially his support of modern French art, brought him into conflict with both Wilhelm II and local artist organizations, and in 1909 Tschudi left Berlin to become director of the Munich art museums. In Munich he brought the same modern program—and controversy—to the Neue Pinakothek, which had been created in 1846 by the Bavarian king Ludwig I as Germany's first museum dedicated to the work of living artists.

Tschudi's efforts to transform German museums would be emulated by others, such as his successor at the National Gallery, Carl Justi, and Gustav Pauli, whose 1910 purchase of a painting by Vincent van Gogh at the Bremen Kunsthalle provoked Carl Vinnen's vehemently nationalistic *Ein Protest deutscher Kunstler*.[19] Outside the state museums, Karl Ernst Osthaus's privately financed Folkwang Museum in Hagen opened in 1902, designed by the Belgian painter and architect-designer Henry van de Velde, who encouraged Osthaus to purchase

the modern art for which the museum was best known.[20] By the 1920s museum directors throughout Germany were acquiring the art of the international avant-garde, including works by members of Die Brücke, the Blaue Reiter, the Neue Sachlichkeit, and others. Ironically, the extent of these purchases would become clear only in the late 1930s, after the Nazi confiscation from museums of about sixteen thousand works, a small portion of which were shown at the 1937 Degenerate Art exhibition in Munich.[21]

In the late 1920s, the German museum with the greatest reputation abroad for its support of modern art was the Landesmuseum in Hanover. This was less because of the quality of its contemporary collection—though that was high— than it was due to the gallery in which it was displayed, the Abstraktes Kabinett (Abstract Cabinet) designed and realized by El Lissitzky in 1927–28. The Abstract Cabinet was the culmination of a series of "atmosphere rooms," in which the director, Alexander Dorner, had reinstalled the collection in galleries meant—through wall color and decorative appointments—to immerse the viewer in the spirit of each art historical period.[22] The design of the Abstract Cabinet was intended not only to present the spirit of modern art, however, for in its interactivity and flexibility it embodied Dorner's notion of a museum appropriate for the modern age. (Like Tschudi, Dorner wanted the museum to be more than a mausoleum of past artistic achievement, believing that it should play an active role in preparing the public for modern life.) Visited by progressive critics and museum people from around the world, including the founding director of the Museum of Modern Art in New York, Alfred Barr, Jr., Hanover's Landesmuseum represented the European museum's most advanced engagement with the contemporary. (Soon significant attention was also directed to Lodz, Poland, after the outstanding modern section of its Museum of Art opened in 1931.)[23]

Like their European progenitors, American museums collected works by living artists, although they generally confined acquisitions to the traditional and the indisputably acceptable. But the civic spirit that was so much a part of their founding led to plans such as one proposed in 1833 for the creation of a museum in Detroit, which called for collecting one or two examples of the work of "every American painter, living or dead, who has attained to a certain standard of fame," plus "original works by the great modern European painters, to be chosen on the same principle" and copies of Old Masters.[24] By the 1920s the city's art museum actually did move into the modern and contemporary, under the leadership of German scholar William Valentiner, who acquired German Expressionist works soon after his 1924 appointment as director of the Detroit Institute of Arts and later commissioned Diego Rivera's *Detroit Industry* murals for the museum.[25] For many years there would be no national museum

charged with collecting the work of living American artists, until the Whitney Museum of American Art in New York opened in 1931 as an institution meant to perpetuate the commitment of its founder, Gertrude Vanderbilt Whitney, to the country's advanced artists.

Throughout the United States, museum funds were allocated to purchase the work of living Americans, most notably donations given for that purpose by George A. Hearn to the Metropolitan Museum of Art in New York. But some time after the donor's death in 1913, the museum's Law Committee interpreted the gift's terms so that "living American artists" was taken to mean living in the year that the relevant fund was established. Thus the Met was free to use the Hearn funds to purchase older American art of recognized historical importance—such as that of John Singer Sargent—rather than restrict acquisitions to the work of contemporary artists. Because of the museum's lack of interest in contemporary American work, the Hearn funds were used little and their accumulating income largely went unspent. Well into the 1930s, American artists would protest this withholding of acquisition funds meant for them.[26] It was in part to obtain use of the Hearn funds that the Museum of Modern Art—despite its European focus—began talking with the Metropolitan Museum about establishing a relationship like that between the Luxembourg and the Louvre. But more to the point for MoMA was the question of what would be the most appropriate sort of collection for a museum of modern art.

For a museum dedicated to modern art, there is no tension of the sort that we have noted between the traditional conception of the museum and the collecting of contemporary art. However, there is the problem of how current the holdings of such a museum should be. The founders of the Museum of Modern Art initially conceived of a collection from which older works would be deaccessioned to make room for newer ones—since for them, as for others at the time, modern art meant contemporary art[27]—and in 1931 they entered into negotiations with the Metropolitan Museum of Art to create a system to implement the process. The metaphor chosen by Alfred Barr, Jr., in 1933 to describe the MoMA collection in this respect was that of a torpedo moving in time, passing through art history to capture the new and jettison the old within something like a hundred-year time frame. Barr's eventual view was that the museum should not hold works for more than fifty or sixty years after they were created, and the 1947 agreement between the two institutions seemed to anticipate that every work in the MoMA collection some day would move to the Met. Not surprisingly, the Modern's trustees began to look for a way out of this agreement in 1951. Worries about future gifts and holding onto their patrons, and concerns about losing their most valuable assets—their Cézannes, van Goghs, and Picassos—led in 1953 to an official repudiation of the notion of transferring

MoMA's collection piece by piece to other institutions and to a commitment "to have permanently on public view masterpieces of the modern movement, beginning with the latter half of the nineteenth century."[28] With this development, MoMA lost the uniqueness of its collection concept and in this regard joined the ranks of traditional institutions, albeit with a commitment to a special area of collecting.

As modern art—viewed as works of periodized art history—increased in price and notoriety, and as the market for contemporary art began to boom in the postwar period, it became clear that collecting and holding onto such artworks was important for museums. So while some institutions that focused on contemporary art—such as the short-lived Harvard Society for Contemporary Art in Cambridge, Massachusetts (1928–34), and Boston's Institute of Contemporary Art (established in 1936)—were dedicated solely to mounting exhibitions, collecting institutions embraced the established model of holding and preserving artworks in perpetuity. An important exception was the New Museum of Contemporary Art in New York, founded in 1977 by former Whitney Museum curator Marcia Tucker.[29]

Taking the commitment to contemporaneity to rule out permanency, the New Museum created the "Semi-Permanent Collection." According to its 1978 collecting policy, the New Museum would seek to acquire at least one work from each of its major exhibitions, and each of these pieces was to be retained for at least ten years and no more than twenty. Works that entered the collection outside the exhibition program, whether purchased or donated, must have been created within the previous ten years and would be deaccessioned within ten years of acquisition.[30] (While the New Museum thus outdid Barr's fifty-to-sixty year horizon, it embraced the view expressed in 1933 by the MoMA board president A. Conger Goodyear that his museum should hold no works more than twenty years old. This was echoed in a speech given that year to the American Association of Museums by the president of the Metropolitan's board, William Sloane Coffin—with whom Goodyear was negotiating the collection transfer agreement—in which he stated that "ten or twenty years should be the limit of modernity.")[31] But as the ethos of contemporary art changed from the radicalism that motivated Tucker in the late 1970s—that era of institutional critique and the dematerialization of the artwork—and as the New Museum attained institutional maturity, this policy became increasingly problematic. The institution currently is reassessing its collecting practices, and the future of the Semi-Permanent Collection is uncertain.

This brief discussion of the museum's engagement with contemporary art has marked two points of conceptual tension. First, collecting contemporary art conflicts with the traditional notion of the art museum as an institution that

preserves works that have withstood the test of time, placing them within an art historical narrative in which new works can have no definitive place. Second, with the creation of museums devoted to "modern" and "contemporary" art, the focus on the new was found to conflict with the traditional museum goal of preserving its holdings in perpetuity. Each of these concerns has been used to argue against bringing contemporary artworks into permanent collections.

Of course the time is long gone when museums debated the appropriateness of collecting contemporary art, a point hotly argued in the late 1920s in America's premier training ground for museum curators and directors, Paul Sach's "Museum Course" at Harvard.[32] The rising visibility of contemporary art in the media and the status accorded its acquisition—spurred in the late 1980s by publicity surrounding auction prices and more recently by the interpenetration of art, entertainment, and fashion[33]—have brought contemporary art into the center of museum activity. What would require justification today would be for a general museum not to collect contemporary art, and departments of contemporary art and curatorships in this area, along with graduate training programs, have proliferated.

With these developments have come a new set of concerns for museums, grounded in a variety of historical changes. Institutional structures created at an earlier time to meet different needs are being called into question by new artistic media and by the use of the term *contemporary* to designate a particular kind of artwork. Alternative conceptions of the artwork and new technologies have created special problems of preservation and conservation. Broader social and political changes have generated new artistic categories and have broken down established national and ethnic divisions, all of which have affected how collections are built and their contents organized. Dealing with these and related collection issues is part of the challenge of current museum work, calling for practical decisions both on the level of institutional policy and with regard to particular objects. The essays in this book are written by people who contend with these matters on a daily basis, and who have given them a great deal of thought.

The essays in *Collecting the New* can be seen to fall into four groups. The first set approaches museum collecting of contemporary art in terms of general issues, each discussed with regard to a particular museum. Howard N. Fox, using the example of Los Angeles County Museum of Art, addresses the notion of forming a definitive collection in a time of diverse artistic practices and the breakdown of established art historical narratives. Robert Storr discusses the acquisition process itself, focusing on the practices of the Museum of Modern Art, New York. And Jeffrey Weiss of the National Gallery of Art, Washington D.C., looks at issues surrounding the acquisition of contemporary art for a museum

such as his own, which collects Western art since the Renaissance, versus the collecting activity of a museum of contemporary art. The second part of the book deals with contemporary art in particular media, focusing on kinds of work that present specific problems for museum collecting. Here Christophe Cherix discusses drawings and prints, Chrissie Iles and Henriette Huldisch, film and video, and Steve Dietz, digital media. The third set of essays focuses on regional- and ethnic-specific collecting. In this section, Vishakha Desai addresses contemporary Asian art; Pamela McClusky, contemporary art from Africa; Gabriel Pérez-Barreiro, contemporary art of Latin America; and Lowery Stokes Sims, contemporary art by African-Americans as collected by the Studio Museum in Harlem. In the book's final essay Glenn Wharton discusses conservation problems presented by contemporary works of art, special preservation concerns for museum collections, and how institutions are addressing these challenges.

This book represents just one way of organizing an overview of this broad field—alternative categories of discussion might well have been chosen, and other topics selected under these headings. In fact, new forms of cultural production and new ways of thinking about them, as well as changes connected with globalization and ethnic hybridization, call into question two of the book's central divisions. With many artists no longer confining themselves to a limited range of media, and as national and ethnic distinctions become increasingly porous, medium-, nation-, and ethnic-specific collecting all become problematic. But during periods of historical change, problematic categories still must be discussed in older terms, at the same time as their validity is questioned and new terminology and practices are formulated. Museums now find themselves at such a historical juncture, and the essays in *Collecting the New* are occasioned by the need to engage the issues that come with this territory.

NOTES

1. See, for instance, Reesa Greenberg, Bruce Ferguson, and Sandy Nairne, eds., *Thinking about Exhibitions* (London: Routledge, 1996); and Emma Barker, ed., *Contemporary Cultures of Display* (New Haven, Conn.: Yale University Press, 1999). Discussion of the role of the contemporary curator also has focused entirely on exhibitions, as in Carin Kuoni, ed., *Words of Wisdom: A Curator's Vade Mecum of Contemporary Art* (New York: Independent Curators International, 2001); Paula Marincola, ed., *Curating Now: Imaginative Practice/Public Responsibility* (Philadelphia: Philadelphia Exhibitions Initiative, 2001); and Carolee Thea, *Foci: Interviews with Ten International Curators* (New York: Apex Art, 2001).

2. Russell Lynes, *Good Old Modern: An Intimate Portrait of the Museum of Modern Art* (New York: Atheneum, 1973), 287. Stein's view still is not a dead one, for in 1999 we find Ernst Gombrich remarking, "I think that a museum of modern art is a contradiction in terms. Museums

used to exist to preserve the treasures of the past and to save them." Quoted in James Putnam, *Art and Artifact: The Museum as Medium* (New York: Thames and Hudson, 2001), 184.

3. The traditional connection of museums with judgments of artistic quality has been challenged on social and political grounds, but the association remains and it underlies accepted curatorial and art market practice. For an important airing of this discussion, see Michael Brenson, "Is 'Quality' an Idea Whose Time Has Gone?" *New York Times*, Sunday, 22 July 1990, Arts and Leisure, pp. 1, 27. The appeal to the test of time certainly rests on faith in the convergence of art historical opinion, a faith called into question—despite finding support in the authoritative stance of the museum—by explorations of the history of taste and artistic rediscovery. See Francis Haskell, *Rediscoveries in Art: Some Aspects of Taste, Fashion and Collecting in England and France* (London: Phaidon Press, 1976), 4.

4. A legacy of Romanticism, the historical determination of the masterpiece finds the persecuted modern artist redeemed by art history. For this view as presented in Delacroix's journal, see Walter Cahn, *Masterpieces: Chapters on the History of an Idea* (Princeton: Princeton University Press, 1979), 142. On the museum and the masterpiece, see ibid., 149–50, and Hans Belting, *The Invisible Masterpiece* (Chicago: University of Chicago Press, 2001), 32–39.

5. Philip Fisher, *Making and Effacing Art: Modern American Art in the Culture of Museums* (New York: Oxford University Press, 1991), 6. Similar connections between art history and the museum object have been made in the terms of postmodern critique by Donald Preziosi, as in his 2001 Slade Lectures, *Brain of the Earth's Body: Art, Museums, and the Phantasms of Modernity* (Minneapolis: University of Minneapolis Press, 2003), 18–19.

6. Fisher, *Making and Effacing Art*, 28. Commenting on the strong prices for postwar American art, the collector Eli Broad recently remarked, "Art of the 1950s, 60s, and 70s has passed the test of time. . . . Collectors are more comfortable buying those artists now than when they first emerged because people didn't know then how the work would be viewed historically." Quoted in Kelly Devine Thomas, "The Most Wanted Works of Art," *Artnews* 102 (November 2003): 133.

7. For Greenberg's involvement in the art world and his role as art advisor, see Florence Rubenfeld, *Clement Greenberg: A Life* (New York: Scribner, 1997), 214–27, 251–53, 270–79.

8. James J. Sheehan, *Museums in the German Art World: From the End of the Old Regime to the Rise of Modernism* (New York: Oxford University Press, 2000), 40. Mechel was one of Europe's most successful art dealers before he was summoned to Vienna by Joseph II to install the Habsburg collection in the Belvedere. His Belvedere installation followed the plan that he had created for the electoral gallery in Düsseldorf, according to which national schools of painting were arranged in chronological order, a departure from the "artistic" or thematic hangs common in eighteenth-century collections. Mechel's reordering of the painting collection was related to a more general rearrangement of the Habsburg collections, with the natural history and coin collections pulled out of their previous Wunderkammer setting for systematic investigation. On this point, see Luke Syson, "The Ordering of the Artificial World: Collecting, Classification and Progress," in *Enlightenment: Discovering the World in the Eighteenth Century*, ed. Kim Sloan (London: British Museum Press, 2003), 113.

9. For a history of the Louvre, see Andrew McClellan, *Inventing the Louvre: Art, Politics, and the Origins of the Modern Museum in Eighteenth-Century Paris* (Cambridge: Cambridge University Press, 1994).

10. Maria de los Santos, Garcia Felguera, and Javier Portus Perez, "The Origins of the Museo del Prado," in *Manet/Velazquez: The French Taste for Spanish Painting*, eds. Gary Tinterow and

Geneviève Lambert, exh. cat. (New York: Metropolitan Museum of Art; New Haven, Conn.: Yale University Press, 2003), 117.

11. The Gallery of British Art was founded 1857 in the South Kensington museum complex, and Pavel Tretykov's collection of Russian art, begun in the 1850s, was opened as a municipal museum in 1894. J. Pedro Lorente, *Cathedrals of Modernity: The First Museums of Contemporary Art, 1800–1930* (Aldershot, England: Ashgate Publishing, 1998), 104–12, 171–73.

12. On the history of the Museum of Living Artists in the Luxembourg Palace, see ibid., 55–96.

13. Ibid., 227. In 1936 Gallatin changed the name to the Museum of Living Art, a move that seems to have been prompted by the founding of two competing institutions, the Museum of Modern Art in 1929 and the Whitney Museum of American Art in 1931. In 1942 the Museum of Living Art was disbanded when NYU took back the space for other purposes, and most of the outstanding Gallatin Collection eventually went to the Philadelphia Museum of Art. For Gallatin's museum, see Gail Stavitsky, "A.E. Gallatin's Gallery and Museum of Living Art (1927–43)," *American Art 7* (spring 1993): 47–63. As an institution for the collection and display of modern art, the Gallery and Museum of Living Art was preceded in the United States by the Société Anonyme, established by collector Katherine Dreier in 1920, and by the Phillips Collection, created in 1921 when Duncan Phillips opened two rooms of his Washington, D.C., mansion to display his personal collection to the public. The Société Anonyme initially sought a building of its own, but soon devoted itself exclusively to mounting exhibitions of modern art in museums, galleries, clubs, and colleges, the most notable of which was held at the Brooklyn Museum in November 1926 and included more than three hundred works. It was called the Société Anonyme Museum of Modern Art at its founding, but Dreier abandoned the subtitle long before the creation of MoMA. On the Société Anonyme and its collection, see Eleanor Apter, Robert L. Herbert, and Elise Kennedy, eds., *The Société Anonyme and the Dreier Bequest at Yale University: A Catalogue Raisonné* (New Haven, Conn.: Yale University Press, 1984).

14. Francis Haskell has argued that the establishment of the Luxembourg as a museum of living artists prompted the painting of such major innovative works as Théodore Géricault's *Raft of the Medusa* and Gustave Courbet's *Burial at Ornans*, and claimed suggestively that in a sense the Luxembourg functioned as a "Musée des (pas trop) refusés." Francis Haskell, "The Artist and the Museum," *New York Review of Books*, 3 December 1987. And, writing more generally, Henri Zerner has pointed to the uneasy nineteenth-century combination of a historicist view of cultural production and a commitment to the autonomy of the artwork (and of the artist), a double consciousness affecting both the notion of the museum and the developing idea of contemporary art. Henri Zerner, "L'art contemporain commence-t-il en 1818?" in *Ou va l'histoire de l'art contemporain?* eds. Laurence Bertrand Dorleac et al. (Paris: L'Image, 1997). I thank Martha Ward for these references and for comments regarding the collecting practice of the Luxembourg having been more varied than generally assumed.

15. On the French museum system in the nineteenth century, see Daniel Sherman, *Worthy Monuments: Art Museums and the Politics of Culture in Nineteenth-Century France* (Cambridge, Mass.: Harvard University Press, 1989). On the Caillebotte bequest, see Anne Distel, "Introduction: Caillebotte as Painter, Benefactor, and Collector," in Anne Distel et al., *Gustave Caillebotte: Urban Impressionist*, exh. cat. (Chicago: Art Institute of Chicago; New York: Abbeville Press, 1995), 23–24.

16. Sheehan, *Museums in the German Art World*, 113.

17. Robin Lenman, "Painters, Patronage and the Art Market in Germany 1850–1914," *Past and Present* 123 (May 1989): 117–20. For the emotional and economic benefits to German artists of their work entering museum collections, see Sheehan, *Museums in the German Art World*, 94–95.

18. On Tschudi's appointment and collecting, see Peter Paret, "The Tschudi Affair," *Journal of Modern History* 53 (December 1981): 598–600. On Bode's and Tschudi's opposing views on museum collecting of contemporary art, see Sheehan, *Museums in the German Art World*, 159–62.

19. On Vinnen's protest, see Peter Selz, *German Expressionist Painting* (Berkeley and Los Angeles: University of California Press, 1974), 238.

20. On the Folkwang Museum, whose collection was purchased after Osthaus's death by the city of Essen and installed there in a new Folkwang Museum, see Sheehan, *Museums in the German Art World*, 175–78, and Robert Jensen, *Marketing Modernism in Fin-de-Siècle Europe* (Princeton: Princeton University Press, 1994), 210–12. For recent efforts to engage the history of the original Folkwang Museum in Hagen, now called the Karl Ernst Osthaus-Museum, through the exhibition of contemporary art, see Michael Fehr, "A Museum and Its Memory: The Art of Recovering History," in *Museums and Memory*, ed. Susan A. Crane (Stanford, Calif.: Stanford University Press, 2000), 35–59. It was at the new Folkwang Museum in Essen that Alfred Barr, Jr., and Philip Johnson together saw the kind of modernist installation— widely spaced pictures hung at eye-level on a neutral background—that Barr adapted for the Museum of Modern Art in New York.

21. Stephanie Barron, "1937: Modern Art and Politics in Germany," in *"Degenerate Art": The Fate of the Avant-Garde in Nazi Germany*, ed. Stephanie Barron, exh. cat. (Los Angeles: Los Angeles Country Museum of Art, 1991), 19.

22. For Dorner's "atmosphere rooms" and Lissitzky's Abstract Cabinet, see Joan Ockman, "The Road Not Taken: Alexander Dorner's Way Beyond Art," in *Autonomy and Ideology: Positioning an Avant-Garde in America*, ed. R. E. Somol (New York: Monacelli Press, 1997), 86–87, 90–94; Samuel Cauman, *The Living Museum: Experiences of an Art Historian and Museum Director—Alexander Dorner* (New York: New York University Press, 1958), 88–92, 100–104; Mary Anne Stanizewski, *The Power of Display: A History of Exhibition Installations at the Museum of Modern Art* (Cambridge, Mass.: MIT Press, 1998), 16–22.

23. Lorente, *Cathedrals of Modernity*, 177–78.

24. Quoted in Jeffrey Abt, *A Museum on the Verge: A Socioeconomic History of the Detroit Institute of Arts, 1882–2000* (Detroit: Wayne State University Press, 2001), 53. A 1908 newspaper article listed the Detroit Museum of Art (later, the Detroit Institute of Arts) collection as containing 227 "paintings" and 145 "modern pictures" (Abt, 81).

25. Among other American institutions that began buying advanced art in the 1920s was the Newark Museum, which under pioneering director John Cotton Dana and curator Holger Cahill (whose wife, Dorothy Miller, created the series of six *Americans* exhibitions at the Museum of Modern Art from 1942 to 1963) acquired important works of contemporary American modernism. And the Wadsworth Atheneum in Hartford, under the leadership of "Chick" Austin, mounted a radical exhibition program of European modern art during the 1930s, which led to significant contemporary acquisitions.

26. On the Hearn funds and artist protests, see Calvin Tomkins, *Merchants and Masterpieces: The Story of the Metropolitan Museum of Art* (New York: Henry Holt, 1989), 295–300. For information on Hearn's 1906 gift, the Arthur Hoppock Hearn Fund (1911), and the George A. Hearn Fund (1916), I thank Barbara File.

27. But a few months after his appointment as the first director of the Museum of Modern Art, Alfred Barr, Jr., suggested that the two terms differed in significance: "The word 'modern' is valuable because semantically it suggests the progressive, original and challenging rather than the safe and academic which would naturally be included in the supine neutrality of the term 'contemporary.'" Letter to Paul Sachs, 5 October 1929. Quoted in Sybil Gordon Kantor, *Alfred H. Barr, Jr. and the Intellectual Origins of the Museum of Modern Art* (Cambridge, Mass.: MIT Press, 2002), 366.

28. Kirk Varnedoe, "The Evolving Torpedo: Changing Ideas of the Collection of Painting and Sculpture at the Museum of Modern Art," in *The Museum of Modern Art at Mid-Century: Continuity and Change*, ed. John Elderfield, Studies in Modern Art 5 (New York: Museum of Modern Art, 1995), 43. For Barr's "torpedo," see 20–21.

29. A related position—rejecting the display of classics of advanced art in a contemporary art museum—is sometimes voiced, as in Heinrich Klotz, "Center for Art and Media Technology, Karlsruhe," in *New Museology*, ed. Andreas C. Papadakis (London: Academy Editions, 1991), 81.

30. Brian Goldfarb et al., "Fleeting Possessions," in *Temporarily Possessed: The Semi-Permanent Collection*, eds. Brian Goldfarb and Mimi Young, exh. cat. (New York: New Museum of Contemporary Art, 1995), 12–13.

31. Varnedoe, "Evolving Torpedo," 19.

32. Sally Anne Duncan, "From Period Rooms to Public Trust: The Authority Debate and Art Museum Leadership in America," *Curator* 45 (April 2002): 101. Sachs was a member of MoMA's founding board of trustees and proposed an alumnus of his class, Alfred Barr, Jr., as the museum's first director.

33. For a recent example of commentary on this phenomenon, see Roberta Smith, "Art Throb," *New York Times Magazine*, Sunday, 7 March 2004, pp. 80–87. This article is the week's entry on "Style." Its subtitle is: "It's official. The art fair is the chic new matrix between fashion and commerce."

The Right to Be Wrong

Howard N. Fox

CURATOR OF MODERN AND CONTEMPORARY ART,
LOS ANGELES COUNTY MUSEUM OF ART

I n an article about architects Elizabeth Diller and Ricardo Scofidio, Arthur Lubow described the duo going through New York's Museum of Modern Art, emptied and shuttered for renovation, selecting wall fragments where famous works of art had hung, which the architects intended to remove and incorporate into their own impending exhibition at New York's Whitney Museum of American Art. "By taking some walls and rejecting others," Lubow noted in passing, "they would be performing a curator's functions: deciding which works are aesthetically or historically important."[1] It was an innocuous enough observation, one that pretty much sums up a widely held view, among both the public and museum professionals, of what curators are: astute experts who have the responsibility and privilege of picking and choosing, and whose decisions have a lasting effect on what the rest of society gets to see and understand about art.

Curators are imagined to have innate insightfulness, cultivated sensibilities, and special training that allows them to make these judgments on everyone's behalf. But what special credentials entitle curators of contemporary art to ply their decisions? Contemporary art, by definition, has not withstood the test of time. The period covered by contemporary art is from now on. How are museums to collect the new and the unknown?

Collecting the past, the traditional job of museums, is itself a fraught enterprise that challenges curators and institutions to uphold their integrity and standards. When museums, or their curators, misstep, implications about professional expertise and public confidence rumble like distant thunder. Peter Landesman, writing in the *New York Times Magazine* about alleged fakes in the collection of the J. Paul Getty Museum in Los Angeles, for example, observed: "The implications of this controversy are far from trivial. Each year, tens of

millions of museumgoers walk through the entrance of the Getty, or the Metropolitan or the Prado or the Hermitage, and never consider the possibility of having to arbitrate for themselves the authenticity of what they have come to see. A museum's meticulous presentation—exhaustive captions, hushed lighting, state-of-the-art armature—creates an institutional authority that is constructed to seem impregnable."[2]

Curators all recognize the moral, ethical, and practical necessities of presenting what they believe to be authentic objects and factual information; this is not an arguable issue. But the tenor of the presumptions in Landesman's statement, which was written by a journalist and a novelist as opposed to a museum professional, raises serious questions about the perceived role of museums in our society. It reflects a paradigm of the museum as a locus of unquestioned and unquestionable authority—a court of passively accepted authoritarianism. In this paradigm, the museum's impersonal "voice" is expected to speak *ex cathedra* at all times. And yet many people, particularly artists and others with a vested interest in the activities and decisions of museums and their curators, resent the museum for exercising—indeed for even presuming to claim—such authority. Do museum professionals understand the museum to be authoritarian in its pronouncements, its programs, its critical inquiry? Do they claim this for their own role? Do curators, especially of contemporary art, want the public to believe this of the museum and their work? If so, why? If not, why not? What can be done to enlighten the public on the nature of curatorial enterprise?

It is illuminating to consider how museums are seen by their constituents and by society at large. In May 2001 the American Association of Museums announced at its annual meeting the results of a public opinion survey it had commissioned to determine the level of trust that Americans place in museums as a source of objective information. The survey report notes that, "among a wide range of information sources, museums are far and away the most trusted source of objective information. No other institution has a similar level of trust." The survey went on to report that almost nine out of ten Americans (87 percent) find museums to be trustworthy, including 38 percent who see museums as one of the *most* trusted sources. The report further found that Americans of every demographic group—defined by age, sex, level of education, and income—trust museums as sources of information and that this trust is anchored in museums' engagement with history, research, and facts.[3]

Presumably, if queried about the integrity and non-fallibility of museum curators, respondents would have reflected a similarly high confidence. We can only speculate that, if public opinion were to rank the trustworthiness of various other public figures, politicians and trial lawyers would skid to the bottom

of the list; health plan operators might hover somewhere in the middle; and museum curators would balloon to the top.

So much for speculation. To any museum professional, the public perception of museums as fundamentally trustworthy can only be welcome news. At least on first hearing. For however buoying the public's vote of confidence may be, it may ultimately serve to confine and frustrate the real work that curators—and particularly curators of contemporary art—do. Perhaps that perception does not suit the particular function of contemporary curators. Curators of contemporary art might serve their audiences and their institutions better by shrugging off, at least part way, the mantle of infallibility. Curators are, after all, as fallible as anyone else, and their esteemed profession is as susceptible to error, deception, and even the occasional misdeed as any other. And museums are famously—at least among their inner circles and their most astute critics—conflicted about mission, populism, elitism, programs, funding, administration, and the legitimate but often contradictory demands of specific constituencies and the public at large.

Apparently, public opinion does not perceive the "culture wars" that fume within some quarters of the museum world: *Does* quality matter? *Are* canonical truths true? *Can* other cultures be understood? Society at large, especially American society, may not care much about such philosophical problems or the fiscal challenges that beset cultural institutions in the twenty-first century. Thus, while curators should be pleased—even proud—that public opinion has such high confidence in their aspirations, and certainly they should do nothing to betray or undermine that public trust, we may do well to question whence, really, does that public esteem derive?

In our culture there is a popular perception of art museums comporting themselves with Olympian dispassion above the constant churning of ideology and theory, the tides of politics and history, the inconstancy of caprice and fashion. The art critic Hilton Kramer has identified the role of the museum, and of course the function of its curators, as a moral commitment to the "high values of disinterested discrimination and historical preservation that are the museum's sacred trust."[4] Though few in the contemporary art world pay much heed to Kramer's fusty orthodoxies, similar attitudes do resonate elsewhere in American culture. On the tenth anniversary of the creation of the Institute of Museum Services (rechartered in 1996 as the Institute of Museum and Library Services), President Ronald Reagan observed that "America's museums are treasure troves of practical knowledge, creative inspiration, and simple enjoyment. Each new generation rediscovers in them the distilled wisdom of previous generations, the inventions and artifacts that helped them to meet the challenges

of life and that point the way to new accomplishments and an even better future."[5]

Amid such cultural obeisance, what real latitude do museums have to collect the new, the uncertain, the unknowable? How can they conduct research that looks toward the future, rather than the past? What mind-set should curators bring to the task? The issues are both philosophical and practical.

A top priority for any curator should be a good soul-searching about the limits, and the prerogatives, of the curatorial process and the nature of the intellectual authority that curators have. Concomitant would be a consideration of the values the culture ascribes to museum collecting and whether those are the values that best serve museums and the public. Above all, it seems necessary to question the attributes of intellectual authority that the public seems so willing, so eager, to vest in museums and their curators. Rather than accepting the gift of unquestioned trust, museums might do well to inculcate, in the public imagination, the right to be wrong.

To consider these issues, it helps to peg the discussion to a real-life case study. The Los Angeles County Museum of Art serves as a useful specimen, for it exemplifies circumstances that may be applicable to a range of other museums, large and small. LACMA is a relatively young institution, having been chartered as a legal entity with its own board of trustees only in 1961; prior to that, it functioned as a department within the Los Angeles Museum of Science, History, and Art. It opened at its present location, in Hancock Park, in 1965 with a complex of new buildings designed by William Pereira and Associates and today describes itself in grant applications and promotional materials as "the premier encyclopedic visual arts museum in the Western United States," with a permanent collection of more than hundred thousand works spanning the history of art from ancient times to the present.

Although LACMA has collected contemporary art since its inception (and today has no fewer than fourteen curators in five of its ten departments who deal with contemporary art), contemporary art as a discipline is but a single function within one of the largest and most bureaucratically complex museums in the country. Historically LACMA has had a somewhat checkered relationship with the Los Angeles artist community. It is probably true that Los Angeles's Museum of Contemporary Art was founded in 1979 because of the widespread perception that LACMA wasn't doing enough to support and promote the art and artists in its own region. Whether that perception is founded in the truth is arguable, but it remains the tacit understanding of most interested observers.

Fact is, LACMA makes a special point of collecting and exhibiting the art of Southern California, which is one of the major centers for the production of art on the map of the international art world. And now that the achievement of

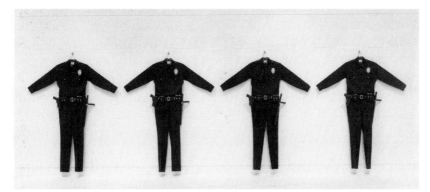

Fig. 1. Chris Burden (American, born 1946), *L.A.P.D. Uniform*, 1993. Four uniforms with Baretta handguns, wool serge, leather, wood, and metal; each uniform: 88 × 72 × 6 in. (223.5 × 182.9 × 15.2 cm). Edition nos. 1, 6, 8, 14 of 30. Los Angeles County Museum of Art, Modern and Contemporary Art Council Fund

Southern California artists has been sustained and internationally recognized for at least four decades, there is a palpable sense of history. LACMA's holdings of SoCal art are impressive indeed, with widely known and frequently written about works by Ed Ruscha (*Actual Size*, 1962), John Baldessari (*Wrong*, 1967; *Heel*, 1986), Ed Kienholz (*The Back Seat Dodge '38*, 1964), Eleanor Antin (*100 Boots*, postcards and installation, 1971–73), and many, many others.

Some, especially within the museum, have described LACMA's particularly strong representation of SoCal art as "the collection of record"; but this simply is not so. For example, although LACMA early on recognized Chris Burden as an important young artist through its annual New Talent Award in 1973, the museum did not own a major work of his until 2000, when it acquired four (of an edition of thirty) of his outsized police uniforms from his *L.A.P.D. Uniform* (fig. 1).[6]

And though the museum collected first-rate works by many New York artists of the 1960s and '70s—Ellsworth Kelly, Frank Stella, Sol LeWitt, Donald Judd, and so on—it collected virtually no works by feminist artists in Los Angeles (or elsewhere), despite the origin of the women's art movement in Southern California. The same was true of Chicano art and African-American art, both of which were significant phenomena in Los Angeles and San Diego. No historical account today of 1960s and '70s art in the United States would fail to address these important developments; yet at the time, LACMA did not act to represent them in its collection. The situation has since changed: the museum's curators have worked to fill in some of the conspicuous historical lacunae, and its acquisitions of recent art are decidedly more inclusive.

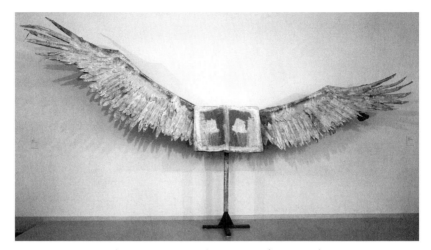

Fig. 2. Anselm Kiefer (German, born 1945), *The Book (Das Buch)*, 1985. Lead, steel, and tin, 114 × 213½ × 34 in. (289.6 × 542.3 × 86.4 cm). Los Angeles County Museum of Art. Purchased with funds provided by the Modern and Contemporary Art Council and Louise and Harold Held

LACMA's collection only glances at international developments in contemporary art, with a handful of European, Latin American, and Japanese examples from the 1980s and '90s. LACMA owns one of the versions of Anselm Kiefer's *The Book (Das Buch)* (fig. 2)—its only major sculpture by a major German painter of the contemporary period. It does not own a painting by Kiefer; nor by Georg Baselitz, Sigmar Polke, or Jörg Immendorff.

As for recent American art, since the early '90s the curators have focused more on the art of Southern California than that of New York or the rest of the nation—and not due to local boosterism. The strategy has been not chauvinistic but opportunistic. Southern California has become a major international focal point for the production of new art, and it enjoys an international regard that is perhaps disproportionate to its numbers. Today, artists come from all over the world to live and work in Los Angeles, just as thirty years ago artists from Los Angeles and everywhere else went to New York. L.A. has become a magnet for visual artists of every conceivable stripe. It only makes good curatorial sense to use limited resources to draw from such a reservoir. Though LACMA's acquisitions in recent years have been primarily of area artists, the careers and achievements of those artists—such notable figures as Mike Kelley, Martin Kersels, Diana Thater, Ed Ruscha, Amy Adler, Lari Pittman, Rachel Lachowicz (fig. 3), Jorge Pardo, Betye Saar, Robert Therrien, Monique Prieto, Bill Viola,

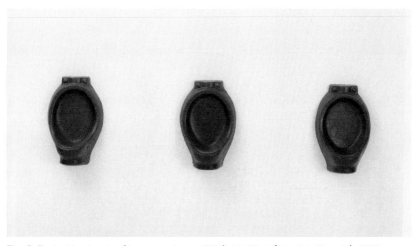

Fig. 3. Rachel Lachowicz (American, born 1964), *Untitled (Lipstick Urinals)*, 1992. Lipstick, wax, plaster, and fiberglass; each unit: 15 × 9 × 6 in. (38.1 × 22.9 × 15.2 cm). Los Angeles County Museum of Art, Modern and Contemporary Art Council, 1995 Art Here and Now Purchase

Pae White, Rubén Ortiz-Torres, Sharon Lockhart, Allen Rupersberg, and Alexis Smith—have been anything but local.

LACMA curators make a point of *not* segregating California artists, or any others. Work by California artists is shown in the same galleries with work by such non-Californians as Kara Walker, Christian Boltanski, Kiki Smith, Gabriel Orozco, Yayoi Kusama, Stephan Balkenhol, Ruth Root, Josiah McElheny, Doris Salcedo, Tony Oursler, Mona Hatoum, Bruce Nauman, Jessica Stockholder, Los Carpinteros, Joseph Kosuth, Annette Messager, Betsabeé Romero, Mariko Mori, and Mimmo Paladino.

Permanent collection installations at LACMA are usually arranged thematically, particularly from the 1970s on, when the dominance of individual "schools" or styles yielded to the pluralism that prevails in the global art world. To select and display art on the basis of its stylistic and formal affinities may always have some merit, but for contemporary artists it often makes more sense to reveal relationships, visual or otherwise, where they exist or can be intuited. This, after all, is how most artists work today: not in concert to establish a new movement with its requisite proponents, theorists, and discreditors, but individually (or sometimes in small collectives) to develop their own art and explore their own vision. Striking affinities may occur among artists who have never met each other, living and working continents apart. It is also

the way most viewers of contemporary art—even the most avid and well-traveled ones—experience new art and discern relationships among artists, not as declarations of unified manifestoes, but episodically, in this show or that, and speculatively, forming tentative conclusions. Reflective viewers and curators perpetually contextualize, and then re-contextualize, the art they see.

At LACMA, rotations of the contemporary permanent collection are as impermanent as resources allow and are conceived to echo that reflective process of seeing and re-seeing. Though individual works that require particularly complex installations—Nam June Paik's *Video Flag Z* (1986), for example, or Bruce Nauman's multipart neon, *Human Nature/Life Death/Knows Doesn't Know* (1983)—may remain on view in the same place for several years at a time, any given gallery is rarely left intact for more than about a year, and sometimes entire galleries change over in less than six months, exasperating docents but proffering frequent visitors new works to see and new contexts in which to look again at familiar ones. Every two to three years, as budget allows, the entire contemporary floor of the museum is closed and reinstalled completely. Inevitably some works stay from one rotation to the next, but they are always in combination with other works and in new contexts.

Every effort is made to underscore the provisional nature of these rotations in didactic panels, curatorial lectures, and docent tours, in order to dispel the notion of the fixity and sanctity of the collection. Hanging new art on the walls and bringing variety to tired galleries is not simply a practical consideration; the rotations are a sort of morality play, suggesting that *all* museum collections are incomplete, mutable, and *preferably* subject to revision and rethinking. And by rethinking works of art, viewers are encouraged both to think for themselves and to perceive that art-making is itself a highly cerebral process. The display of the permanent collection of contemporary art is aimed as much at the mind's eye as at the seeing eye. While museum culture in general has traditionally stressed quality and comprehensiveness as hallmarks of their permanent collections, contemporary curators must embrace tentativity and the constant shaping and reshaping of their collections as positive and vital values. As LACMA's example may suggest, when it comes to contemporary museum collections, their biggest weaknesses—incompleteness and constant revision—are also their greatest strengths.

None of this is official museum policy. And not every curator involved with contemporary art necessarily shares these values and sentiments. Indeed, there is a range of approaches. Some curators stress the importance of masterworks and impressively large examples in their installations. And although LACMA's contemporary curators are essentially free to display their collections as they see fit, there is general accord that it is philosophically desirable to keep the galleries active rather than static and, given that all art objects are by nature out

of the ordinary, that it is both interesting and legitimate to display iconically "Important" works together with ones that are decidedly not masterworks.

The 2004–5 operating budget of the Los Angeles County Museum of Art is approximately forty-one million dollars. Of that, less than one third comes through a ninety-nine-year contract with Los Angeles County, and those funds generally are used for facilities maintenance and related costs; the remainder comes largely from membership dues, ticket revenues, shop and café sales, and grants. No money is budgeted for acquisitions; all acquisitions funds—with the exception of the Photography Department, which enjoys an endowment from the Ralph M. Parsons Foundation—must be raised separately from the operating budget. Historically, the annual membership dues of the Modern and Contemporary Art Council have provided the single most important source of acquisition funds for contemporary art. Most years, the Council funds the acquisition of two to three moderately priced objects; from time to time the Council "mortgages" its bankroll to more costly acquisitions, such as Bill Viola's *Slowly Turning Narrative* (fig. 4), that may be paid out in two or three annual installments. The curators often leverage Council funds, using them in the manner of a matching grant to raise funds from other sources. Combined, these funds enable the department to collect modestly but steadily.

The resulting collection is decidedly rich, with expected major highlights and surprising finds everywhere, but it cannot be said that the collection is "definitive" of anything. A comprehensive exhibition of the museum's contemporary holdings, defined as works from about the mid-1960s to the present, would offer a fertile display of artistic and cultural expression at the close of the modern period. However, only a small percentage—perhaps ten to fifteen percent—of its contemporary holdings are ever on display at any one time because of limited gallery space. And even if the entire collection were totally accessible and interpretively displayed, it would not reveal what is often expected from big, encyclopedic museums: a historically comprehensive master narrative of a culture's artistic accomplishment and aspirations.

Considering the galactic expansion of international art world of the twenty-first century, the question must be asked whether a "definitive" or "authoritative" collection is a viable or even desirable construct. Artists tend to be rather cosmopolitan information processors: international journals are available virtually everywhere; contemporary art from around the world is rife on the Internet; and artists and exhibitions traverse the globe with relative ease. But while contemporary art practice can be observed globally, the simple truth is that there is no central information agency that governs or motivates its disparate activities.

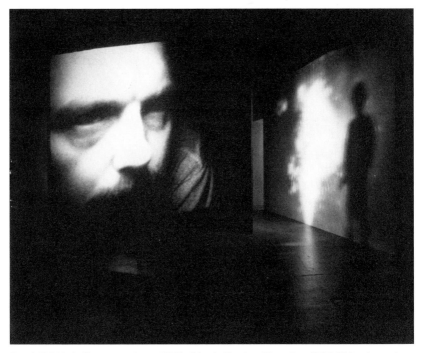

Fig. 4. Bill Viola (American, born 1951), *Slowly Turning Narrative*, 1992. Video/sound installation; room: 19 × 40 × 14 ft. (5.8 × 12.2 × 4.3 m). Los Angeles County Museum of Art, Modern and Contemporary Art Council Fund

Even within individual nations, there is generally not a single school of thought that sustains and dominates a core group of artists whose influence can be traced in the work of followers. The contemporary equivalent of, say, the New York School of Abstract Expressionists, does not exist. Even in such cities as London and Los Angeles, which both enjoyed international acclaim as exceptionally active centers of artistic innovation during the 1990s, there is no prevalent mode of work that adds up to a distinctive "school" of art-making. The firmament of contemporary art is made up less of major constellations than of individual luminaries. And while some are influential, particularly as teachers, the international artists community is not a community at all. It's a free-for-all.

How are museum curators, steeped in a tradition of connoisseurship and *Kunstgeschichte*, expected to deal with the unruly hundred-and-three-ring circus of contemporary art? In the absence of a unified, or even cohesive, artistic practice, how can there be a coherent narrative? Without a recognized dogma, how can there be canonical examples? These riddles suggest that the notion of a definitive collection—what might be called a "collection of record"—may be

phantasm, or worse, a red herring that is wrong-headed in conception and distracting in practice.

The role that modern Western civilization has assigned to art museums—certainly to "encyclopedic" museums like New York's Metropolitan Museum of Art, the Art Institute of Chicago, or Los Angeles County Museum of Art—is to serve as custodian of the best of the past. Indeed the very derivation of the word *museum*—the dwelling place of the muses—reflects our regard for the museum as a kind of sanctified space; and the Beaux-Arts and Neoclassical architecture that was long the paradigm of museum building, as well as the typology of their architectural form in the classic temple, has only reified that conceit. Every value ascribed to art museums vests the institution with exceptional virtue and responsibility. The culture confers a gravitas upon art museums comparable to that of churches and courts.

Such notions about art and its temples inculcate a faith—a superstition, really—that museums as institutions must embody that "sacred trust," those "high values of disinterested discrimination and historical preservation" that Hilton Kramer moralized about. Museums with a focus on contemporary art might do well to shun this folklore, about their nature. How much "authority" do they in fact have? How much do they want, even in theory? Is it beneficial to museums, or to the public they serve, to propagate the notion that museums have a "sacred trust"?

This idealized vision of museums tends to cast the museum as a reliquary, a mausoleum, a shrine to the past and the supremacy of its material culture. Conceiving the museum on such a model serves to discount the actual involvement that a museum might claim with the culture of the present, or even of the future. Though most large museums in the United States and Europe now collect modern and contemporary art, museums constitutionally foster a perception of history that relates almost exclusively to the past, just as some religions and cultures do. Yet it is just as valid to perceive history as a force that unfolds in the future. Rather than conceiving the museum's relationship to history as a relationship to the past, it is possible to imagine a relationship to the future. Museum curators need not restrict their role to preserving the past or to preserving the present as the past for future generations; like artists and scientists, they can at least speculate.

Historically, museums and their forerunners—athenaeums, *Kunstkammers*, armories, treasuries, archives, libraries, zoological and botanical gardens, and *Wunderkammers*—were not considered as "preserves" removed from the normal ebb and flow of life. Such cabinets were never complete, and the most princely and splendid of them convincingly reflected their owners' increasing intercourse with the world—their wealth, their power, their knowledge, and

their status. These prototypical museums were not conceived as hallowed manifestations of eternal and immutable truths. The function, the vitality, and the success of such collections depended on their constantly changing to reflect the exploits and passions of their founders and discoveries in the newly explored world beyond the confines of the collection.

The civil rights struggle of the 1950s and '60s, followed by the countercultural revolutions into the next decade brought an unprecedented call upon museums (and many other cultural institutions) to redefine their missions and programs more inclusively and eclectically. The 1970s saw the dawning revelation of the non-insularity of museums. Consensus was building among artists, museum professionals, and some of their mainstay supporters, at least in the United States, that museums do not, could not, and never did embody the Parnassian ideals of "sacred trust" and "disinterested discrimination."

To the contrary, it was quickly becoming clear that museums' internal policies and day-to-day operations are subject to external conditions; that museums themselves are the instruments of the taste and vision of those who govern, support, work in, and attend them; that there are legitimate and often contradictory claims upon the resources and programs of museums; and that museums function, whether they wish to or not, as dynamic forces within societies, shaping and reflecting our perception of art, creativity, and culture itself. This same lesson was relearned during the culture wars beginning in the 1980s, when the art world was again rocked, this time by political and religious conservatives rebelling against government funding for controversial art by such figures as Andres Serrano, Robert Mapplethorpe, and Chris Ofili.

In today's global art world, which flourishes in societies that tolerate divergent cultural traditions and ideologies, museums have a responsibility not to serve as ideologues for the hegemony of one cultural vision over all others. In encyclopedic museums especially, a cosmopolitan spirit of intercultural exploration is appropriate. And an awareness of how quickly the art world evolves, always in relation to the larger world beyond, is essential. Anticipation of the future, rather than codification of the past, is a necessary attribute of the contemporary curator's function. That aspiration is anything but certain, and its expression is anything but authoritative. Curators should assert the prerogative not to be infallible. They should be candid about the limits of their enterprise and educate audiences in the provisional nature of their collections and exhibitions. In short, curators may need to behave like, and to publicly acknowledge their similarity to, research scientists.

It might seem inapt to compare curators of contemporary art to scientists; curating, especially contemporary art, is speculative and subjective, while science is analytical and precise. Or so we imagine. The history of science is in

actuality the history of revised ideas, with new realizations and knowledge supplanting invalidated concepts. Experimentation and verification, essentials of the scientific method, are rooted in speculation: "what happens if. . . ." An "unsuccessful" experiment is as useful and necessary as a "successful" one; an untried theory only exists to be put to the test. And disproved theories do not become discarded and forgotten knowledge; they remain part of the ever-evolving history of ideas.

Among museums, or within encyclopedic museums, contemporary collections might position themselves in the spirit of *Wunderkammers*, more as laboratories and sites of discovery than places of sacred trust intended to preserve the received culture. A healthy curiosity is in order. Contemporary curators, like scientists and contemporary artists, should not resist experimentation; it's part of the job.

NOTES

1. Arthur Lubow, "Architects, in Theory," *New York Times Magazine*, 16 February 2003, p. 36.

2. Peter Landesman, "A Crisis of Fakes," *New York Times Magazine*, 18 March 2001, p. 40.

3. American Association of Museums, "AAM Press Release: Americans Identify a Source of Information They Can Really Trust," 7 May 2001, http://www.aam-us.org/pressreleases.cfm?mode=list&id=21 (accessed 9 August 2004).

4. Hilton Kramer, *New York Times*, "The National Gallery Is Growing: Risks and Promises," 9 June 1974, sec. D, p. 19. Researchers using the Proquest Newspapers search engine will find the same article on page 137.

5. Quoted by Robert S. Martin in Institute of Museum and Library Services, Washington, D.C., "[Press Release:] 25th Anniversary Museum Services Act," 26 June 2002, http://www.imls.gov/whatsnew/current/sp062602-1.htm (accessed 9 August 2004).

6. LACMA's former New Talent Award was conceived as a way to recognize emerging artists in the greater Los Angeles area through an annual purchase award conferred upon two or three artists out of hundreds of applicants. In the mid-1960s and '70s the $3,000 grant was enough to pay a year's rent on a studio space—a substantial subsidy to the artist that had the intended effect of helping to keep artists rooted in Los Angeles rather than moving to New York. In exchange for the monetary award, artists selected one of their works to enter the museum's permanent collection. In the case of Chris Burden, who in the 1970s was a performance artist, there were no works for the museum to collect; rather, the artist presented the museum with the Chris Burden Deluxe Photo Book 71–73, a notebook of documentation from his performances of 1971 to 1973. Apart from this acquisition, the museum owns several of his works on paper.

To Have and to Hold

Robert Storr

ROSALIE SOLOW PROFESSOR OF MODERN ART,

INSTITUTE OF FINE ARTS, NEW YORK UNIVERSITY

R egular readers of the cultural coverage in the *New York Times* will know that on Fridays one is likely to find stories of notable acquisitions—and sometimes of equally significant deacquisitions—that have been announced that week by one or more of the country's major museums. With considerable press office fanfare but for the most part little in the way of detailed curatorial background, these stories emphasize the dramatic nature of such events, and all too often concentrate on the cost and social prestige of the transactions. One of the consequences of this mixture of attention-getting publicity and procedural opacity is a growing skepticism about the ways in which museums build, manage, and reconfigure their collections.

To the extent that most museums are public institutions by virtue of their official governance or the nonprofit status they claim, these decisions and the reasons for them are a matter of public interest and consequence. This is true not only because they concern the disposition of large sums of money and the corresponding accountability of museum patrons and professionals but because the works of art gathered or dispersed in this manner constitute a cultural resource whose use by the public is enhanced or diminished by those decisions. However, it is in the nature of art collecting—due both to its competitiveness and to the strictures that may be, and frequently are, imposed by the seller, buyer, or donor of a work—that full disclosure before or even after a deal has been completed is impossible. Thus the issue of how much light can be shed on deliberations that are, in many respects, highly confidential has become a crucial one of trust between museums and the various communities they are intended to serve. Under these circumstances, the greater understanding that people have of the basic process of museum collecting, and the more rationally and equally

the power to select which works will enter or leave such collections is divided between benefactors and curators, the more faith the public can have in the outcome, even though the specifics in most cases will, of necessity, remain unknown to them.

The goal of making works of art available to a general audience is predicated on the negotiated transfer of great wealth in which it is the curator's job to propose and the patron's choice to dispose. What curators do is play Robin Hood, taking works of art from the drawing rooms of the privileged and the showrooms of the art trade and putting them places where those generally less privileged can see those works on a regular basis. Ideally, this removes them permanently from market circulation, with all its ups and downs, and returns them to a situation where their worth is determined by their "use value" as objects of inquiry, reflection, and pleasure they provide as "useless" objects on which idle mind and senses may fasten and in the neighborhood of which they may freely wander. Of course, unlike the Robin Hood story, the "haves" are not at all surprised by ambushes that have been laid for them, and generally put up only moderate resistance if, in fact, they are not already actively encouraging their own divestiture.

Once upon a time, this game involved relatively few players and, where modern and contemporary art as opposed to Impressionism or the Old Masters were at issue, relatively reasonable sums. All that has changed. It is sufficient to read the auction results over the last twenty-five years to see the exponential rise in values in the modern and contemporary field. A quick review of recent "100 top collectors" lists and of the news columns that track the activities of curators in the art glossies makes it plain that the cast of characters has increased in proportion to this escalation in price. Moreover, as important works are taken out of circulation through institutional acquisitions, the shrinking number of those that remain within reach of potential owners private or public intensifies the scramble, and adds to the pressure to go trophy hunting instead of following more considered strategies based on the previous patterns of collecting or the best use of existing or obtainable funds. Such competition also increases incentives to blur the distinction between the rules that govern institutional conduct in this sphere and those which generally apply to individuals, and which in the hot pursuit of coveted things are frequently bent.

A basic issue should be stated at this juncture, and its importance grows as the boards and acquisitions committees of our major museums are filled by patrons whose entrepreneurial spirit may come in conflict with the more cautious practices of museum professionals. It involves simple, almost self-explanatory principles that are nonetheless easily lost sight of when they matter most. The galleries of our major museums are not, or at any rate should not be,

extensions of the living rooms of donors, nor should they express the personal likes and dislikes of anyone involved in acquisitions, including curators, if that merely means acquiring what one would comfortably live with or eagerly show off. The criteria for judging a work's value to a collection transcends taste and—in the case of much modern and contemporary art that has deliberately upset the apple cart—it may willfully violate prevailing tastes. Everybody knows this is true when retrospectively considering paradigm-breaking works of previous avant-gardes, but experience shows that frowns around the table at acquisitions meetings often reflect unexamined preferences and comfort zones or a spontaneous resistance to the "new new" that is often grounded in a defense of the "old new."

Leo Steinberg's seminal article "Contemporary Art and the Plight of the Public,"[1] which explains how his first encounter with the work of Jasper Johns flew in the face of his admiration for the Abstract Expressionists, is the fullest, most subtle analysis of the dilemma such aesthetic shifts entail. *60 Minutes* reporter Morley Safer's mockery of the contemporary painter Robert Ryman under cover of maintaining the high standards of historical modernism represented by Joan Miró, is a prime example of this phenomenon as a manifestation of naiveté, ignorance, and unacknowledged malice.[2] Between these two extremes may be located the basic instincts of many patrons, and the reflex responses such aesthetic habits prompt must be persuasively answered by curatorial advocates of work that runs counter to them. The fact that "art lovers" are repeatedly confronted by art that is unlovable is where the education process— the essence of collecting for institutions—begins.

By much the same token, changes of taste should not provoke the sudden disposal of works that have become unfashionable and may remain so for long periods of time, if not for the indefinite future. Art history is not a script subject to emergency rewrites that arbitrarily dispense with protagonists essential to one phase of the story but incidental to others. Nor for that matter is it always clear which "minor characters" or "lesser" works of art will turn out to be the crucial points of reference for future generations. Anyone who bought Frida Kahlos in the 1930s because she was a vibrant curiosity in the burgeoning field of Mexican painting or because she was the colorful wife of the world famous Diego Rivera, and then sold them off in the 1950s or 1960s when Latin American art fell from favor, will appreciate the shortsightedness of such a move—and the exorbitant cost of correcting it now.

Neither are museum collections piggy banks waiting to be broken to pay for enthusiasms of the moment. If patrons are truly persuaded that a given work is worthy of the institution they serve, then they should, as a rule, be prepared to pay for it themselves rather than relying of patrons of previous times to pay for

it through the sale of the works those predecessors once believed in with equal conviction. Indeed, in choosing works museums not only record aspects of the history of art in a given period, they are also selecting examples that implicitly document what a society valued in the same or subsequent periods. To tamper in any substantial way with that record is to falsify the past in the name of the supposedly superior judgment of the present, thereby falsifying cultural history itself.

Moreover, insofar as collectors of today don't wish to be second-guessed by those of tomorrow with the result that their contribution is altered or erased, they should not be too quick to second-guess those of yesterday, especially for reasons of economic expedience. Unfortunately this occurs with ever greater frequency. Perhaps the only remaining disincentive is to remind those tempted to "trade in" or, worse, "churn" significant parts of existing collections that ill-considered deacquisitions can garner as much or more bad publicity as well-thought-out acquisitions generate good publicity. After all, who wants to go down as the person who sold off the work better remembered than the one bought in its place, especially in the realm where memories tend to be long? This has happened. Take for example the "exchange" of a Dutch museum's only neoclassical Pablo Picasso (a small painting but a gem) for a room full of Gunther Förgs? In the final analysis, miscalculations with regard to deacquisitions can annul the positive response to works acquired by that means. In poker-playing terms, it seldom makes sense to exchange an ace for an ace, much less for a Jack or a ten, and no sense at all to break a winning straight or a flush for the sake of a solitary high card.

The sole justification for parting with works already in a collection is to trade up in the same area—style, period or artist and only when the merits of the work being acquired far outweigh those of the work being deaccessioned. An example: Lillie Bliss's personal collection formed the nucleus of the Museum of Modern's Art's original holdings. It was given with no formal constraints but rather on the understanding that MoMA could exchange or sell parts of it to obtain things the curators wanted more. The result was that Miss Bliss's name appears on a wider variety of works than she herself pursued and, in some instances, on works of higher quality than those she owned by the same artist. However, MoMA husbanded this trove for years, kept the very best things and some of the lesser but nevertheless exceptional ones, and made changes only with the greatest of caution. Based on this precedent it has successfuly been able to resist pressures to place restrictions on gifts of comparable importance from other sources. Mistakes both major and minor have been made along the way, but the basic integrity of the traditions initiated by Miss Bliss's benefaction have, so far, been maintained.

What follows are some touchstones for preventing unwise deaccessions. The fact that a work may be infrequently exhibited does not necessarily imply that it is inferior and therefore dispensable. For example, small paintings, fragile objects and works on paper are, for a variety of practical reasons, often shown sparingly. Nevertheless, they may also be singularly significant in artistic or historical terms and should not be treated as a "cheap" way of building toward a large sum. Only rarely should the unique example of a work by a given artist, or of a given type, be cashed in and never merely because it seems like a loose counter. It is important that gifts to museums not be accepted if there is in fact no interest in them, and it is equally important that they not be accepted simply in order that they be "flipped" later unless that is the express desire of the giver, and even so such generosity may lead the museum into being viewed as a market speculator in ways that can be extremely damaging. Serious donors resent seeing their work casually accepted, and resent even more its being casually spent.

Another example: with the agreement of the family of the donor the Museum of Modern Art recently sent to auction a work by George Bellows that had come in a large and varied bequest because Bellows had never been a painter in whom the Museum had expressed much interest. The windfall that resulted from that sale has funded the acquisition of a number of major works within the Modern's purview, and credit for them has gone to the donor of the Bellows. That said no works by living artists should ever be sold off except to obtain a demonstrably better one by the same person, lest the museum's actions be perceived as "disowning" someone in whom it had previously placed its faith and thus heavily prejudicing others against him or her for the duration of that artist's career. Usually, though, artists are glad to see the examples representing their accomplishment upgraded. However, they can, on occasion, mistakenly turn against aspects of their earlier production or misjudge the value of what they are currently doing, so museum's should be very leery of offers to swap old work in the collection for new ones in the studio, as well as of offers to repair damaged works in the collection that may not survive intact the "operation" meant to save them. Building collections of modern and contemporary art that have lasting value is a multigenerational enterprise that requires respect for the decisions of all involved. From all participants it demands both daring and commitment. Practically speaking this means a willingness to take chances combined with a determination to stand by decisions that have been made even after those who made them have passed from the scene. In short, museums that enter into the field of modern and contemporary art collecting cannot do so half-heartedly, nor can they play it safe and succeed. Nevertheless they must operate on what would seem to be two opposing assumptions that, over the

long haul, actually converge: on the one hand, they must be aggressively forward-looking in their strategies of acquisition; on the other, they should be extremely conservative in their deacquisition policies.

An all too familiar consequence of market pressures and inordinate competition among museums for generally sought-after artists is copycat collections in which middling examples of work by those artists predominate. While each museum of this kind can boast of having "their" painting by W or video by X alongside comparably good but seldom excellent photos by Y and sculptures by Z, the ensembles tend not to be superlative in any domain. With luck, they may be ornamented by a handful of first-rate things. So long as museums collect by lists of artists first and list of works second, there is no way out of this cul de sac. However, museums that carefully assess the strengths of their collections and the reach of their resources, and specialize in one or more areas—foregoing opportunities to seize prized works outside that area—on the whole fare better than those that habitually chase the fire engines of consensus taste or lurch from one plan to another in accordance with the passions or personalities of patrons, directors, or curators.

As a repository for twentieth-century German art, the St. Louis Art Museum is a case in point. Although it houses masterpieces from many cultures and periods, including marvelous paintings by School of Paris painters from the Impressionists through Henri Matisse and Picasso, as well a equally remarkable works by American artists from David Smith to Richard Serra, the museum's collection of German Expressionist painting coupled with their comprehensive representation of Max Beckmann make it a must-see for anyone interested in such material. The recent purchase of blocks of work by Gerhard Richter and Anselm Kiefer as well as single items or smaller groups of works by their contemporaries augment and update these earlier acquisitons. One can only think that whatever alternatives may have been sacrificed to these concentrations are far outweighed by them. And in the rivalry among institutions, none other, not even the Busch-Reisinger Museum at Harvard or any of the museums in New York, including the Museum of Modern Art, can match St. Louis in the depth of its holdings in these domains.

Another museum with an impressive but relatively small synoptic collection of modern and contemporary art is the Walker Art Center in Minneapolis. Lately they have decided to focus on certain performance and conceptually oriented practices of the 1960s to the present, while fleshing out their account of painting and sculpture in this period. Having boldy and presciently moved into these arenas, they were able to pick up signal things when they were still attainable for moderate prices. In addition to sponsoring an adventurous exhibition program in the same areas, the Walker has thus become a worldwide

destination for those dedicated to the most advanced art of the second half of the twentieth century, and the beginning of the twenty-first.

Yet like many museums, the Walker has, on occasion, suffered setbacks in choosing not to buy key works that fit directly into their schema outright because they counted on the generosity of patrons who promised to buy expensive things for them and, in the end, failed to. Thus, a rare early sculpture by Bruce Nauman, *Henry Moore Bound to Fail* (1967; private collection), that had been on long term loan to the Walker from a board member, and seemed certain to end up there, went to auction and sold to a private collector in Europe at a price no museum anywhere in America could meet. There are many more incidents of wished for, tacit, or even official commitments unfulfilled by patrons. Sometimes it is a matter of miscommunication between the presumed donor and the museum. Sometimes the collector's hand is forced by financial troubles. Sometimes hurt feelings, skittishness, sheer fickleness, or an opportunistic lunge at profit overrules the collector's better intentions.

The lesson is that musuems should not foreswear pursuing major works by key artists simply based on the temporary deposit of roughly comparable things at the museum by collectors, dealers, or artists. Furthermore, they should be leary of accepting such loans if the presence of works on the museum walls gives the impression that that "base is covered," thereby dissuading someone else more ready to give up front from stepping forward. Verbal agreements and handshake deals are not enough, and often lead to divisiveness later on. Promised gifts should be on paper and binding. Partial gifts with the donor retaining a liftetime interest in the work should guarantee the museum periodic access to that work for a period of time equal to the percentage owned by the museum, and complete ownership of the work at such time as the donor decides to turn it over or dies, should not be compromised by any residual interest in the work by the donor's heirs or creditors.

There are a variety of factors that undercut the bond between patrons and museums, and chief among them now is the proliferation of the latter and the increasing scramble for the attention of the former. With so many institutions waiting to benefit from so few individuals, and with the growing practice of patrons having membership on multiple committees and boards at different institutions in the same city or in different cities or countries, the often unclear guidelines for commitment become ever more ambiguous and tenuous. In a sense, it is a "givers" rather than a "getters" market, though the "getters" are constantly creating new inducements to gain the allegiance of "givers." These range from special showcase exhibitions and naming opportunities (both reasonable things to offer) to the commitment to accept a collection unedited by curators (an unconscionable concession to private interests in any professionally run

public entity) or to assurances that the donor's collection will remain intact in a dedicated space. The latter option is very tempting on both sides, but a terrible mistake. As museums come to rely more and more on reshuffling and reinstalling their collections as means of engaging the public, and as critics and scholars argue with greater and greater effect that history should not be regarded as fixed but should instead remain open to constant reinterpretation—which, in a museum context, signifies scholarly as well as imaginative and unconventional realignment of actual works—the promise to keep any work or group of works in a given location robs the curatorial staff of the opportunity to rethink the place of specific works within the larger and variable scheme of things. It also threatens to condemn the cherished benefaction of the donor to a prematurely dated and unnecessarily stale permanence.

As its grandiosity and aesthetic and art historical incoherence attest, the Lehman Wing at the Metropolitan Museum of Art in New York is a prime example of the folly of building chapels to donors, no matter how extraordinary their gifts may be. MoMA's continued resistance to this concept, sometimes in the face of intense pressure from on high, is one of the things that has insured that it remains a living museum of modern and contemporary art. Despite its many expansions and the monumental scale of its operations, the collection still circulates through architecture rather than being imprisoned by it or cordoned off into spaces dedicated to specific sponsors.

Creating permanent chapels to individual artists is also a bad idea, whether the impetus comes from a devoted collector or from an artist who has crossed over into the category of patron by giving works or by selling them to the museum on a preferential basis. Piecing together "long suits" of Joseph Beuys, Louise Bourgeois, Johns, or Ryman makes sense when it is possible, and seeing their works in clusters is always illuminating, not to mention moving. But once and for all plucking them from art history, and cutting short the conversations their work may have with that of their contemporaries—Beuys with Fluxus or Arte Povera, Bourgeois with Eva Hesse or Yayoi Kusama, Johns with Robert Rauschenberg or Cy Twombly, Ryman with Frank Stella or Robert Mangold—terribly limits the range of meanings that can be found in them. In addition, it threatens to change the variously engaged viewer into a simple contemplator and to turn the energetic artistic dialogue of a particular time into a series of "timeless" and walled-off monologues. One-person museums have their place, but a general museum of art should never allow itself to become an aggregate or constellation of such individual repositories. It is up to curators to convince collectors and artists of the error of such a concept, and at the extreme to say no to the suggestion even when it means the loss of a donation.

In the context of representing major figures in high concentrations, the value of simultaneously pursuing the best things produced by notable "little masters" should not be underestimated. It is they who contribute the subtlest textures to the fabric of art history. Umberto Boccioni and Giorgio de Chirico are arguably the most innovative Italian painters of their period, but Giorgio Morandi cedes nothing to them on the walls of any museum lucky enough to own a good example, and his presence is a powerful corrective to the philosophical and ideological content of the other two modernists. Something of the same may be said of Myron Stout when put in the context of Jackson Pollock and Barnett Newman. The triumph of a lesser artist of this type is worth more than the average production of most great ones. Besides their own merits, such exceptional works add much to our appreciation and understanding of the best by great artists, not to mention the fact that the unrealized potential of work of "little masters" is sometimes where the leading lights of subsequent generations push off. Resources well spent on such unique things are the grace notes of a well-composed collection.

There are, to be sure, many other contingencies that bear on how musuems collect, such as mandates or pressures to pay special attention to local or regional artists or artists representing the institution's social and cultural constituencies. Then there are those cases in which the mission statement of a musuem originally dictated that it should address a narrow segment of art-making, but changing circumstances prompt a widening of that focus while keeping faith with the founders' cautions against the wholesale abandonment of that emphasis. The truth of the matter is that "The Museum" so often discussed in theoretical literature does not exist; instead there exists a plurality of museums just as there does a plurality of art making. The differences among museums can be positive indicators of how they should proceed and where they should concentrate their efforts, with the result that these differences will encourage people to come to them to explore their strengths rather than pass them by on the assumption that they more or less replicate each other.

In conclusion, though, a few words about the distribution of responsibility that should be established and/or maintained in *all* museums when it comes to the actual process of deciding which works should enter the museum and which should be let go. As in all democratic institutions, a clearly defined and immutable separation of powers is the best protection against undue influence and precipitous judgments of any parties to the process and the unifying principle that holds them together in situations where strong emotions might otherwise irrevocably divide them. My examples here are the traditions—one might call them the precedents and common law—that evolved over many years in the Painting and Sculpture Department of the Museum of Modern Art.

A museum toward which enormous attention is turned and in which enormous power is concentrated, it is potentially most suspectible to abuses of power. And yet, until now at least, it been among the most scrupulous in preserving the balance I hope to describe.

The terms are fairly simple. Curators charged with overseeing the existing collection, who for that reason are most knowledgeable about its specific strengths and weaknesses, are the only ones in a position to present works of art for consideration to the acquisitions committee. Committee members—a mixture of board members, collectors, patrons, and occasionally scholars with a proven interest in the kind of art dealt with by the given committee (photography, prints and illustrated books, and architecture and design also have committees at MoMA)—are the only ones to vote on whether to accept or reject a specific proposal, since they are the ones who fund the acqusitions or shoulder fiduciary responsibility for the museum as a whole. Committee members may not come to the table with their own proposals, although prior to a meeting they may consult with curators about their interest in giving or paying for a work. For their part, curators may not commit the museum to buying or accepting as a gift any work without first going to the committee. (In some museums, and during some periods at MoMA, curators have asked for and received permission to pass on works under a certain value with committee approval, but as convenient as this may be, it opens the door to favoritism, private dealings, and mischief of other kinds.) Committee members must be prepared to accept the refusal of curators to act on their offers or suggestions in good faith and without further pressure or recrimination, especially in situations where they are unaware of negotiations with others—dealers, artists, collectors—that may involve works similar to those which they are advocating, or about which the curators may have reservations. Among them might be aspects of a transaction that curators may have reason to believe might compromise the museum but which they are not in a position to disclose to the committee members. Whatever the criteria may be, curators must feel secure in their authority to say no as well as yes to anyone who approaches them with a prospect, especially those with a vested interest in the outcome and even those who pay their salaries.

By the same token, curators must accept the decision of committee members even when it goes against them. Assuming that they have an overriding belief in the artist or artwork, they may, after a decent interval, make a similar proposal based on changing sentiment among committee members, changing factors governing the allocation of scarce resources and other matters that may have left the door open. That said, in laying the ground for a decision or in attempting to revisit a previously negative decision, curators must not play politics

within the committee in ways that pit members against each other, or lobby outside the committee in a manner that might allow the interests of dealers, artists, or other outsiders to interfere in the committee's functioning. In effect, curators act as lawyers presenting the best case they can on behalf of their client, which is an artist and specific work. The committee is the jury and their judgment is final.

In this context, museum department heads should grant individual curators serving under them the greatest lattitude to speak for works that fall within their expertise, and encourage debate within their departments and the committee rather than stiffling it for the sake of a prearranged consensus. Such manipulations tend to obscure important differences of opinion out of which a broader and more supple consensus might eventually grow, and they preclude daring choices. The depth, richness, and diversity of MoMA's permanent collection is the joint creation of persistent men and women who *did not agree* about what modern art was or should be, and who accomodated those divergent views in order to place the most compelling works representing their conflicting notions before the public. Alfred Barr, the founding director of the museum and for many years the chief curator of its collections, refereed this give and take. He counseled patrons but did not dictate the policy from a position of absolute authority.

Only a man of Barr's aesthetic catholicity and exceptional foresight and fairness should preside over the building of a collection to this degree. He was not unique, but in the history of museums of modern and contemporary art there have been very few others whose abilities approximate his. The qualities that distinguish a successful manager of museums, which have evolved in our era into such complex structures, and those that make for a comparably successful curator of collections overlap, but they rarely appear in equal measure in the same person. Only hubris, or the misconception that acting as a curator is the reward for the often thankless hard work of a director tempts people into confusing these increasingly divergent roles. Prudent directors choose the path of discretion in this area. Thus they should attend all meetings of all committees so as to be able to hear all sides of the discussion and be in a position to report on it to the board or absent committee members. Yet they should recuse themselves from the committee deliberations, even in cases where they have specialized knowledge, lest they preempt the process by effectively dictating its results. In situations where directors see institutional issues or priorities as being at stake, they should broach them with the department head and committee chair who represents the curatorial staff and the committee respectively. But once a work has gone to committee, the question of advocacy and judgment should rest with those delegated to make them.

Resuming the legal model, something like the principle of *habeas corpus* should apply to all discussions about acquiring or deaccessioning works of art. Unless the scale of the work or the cost of shipping or installing it are truly prohibitive, no decisions should be made except when all those speaking for or voting on the work are in the presence of the original. Eloquent words and good slides can be very misleading; the real thing is its own best—or worst—advocate. Following the same logic, no work should be removed from a collection unless it can be directly compared to the one for the sake of which it is being sold off or exchanged. No work of art should ever be sold except to pay for another work of art, nor sold in anticipation of acquiring another as yet undesignated by the curators. When in doubt, the committee should stand pat instead of hoping for the luck of the draw.

Cards and courts; these metaphors are intended as an admission that, rather than being a matter of serenely disinterested scholarship or discernment, museum collecting is in fundamental ways a game predicated on lively contention among the players. But as the great Dutch historian J. L. Huizinga spelled out in his book *Homo Ludens*, all games have rules upon which their integrity depends. Breaking them spoils the fun and vitiates the outcome. None of the participants win and the public is betrayed.

NOTES

1. *Harper's Magazine*, January 1962, reprinted in Leo Steinberg, *Other Criteria: Confrontations with Twentieth-Century Art* (New York: Oxford University Press, 1972).
2. "Yes . . . but Is It Art?" *60 Minutes*, CBS, September 19, 1993.

9 Minutes 45 Seconds

Jeffrey Weiss

CURATOR AND HEAD, MODERN AND CONTEMPORARY ART,
NATIONAL GALLERY OF ART, WASHINGTON, D.C.

I n 2001 the National Gallery of Art in Washington, D.C., mounted an exhibition of sculpture by Cy Twombly. The exhibition, originally organized by the Basel Kunstmuseum and the De Menil Collection in Houston, was shown not in I. M. Pei's late-modernist East Building, which houses the museum's permanent collection of twentieth-century art and is the site of most special exhibitions of work from the modern and postwar periods, but in John Russell Pope's mid-century Neoclassical West Building. There Twombly's work occupied the Mellon galleries. These lofty, sky-lit beaux-arts spaces, normally distinguished by dark colored walls and heavily filtered from the sun, were painted white for the occasion and opened to a radiant flood of natural light. The sculptures, rough yet highly formal found-object constructions slathered in white paint and lumpy plaster and implanted with weedlike nails, were installed in close collaboration with the artist. The exhibition was spacious and spare: some of the objects were placed directly on the old, wide-plank oaken floor, and each looked as if it had been left alone to find its own place, although positions and relationships were, of course, minutely—if intuitively—determined through four days of trial and error. That process managed to be both excruciatingly intense and playfully offhand: the presence of the artist at the installation lent to the proceedings the urgent imperative of authenticity as well as a distended, almost otherworldly rhythm of reverie and ennui. Once placements were finally established, the bases were weighted from the inside and the rooms were mopped. Twombly was heard to say that his sculptures looked as if they had been left behind centuries ago.

Even though the building is actually only six decades old, the interior belongs to a historical revival style that is perhaps especially pertinent to the

antiquarianism of the South, where the artist was born and raised and where, some speculate, he first derived his expansive affinity for the sites and artifacts of ancient Greece and Rome. The installation of Twombly's sculpture—distressed white fetish objects gracing white-washed, light-filled classical-revival galleries— produced an Elysian encounter of the patrician and the bohemian that managed to be both irreverent and moving. Almost accidentally complex in its nesting of archaeology, historicism, modernist practice, and post-Symbolist nostalgia, the exhibition was spiritually true to the life of Twombly's work in the late-century imagination yet wholly uncontrived, inhabiting as it did the Neoclassical museum interior as a found space. Such a result (in its intentional and its inadvertent consequences) would have been impossible to achieve in a museum devoted solely to modern and contemporary art.

Apart from the artist's studio, there is, of course, no "authentic" setting for Twombly's sculpture—only multiple settings, some more viable than others and each representing an interpretive frame. Likewise, the very definition of the terms *modern* and *contemporary* is at least partly contingent on setting. They are historical categories, but they are not exactly fixed: employing modern to mean "modernist" does allow us to circumscribe dates—roughly 1880 to 1960— within which the rubric possesses critical and historical meaning. The contemporary is far more elusive: relative to the history of Western art since the early Renaissance, it could well be said to apply to art from, say, the postwar period— what qualifies as ancient history for the *momas* and *mocas* of our museum world, where "contemporary" stands for the present and the very recent past. According to the measure of historical time, then, no body of material remains contemporary for very long; this condition has a serious bearing on the relationship between any art museum and the present or the "new." Perspectival coordinates occupy the long view differently than the short view, and biases (distortions that result from any system of perspective) follow suit.

When the National Gallery was inaugurated in 1941, its bylaws actually prohibited the acquisition of work by living artists. Modernism and the "contemporary" were anathema to the original values of the institution, which was specifically modeled after the National Gallery in London, a "picture gallery" of Old Master painting. In Washington, the museum—a public institution founded through private benefaction—was constructed around the collections of Andrew W. Mellon and, subsequently, Samuel Kress and Joseph Widener, whose own tastes (following those of the English aristocracy) were largely devoted to the Old Masters. Even more—as John Walker, the original director of the museum, has explained—modernism was to become tainted in the McCarthy-era public sphere as an abstruse manifestation of Communism.[1] By the early 1960s the outer reaches of the historical collection had begun to shift, as Impressionism,

Post-Impressionism and the so-called School of Paris were channeled into the museum through other collectors, above all Andrew's son and daughter, Paul Mellon and Ailsa Mellon Bruce, and Maud and Chester Dale, whose bequest—on Dale's death in 1963—was the occasion of an official policy shift. The encroachment of the modern was, nonetheless, incremental. The prohibition against living artists was lifted in order to make space for the likes of Pablo Picasso; art of the present continued to remain out of view. This represents, not a failure but a combined result of historical taste, political prejudice, and what we might think of as inevitable Old Worldism: the phenomenon of the American art museum, as an institution, erecting itself around the relics of European culture imported to this country in large quantities according to the ambitions—trophyism, acculturation, and education through exposure to Great Works—of a generation of patrician New World aspirants to Old World taste. A parallel historical narrative belongs to the emergence of those art museums in the United States devoted solely to new and recent art. Many of these institutions were founded or supported by an enlightened leisure class of women who substituted the eccentric, astonishing, ungroomed art of their own unfolding century, and even their own country, for the stately spoils of the Grand Tour.

These two tales can sometimes appear as far apart as, say, *The Golden Bowl* and *The Autobiography of Alice B. Toklas*. But together they relate a single, composite, peculiarly American fable of crass opportunism, lofty idealism, conflicted progressivism, and, in the case of the National Gallery, private versus public reach. It was with the founding of the East Building, which opened in 1978, that the museum openly declared itself to be in the business of acquiring and showing modern and postwar art. But the old, self-imposed limitations (the living-artist ban) retained a kind of half-life that is best represented by a well-intentioned but misdirected series of special commissions for Pei's vast atrium space, a group of inflated works by artists who were, for the most part, in the very late—or, in the case of Joan Miró and Alexander Calder, whose submissions were executed after their deaths, quasi-posthumous—phases of their careers. The syndrome is not without continuing relevance to many new museums of contemporary art, enormous buildings that demand big art; in such cases, the art is acquired in order to fill the building, while the building, in turn, is often intended to motivate the expansion of modest holdings that are otherwise overwhelmed by the sheer scale and capacity of the architecture. The strategy behind the commissions for the East Building might be characterized as the pursuit of "new" art by "old" masters—well-suited, in theory, to a public museum founded on highly conservative principles of taste. It does not take hindsight, however, to recognize that there was potential for more outstanding

commissions in this setting. One can envision a roster that might have included, for example, Ellsworth Kelly, Claes Oldenburg, Sol LeWitt, and Donald Judd— artists who, having safely reached mid-career, were producing work that was not only important and fresh but capable of a physical expansiveness wholly devoid of gigantism (or, in the case of Oldenburg, gigantic by deliberate conceit). The museum atrium could also have done without commissioned work altogether, which over time can become burdensomely unmovable, although, in principle, the celebratory nature of a commission still feels right and, in retrospect, gratifying given the museum's initial ideological antagonism toward modern art.

In its very nature as a massive compromise, the East Building commission episode represents a defining passage in the changing place of twentieth-century art at the National Gallery. With the opening of the building, the idea of "contemporary" art—a term that was rarely used at the time—came to straddle an unacknowledged institutional fault line. As the collection of twentieth-century painting and sculpture began to grow through gifts and purchases, the "contemporary" would, for some time, continue to be represented by the late work of long-established masters, notably (in the case of a huge exhibition project that resulted in gifts from the artist) Robert Rauschenberg. The late-work principle would later prevail in the Sculpture Garden, which opened in 1998 with late-period or recent works by Miró, LeWitt, Lucas Samaras, Oldenburg, Mark Di Suvero, Roy Lichtenstein, Magdalena Abakanowicz, and others (although there are exceptions—Scott Burton, Isamu Noguchi, David Smith, and Tony Smith).

Inside, serious collection-building in art since mid-century was devoted instead to what might be referred to as the historical contemporary, especially Abstract Expressionist painting—Jackson Pollock, Barnett Newman, Mark Rothko, and others. Here, enormous gains were made during the 1970s and early '80s, and the result is a collection that now boasts individual masterpieces as well as holdings in depth. The acquisitions were brilliant: Pollock's *Lavender Mist* (1950) was purchased from the collection of Alfonso Osorio; a large body of paintings by Rothko—including several dozen classic- and late-period canvases—was given to the museum by the second Mark Rothko Foundation, which, under the enlightened and heroic leadership of Donald Blinken, distributed work from the artist's estate to museums around the country, with the National Gallery lobbying to be the major repository; Newman's *Stations of the Cross* (1958–66), a single work composed of fifteen panels, was acquired for the Gallery from Annalee Newman, the artist's widow, by Robert and Jane Meyerhoff, a sale that occasioned gifts to the museum of other paintings from Newman's estate.

Abstract Expressionism was not just historically but rhetorically right for the National Gallery, representing the grand emergence of American art on the world stage (and, ironically, promoted as such abroad by the federal government during the era when modern art was also being identified as ideologically unsuited to the values of a public institution in the United States). Moreover, its formal ambitions were understood to draw from the history of painting since Paul Cézanne, and its high seriousness could even be described in terms—such as the spiritual and the sublime—that squarely belong to the realm of the Old Masters. Despite their large dimensions, these canvases were, in a manner of speaking, picture-gallery paintings. In the context of the 1970s, the acquisition of big American canvases belonging to the late phase of high modernism demonstrates an institutional ambition that was conservative in its adherence to recent historical consensus, yet sophisticated in its acknowledgment of the mid-century divide. Related acquisitions of outstanding significance include a set of Henri Matisse cut-outs, several of which are monumental in scale, a body of work that clearly corresponds to an institutional affinity for large objects (partly motivated, again, by Pei's East Building spaces) and, to be sure, for the decorative. Subsequent acquisitions—largely gifts—would bring the collection well into the field of Pop art, but it would take some time before the museum was convinced to pursue more rarefied strains of work from the generation of 1960.

Overall, the National Gallery might be said to have come quite late to collection-building in modern and postwar art relative to long-established institutions devoted solely to the twentieth century, such as the Whitney Museum of American Art and the Museum of Modern Art in New York. Even compared to collections of twentieth-century art at the so-called encyclopedic museums of Western art—the Metropolitan Museum of Art in New York, the Philadelphia Museum of Art, and the Art Institute of Chicago—it has, in certain respects, not quite caught up. Early purchases and gifts in classic modern art and postwar painting established genuine strengths (early Picasso, Fauve painting, bodies of work by Matisse, Constantin Brancusi, Alberto Giacometti, Arshile Gorky and Georgia O'Keeffe, distinguished individual works by Wassily Kandinsky, Miró, Jean Arp, Piet Mondrian, René Magritte). But there are only a few instances of depth and, despite ongoing activity, deficiencies remain conspicuous (German and Austrian painting, Italian Futurism, Dada, the Russian avant-garde, gallery-scale Minimal and Conceptual art, European art after 1955).

Moreover, since opportunities for important modern acquisitions—now fast disappearing—were at the time still relatively plentiful, the directions that were and were not pursued are pointedly revealing of biases and taste. Acquisitions in twentieth-century art were certainly more idiosyncratic than collection-building in the various departments of Old Master painting, which were

founded on a few large private collections—reflecting an episode in the history of taste that predates the museum—and grew in directions that, given the shrinking market in Old Masters, now appear to have been largely inevitable (notwithstanding a detectable prejudice against Mannerism, academic history painting, Victorian painting, the nude, and sacred art since the Renaissance, to name a few unspoken prohibitions in art before 1900). In the field of modern and contemporary, limitations were somewhat obviated by the Department of Modern Prints and Drawings, where a relative lack of presence in the public galleries (since paper must be protected from extended exposure to light) has allowed—at times even promoted—a greater tolerance for risk. Of course, exploiting the potential for risk requires not only expertise and perspicacity but also strong curatorial will.

It is impossible to examine the role of contemporary art at the National Gallery without acknowledging that museums of contemporary art, as a species of institution, have proliferated internationally since the founding of the East Building, and that their activity impinges on our definition and our very sensation of contemporaneousness. According to Gertrude Stein, a museum can be a museum or it can be modern, but it cannot be both. Obviously, her words have been flagrantly disregarded in practice, but they remain a pithy philosophical challenge. In our case, they remind us that the *mocas* embody an operational paradox: they want to be museums of the present—even the future—while their identity as museums undeniably confers instant pastness onto present art. No amount of rationalization will change the fact that, in their precincts, a new acquisition often radiates homelessness. Plucked from the blur of international art-making, hauled into the center of an empty white cube, and subsequently stuck away in storage in order to clear space for the next specimen, the work can appear to have been brought up short and strangely defeated or sapped while, conversely, the museum space becomes almost indistinguishable from a showroom. Both effects are heightened when the work in question—a showpiece prop from Matthew Barney's *Cremaster* cycle, for example—is extracted from a larger installation, performance, or film, where its significance almost solely resides. The museum is, ideologically, a historical place, and the aura it thereby confers on objects of the present or the very recent past is often that of novelty. Novelty is history's way of condescending to the new, and the consequences can be crushing.

The downward spiral from novelty and fame to neglect is, of course, a critical cliché. That the *moca* can incarnate this kind of transience is not a flaw so much as an aspect of its intrinsic content, even when—too often—transience is

tacitly tolerated by the institution rather than knowingly engaged. Conversely, the museum that represents centuries of art possesses an inherent slowness, a relationship to historical time that is devoid of urgency; in such a place, the presence and momentum of contemporary art—the process through which the museum, the studio, and the marketplace now collapse upon one another— can appear distractingly antic. All museums are monuments to taste or fashion in some form, but contemporary art is inseparable from fashion in a way that past art (while it remains, of course, partly attached to the specific conditions of the original time and place of its making) is not. This, too, is no flaw, but a perspectival fact: the relationship between art and the currency of fashion will shift as time passes and new art becomes old. In the meantime, as *mocas* perpetuate themselves, they manifest a realm of the perpetual present that requires ongoing renewal. Can we say that there are elements of contemporary art that fail the art in the domain of the *moca* yet are preserved at the museum that possesses a longer view? The much-vaunted transgressive nature of some new art—its traffic with political subversion, for example, or its antagonistic relationship to canons of aesthetic decorum—might be diminished by a setting in which the abnormalities of transgression constitute a norm, while the aesthetic significance (at least) of that transgression achieves genuine purchase, even an intensification of power, when it shares physical and ideological space with historical objects. It can also be claimed, however, that the *moca* allows the largely transgressive politics of contemporary art to represent itself as a form of living activism in an arena of heightened expectation that nourishes or perpetuates the immediacy of the work.

The distinction between museums of contemporary art and those that represent centuries of work is, of course, not just philosophical but practical, although practice is wholly contingent on the sometimes unconscious conceptual dimension that conditions or motivates the values of the museum, as well as its activity. Perhaps the philosophical distinction can be defined as one that we draw between experience and memory, one that has been drawn by Walter Benjamin in his essay on Proust from 1929 (the founding year of the Museum of Modern Art): "An experienced event is finite—at any rate, confined to one sphere of experience; a remembered event is infinite, because it is merely a key to everything that happened before it and after it."[2] Applied to the museum, nothing less than a spiritual premise is at stake here, the very nature of the museum as a site of encounter—a repository of accumulation, preservation, and display in the service of the encountering soul. There are, however, extenuating conditions. The *moca* shrinks time, which is to say that, as a museum, it implicates an historical condition for the object but does not manifest one. The museum of art since the Renaissance instead actualizes historical time, although

temporal experience of history in this regard can take the form of a suspended state, a curious kind of timelessness that heightens the sensation of petrifaction sometimes ascribed to rooms full of past art—"a wax-floored solitude," Paul Valéry wrote in 1923, "savoring of temple and drawing room, of cemetery and school." Valéry was speaking of the art museum as a heterogeneous deposit of like and unlike works, a "domain of incoherence" where multiple objects—each of them "charged with years of research, experiment, concentration, genius"—encroach on the visitor all at once, hopelessly competing for his undivided attention and thereby attaining "sad and stupefying" results.[3] We do not need to accept this neurasthenic observation in order to acknowledge that the expanding and contracting nature of historical time is squeezed by the principle of simultaneity endemic to the art museum. But this phenomenon has little bearing on the experience or interpretation of contemporary art. The *moca*'s ennui takes a different form, in which the promise of perspective (which cannot possibly be fulfilled) gives way to a denatured experience of placelessness, all the more in that *mocas* everywhere have come to resemble one another in many respects: in contents above all, but also in presentation and design.

The ultimate test of a *moca*'s relationship to history is not its acquisition policy, but its policy pertaining to the process of deaccessioning art. The Museum of Modern Art in New York was originally grounded in the principle that, to be both a museum and be modern, it must not hold works of art in its collection once they have attained a certain age. In this, Alfred Barr, Jr., was imitating a practice established by the Musée du Luxembourg in Paris, which sold historical paintings to the Louvre. The Modern contrived such an arrangement with the Metropolitan Museum of Art, although it was abandoned after only five years; since then, MoMA has retained the prerogative to deaccession art from time to time as a selective fund-raising practice for new acquisitions. What does *modern* mean at the Modern (where the museum's very name—a brandname by now—will someday cease to hold meaning, if it hasn't already)? For Barr, the difference between *modern* and *contemporary*, as epithets, was not chronological but qualitative: the distinction between aesthetic progressivism and "safe" or "academic" art that is merely new (his designation for the general field of concern was "current past").[4] Since Barr's time, historical value judgments of this kind have been challenged on ideological terms and pointedly revised. Significantly, the New Museum of Contemporary Art, also in New York, applies the early MoMA policy, assuring that it remains, in this respect, strictly devoted to the progressive present, relatively speaking. Is it, however, a "museum"? According to what definition, if not one that has been invented for the sole purpose of reconciling historical museum practice with the inherent impermanency of the new?

The National Gallery is currently prevented by its charter from deaccessioning works in its collection (except in the case of duplicate prints); once purchased or accepted as a gift, an acquisition is considered irrevocably permanent. This practice, which is intended to instill confidence in collectors who are contemplating gifts to the museum and want to believe that their legacy will never be converted into cash, is literally conservative, and its impact on the role of contemporary art in the collection is deep: it leaves no room for revision by later generations of curators and museum boards, thereby clouding the potential acquisition of young art with a fear of commitment. The prohibition against deaccessioning art could be changed, of course, although, in addition to protecting gifts and representing a safeguard against the vagaries of the history of taste, it exerts a possibly deliberate check (conscious or unconscious) against addressing art of the immediate present with anything more than bland engagement. Policy change, in other words, would have to be motivated by philosophical change.

Art museums seldom face their own historicity in more than a superficial way. At *moma*s and *moca*s as well as museums of past art, the permanent collections are subjected to the pull of something like an institution's historical unconscious, where the present either sustains no truly viable trace or remains virtually unacknowledged (although the conceit of the present is at play in both settings). At the National Gallery, the role of the contemporary may well find its profoundest place on the level where the museum hosts the living artist as visitor—one of the most significant functions the museum can serve, although one that often remains curiously unexamined (much more so than at MoMA, for example, or, significantly, the National Gallery in London, where artists are invited to curate exhibitions drawn from the permanent collection).

Attempts to institutionalize contemporary art—to proceed self-consciously—have so far largely failed at the National Gallery. The Collectors Committee, which was originally formed to commission work for the East Building and was then perpetuated as an ongoing resource for the purchase of contemporary art, has never been truly deployed in that way. It has, instead, been responsible for acquisitions—some of them extremely significant—that rarely postdate 1970: Magritte, Miró, and Aleksandr Rodchenko, as well as early classic-period works by Louise Bourgeois, Samaras, Twombly, Eva Hesse, Dan Flavin, Yayoi Kusama, Ed Ruscha, and Tony Smith. Committee acquisitions of new or recent art, including works by Anselm Kiefer, Sigmar Polke, and Gerhard Richter, have been exceptional; and by the time of the acquisition, even these artists had reached or exceeded mid-career. The history of the Collectors Committee has, of course, been partly shaped by the guidance of curators, and it certainly also reflects the curators' internalization of an ongoing institutional ambivalence

toward the new. That conflict, in turn, is expressed by the Committee itself, whose membership has always been divided by a taste for or against recent art, especially works that belong to genres that are by nature largely conceptual, anti-decorative, confrontational, grotesque, or abject, as well as works—installation art, for example—that depart from conventional media or occupy unusual amounts of space. (The division in taste tends to occur along the line that separates Committee members who are collectors from those who are not.) The tacitly proscribed categories formerly included Minimal and Process art as well, but recent acquisitions—noted above—represent a change, one that probably reflects in part the absorption of the language of Minimal art, in particular, into architecture and design, which has resulted in a domestication of the work in the name of modernist decoration. It is an ironic fate for objects that were once thought (and in some precincts are still thought) to defy historicism and to challenge the very limits of the definition of art. These acquisitions may also be proof of the function of passing time: Minimalism and Process art, along with Conceptualism, belong to the generations of 1960 and 1970—now perhaps comfortably historical. The museum's surprising acquisition of the Herbert and Dorothy Vogel Collection (a vast study collection that also includes substantial works by LeWitt, Richard Tuttle, and Robert Mangold, among others) further reinforced to this shift.

For many years, one consequence of the existence of the Collectors Committee has been an unstated presumption that the purchase of even modernist and postwar—not to say contemporary—art was the business of the Committee alone (with selected discretionary support, such as the Bass Fund, spendable money given by Perry and Nancy Lee Bass for the sole purpose of acquiring modern and contemporary art), usually falling well outside the active interest or support of the board of trustees. Since the Committee's budget is small in contrast to the museum's overall acquisition endowment, the impact of this presumption has been effectively to obviate the museum's potential—leaving will aside—to compete at a high level with institutions solely devoted to twentieth-century art for acquisitions in that field. Further, the board bias was for some time effectively ratified by self-censorship on the part of the curatorial staff (always excepting the pursuit of works on paper). There have never been collectors of modern or contemporary art among the trustees of the National Gallery, with the notable exception of Paul Mellon, whose wife acquired paintings by Pierre Bonnard, Rothko, and Richard Diebenkorn.

Nonetheless, in recent times, as the population of the board has changed, prejudices have begun to shift, something that may come to favor new support for acquisitions in mid- and late-twentieth-century art; the degree to which institutional policy is a function of individual tastes—including curatorial

biases—should not be underestimated. Nor should the potential for break-throughs: in 2001 the board supported a curatorial initiative in postwar art, acquiring two rare and important early paintings by Robert Ryman from the artist himself, using funds normally devoted to the Old Masters. This purchase belonged to a broad, deliberate pursuit of individual works from the 1960s and 1970s, including a large early sculpture by Richard Serra acquired through the support of the Cafritz Foundation. But in both real and complex symbolic terms pertaining to the very significance of Ryman's work (its critical relationship to the condition and practice of painting), the board's decision to support the Ryman acquisition from endowed funds was a stunning—if so far anomalous—historical turn. It is important to distinguish means of acquisition. References here to the Collectors Committee, the Cafritz Foundation, and the Bass Fund reveal one instrument—the discretionary acquisition fund—through which the pursuit of contemporary art, while remaining subject to institutional consensus, is protected from competing for support with Old Master painting. Of course, important gifts of art also allow the museum to acquire work well above its own means. Here the Meyerhoff collection, comprising gifts and a future bequest of works by Jasper Johns, Rauschenberg, Kelly, Lichtenstein, and Frank Stella as well as Abstract Expressionist paintings, is the most prominent example. But acquisitions that draw from the museum's endowment possess separate significance.

It has been argued that truly contemporary art (as opposed to examples of the historical contemporary, such as Ryman and Serra) will—and should—never hold a serious place in the development of the National Gallery's permanent collection or exhibition program. It is sometimes claimed, for example, that the representation of new art remains beyond the museum's purview because this mission is already fulfilled by other institutions in Washington, such as the Hirshhorn Museum and Sculpture Garden and the Corcoran Museum of Art. This position (which is, to begin with, tautological) fails to account for the history of the art museum as a history of institutions—each possessing its own identity—that rarely organize themselves according to reciprocal lines of demarcation (not, in any case, for reasons of convenience). Those separate identities have long been responsible for allowing art to be represented in a multiplicity of ways, thereby forestalling the deadening tyranny of a single or consensual narrative and maximizing the visitor's process of discovery and the potential for breadth of interpretation. There is, in other words, no such thing as simply showing art, according to which principle museums in any given city should avoid redundancy at all costs; rather, every institution is a setting and every installation a critical or interpretive act. Similarly, the relationship of a given work to its institution and the institution's collection influences the

historical significance of that object—one that can be said to change from place to place.

The idea that the National Gallery has no business trafficking in the contemporary could be more convincingly attributed to its own inhibitions: the museum has simply not been pragmatically well positioned to pursue new art in an effective manner. Without aggressive private support in this area—something that is difficult to come by largely because philanthropically inclined collectors of contemporary art generally throw their resources behind museums that reflect their own art-world identities—the apparent limitations of institutional commitment, even under the best of circumstances, will prevent more than occasional forays into the field. This kind of hesitant acquisition process is anathema to an art scene defined by proliferation and rapid change. The representation of new art at museums thoroughly devoted to the contemporary is relevant to the philosophy of contemporary art at the National Gallery only because those institutions serve the art and the public in ways that the National Gallery cannot hope to accomplish without unlikely levels of institutional change.

Will wisdom beget change? The only reasonable philosophical claim against the programmatic pursuit of contemporary art at the National Gallery is the simplest one: that the museum's mandate is and should remain largely historical. In this scenario, collecting activity is to be conducted behind lines—the transversals of historical perspective—that will continue to move forward with time at a certain remove from the ever-advancing present. According to this scenario, the National Gallery should engage the contemporary at precisely that point on the historical continuum where the Modern was once expected to disengage from it. Questions of historical consensus are at issue: when, in the life of a work of art, can it be said that the object belongs to history in an enduring way, and who makes this determination? There is, however, an acute kind of relationship between the museum and the contemporary that may find its way into the deep structure of the institutional psyche. What the National Gallery can unassailably avoid is any move through which, in its representation of "modern and contemporary" art, it comes to resemble the museum devoted solely to art of the present. (After all, the *moca* belongs to a class of museum that may well evaporate in the future, so openly is it the creature of an exploded market for new art—a phenomenon of history rather than a place of historical perspective or self-awareness.)

The National Gallery can however, seek to identify and develop a working relationship to contemporary art that is rigorously self-aware. The optimum terms for such an engagement would probably be grounded in the concept of the artist as visitor and model beholder, which possesses a unique meaning in this setting: in the active acknowledgment (not the concession) that the history of

artistic practice and the deep conceptual and affective chambers of aesthetic experience are not only preserved at the museum, but perpetuated, and that some relationship to contemporary art is therefore not foreign to the identity of the museum, but fully constitutive. There is the potential for an institutional definition of the contemporary that is philosophically and historically sound; accordingly, the National Gallery would seek less to imitate or follow museums of the new than to contribute to the discourse in the contemporary field through means that are wholly unavailable to the *moca*, or even to the *moma*—means that are authentic to the historical museum as an instrument of apprehension.

How this looks would be determined only through the process of self-awareness itself. But the terms of a meaningful and deliberate relationship to contemporary art can be drawn from the concept of a historical present. Surely the National Gallery possesses a temporal optic, one through which a succession of pasts is exposed. Alternatively, the physical nature of the museum might specifically be likened to that of a telescope, in which optical reach exists in tandem with a certain kind of mechanical extension: the way the instrument itself, composed of a series of inserted tubes, possesses the ability to expand and contract. There is a scene in Jean-Luc Godard's film *Bande à part* (1964) in which the three teenage protagonists spontaneously sprint through the Louvre (attempting, the voice-over narration dryly tells us, to beat the previous record of nine minutes forty-five seconds). Guards can be seen vainly trying to stop the mayhem. The episode is a comic lark, a send-up of the tourist's absurd rush through the sites of Paris. Yet in showing the present careening through the corridors of the past, it accomplishes an allegorical feat: it introduces the giddy physical rush of elapsing actuality (contraction) into the slowed presence (expansion—the paintings, the spaces) of historical time. The historical museum is haunted in this way by the phantoms of past presents.

One need not make claims for transcendental values in order to understand that paintings are more than mere artifacts; paintings do incarnate previous actualities. While the frenzy of commodified contemporaneousness rightly remains beyond the precincts of the National Gallery of Art, another kind of present is implicated by its preservation of the past. In this regard, the museum has always hosted the new. What it can and should be expected to accomplish on behalf of contemporary art will perpetually begin with acknowledging and maximizing the specific gravity of its own historical condition.

NOTES

1. John Walker, *National Gallery of Art, Washington* (New York: Harry N. Abrams, 1975), 49–50.n

2. Walter Benjanim, "On the Image of Proust" rev. ed., in *Walter Benjamin, Selected Writings, Volume 2, 1927–1934*, ed. Michael W. Jennings, trans. Rodney Livingstone (Cambridge, Mass.: Harvard University Press, 1999), 238. Originally published in 1929 and revised in 1934.

3. Paul Valéry, "The Problem of Museums" in *Paul Valéry: Degas, Manet, Morisot*, trans. David Paul (Princeton: Princeton University Press, 1989), 203, 205. Originally published in 1923.

4. Sybil Gordon Kantor, *Alfred H. Barr, Jr. and the Intellectual Origins of the Museum of Modern Art* (Cambridge, Mass.: MIT Press, 2002), 365–77.

Breaking Down Categories: Print Rooms, Drawing Departments, and the Museum

Christophe Cherix

CURATOR, PRINT ROOM, MUSÉE D'ART ET D'HISTOIRE, GENEVA

Throughout the world, most public collections of prints and drawings represent only one of the components of the traditional fine-arts museum. The nature of the pieces in such collections—at times midway between document and work of art—requires their curators to consider them outside the strict boundaries of a particular medium and to remain in close contact with the museum's other departments. An engraving can be an original work of art, with no counterparts in other mediums, or it can be a work of reproduction (the printmaker copies a painting by another artist, for instance). In fact, some prints are more relevant to architecture, urban planning, painting, or sculpture than to printmaking per se. Endlessly confronted by questions of categorization, print collections are never completely detached from the fields around them. Thus, the specific problems raised by the acquisition of recent works need to be considered within the broader framework of the museum itself. Because each graphic arts department and its ways of operating are, of course, different, I will use my own experience and domain to sketch out a few possible solutions.

Aside from a few exploratory acquisitions—usually limited in cost and not dependent on institutional consensus—what most museums consider a contemporary acquisition often belongs to a body of work initiated some twenty years earlier. Museums' permanent collections usually reflect the society around them with a certain delay, but their temporary exhibitions, publications, and programs for reaching the public allow them to cultivate a more immediate connection to the present. Thus, Alfred Barr, Jr.—founding director of New

York's Museum of Modern Art, a museum whose very mission was of a piece with its time—"supported the idea of a permanent collection . . . as a measuring tool that could be used by viewers in assessing temporary exhibitions."[1] He imagined the permanent collection not only as allowing the viewers to see beyond the transitory but also as heroic and resolutely modern, "graphically as a torpedo moving through time, its nose the ever advancing present, its tail the ever receding past of fifty to a hundred years ago."[2] In fact, in one proposal that was hesitantly put in place and rapidly abandoned, the collection was even understood as a group of objects that would, so to speak, empty from the bottom: the oldest works being periodically sold off to other institutions, so that the museum would always remain in the process of resolving the present. The real originality of Barr's concept lies not in choosing a multidepartmental structure in which objects are classified by medium, but rather in integrating domains that, until then, had been absent from fine-arts museums: film, design, and architecture were established as particular museum departments.

At the threshold of the twenty-first century, the majority of acquisitions called contemporary come from the period that runs from the early 1960s to the late 1980s. It is our age, then, that faces the challenge of integrating works of art that are no longer entirely the product of historical modernism.[3] Many contemporary works that museums would like to include in their collections no longer correspond to the categories meant to accommodate them, a reality forcing institutions to change. As early as 1979, Rosalind Krauss pointed out that "within the situation of postmodernism, practice is not defined in relation to a given medium—sculpture—but rather in relation to the logical operations on a set of cultural terms, for which, any medium—photography, books, lines on walls, mirrors, or sculpture itself—might be used. Thus the field provides both for an expanded but finite set of related positions for a given artist to occupy and explore, and for an organization of work that is not dictated by the conditions of a particular medium."[4] For categories to remain applicable to the majority of work being produced over the years, they need to be made, as Krauss put it, "almost infinitely malleable," and to expand to the point where they "include just about everything."[5]

Since the early 1960s, many artists purposefully avoided a formalist reading by creating works that could fit into several categories at once. The Museum of Modern Art confronted that very problem when it sought to acquire Mel Bochner's *Working Drawings and Other Visible Things on Paper Not Necessarily Meant to Be Viewed as Art* (fig. 1) immediately following their presentation at New York's School of Visual Arts in December 1966. The installation was made up of four identical loose-leaf notebooks set out on sculpture stands and containing photocopies of, among other things, preparatory drawings done by

Fig. 1. Mel Bochner (American, born 1940), *Working Drawings and Other Visible Things on Paper Not Necessarily Meant to Be Viewed as Art*, 1966. Four identical loose-leaf notebooks, each with one hundred photocopies of studio notes, working drawings, and diagrams; displayed on four sculpture stands. Installation: School of Visual Arts, New York, 1966

artists of Bochner's generation.[6] To the Museum of Modern Art's request to purchase the work in order to place the binders in its research library, the artist replied with a counterproposition: to donate the piece as a work of art meant to take its place in the museum's collection. In the end, for want of an agreement, the *Working Drawings* were returned to Bochner without further discussion.[7] While there is no doubt that today this "installation" would easily enter a department of painting and sculpture or even graphic arts (the work comprises books and printed matter), the anecdote reveals the degree to which certain works do not comply with the categories imposed by institutions. Would these increasingly prevalent "uncategorizable" works be cause for the creation of a unidepartmental museum? Such an institution would eliminate the distinctions between the various media and integrate the full range of artistic practices despite the morphological differences of their component parts. This model of the museum without departments would seem to me applicable from the early 1960s on, as this is the moment when artists purposefully chose to liberate themselves from traditional classifications by medium. However, to divide the twentieth century in two presupposes that postmodernity can be understood outside the context of modernity—taking the risk of cutting artworks from their explicit references. Does it make sense to keep separate the 1981 re-photograph by Sherrie Levine of an image by Walker Evans and the 1936 original vintage print by Evans himself?

During the twentieth century, print rooms and drawing departments gained relative independence. Despite the differences between them—organized around a function (for consultation more than display), a support (paper), or a recourse to a printing die—more often than not such departments have effectively been freed from the tutelage that painting and sculpture departments or libraries had long imposed on them (for instance by viewing prints primarily as documents or drawings as preparatory sketches). However, even though drawing has become an art in itself, photography now rivals painting in terms of both dimensions and aura, and modern printmaking has limited the number of works in an edition, there will always exist a drawing, photograph, or engraving that one could say is "not *only* to be viewed as art" and hence subject to a specific treatment. Paradoxically, it may be those elements in a print collection that were given the least consideration until now—due to their uncertain status and their particular usage—that guarantee graphic-arts departments their specificity.

Geneva's print room, the Cabinet des estampes, has a collection of some three hundred and fifty thousand works covering more than five hundred years of history. The institution is familiar with the problems involved in acquiring contemporary works and has sought appropriate solutions, without modifying

Fig. 2. Gilbert (Italian, born 1943) and George (British, born 1942), *Art & Project Bulletin*, no. 47, December 1971, Amsterdam. Offset, each bulletin signed by the artist in red ink, 11⅝ × 16½ in. (29.7 × 42 cm). Cabinet des estampes, Geneva

its structure, by focusing on categories of objects often overlooked. In 2003 the collection became the permanent guardian of the presentation sets[8] of the *Art & Project Bulletin*, which Geert van Beijeren and Adriaan van Ravesteijn published in Amsterdam between 1968 and 1989. Consisting of one or more double sheets sent free of charge to people registered in a file of eight hundred addresses, the *Art & Project Bulletin* functioned as a true creative space, taking in a broad range of interventions by some of the most important artists of the moment (fig. 2).[9] It was flexible enough to encompass the sketched self-portraits of Gilbert & George (no. 20, 1970); document a piece by Daniel Buren that had been "<u>censored</u> . . . by the [Guggenheim Museum] at the request of some participating artists who felt that their work was compromised and endangered by [its presence] in the exhibition" (no. 40, 1971); carry an original work by Sol LeWitt (the bulletin folded into five-centimeter squares then unfolded; no. 43, 1971); and, at Douglas Huebler's initiative, launch a treasure hunt across Amsterdam (no. 22, 1970).

By turns documentation, description of a project, mail art, advertisement, dissemination of a text, and user's manual, the *Bulletins* attest to the vitality of printed material from the end of the 1960s to the end of the 1980s (fig. 3).[10] Moreover, they renewed a tradition that defined prints in terms of the multiplicity of proofs, their de facto circulation, and accessibility. The technical means

Fig. 3. Emmy van Leersum (Dutch, born 1930) and Gijs Bakker (Dutch, born 1942), *Art & Project Bulletin*, no. 25, June 1970, Amsterdam. Offset, 11⅝ × 16½ in. (29.7 × 42 cm). Cabinet des estampes, Geneva

to produce the *Bulletins*—offset printing, which is an industrial development of lithography—did not exclude their being made part of a collection that otherwise largely comprised traditional techniques. Indeed, a museum, besides being a conservatory of techniques and media, must also bear witness to the specific connections that works of art have with the world at the time of their creation. By incorporating the *Art & Project Bulletins* into its collection, just as it would a print by El Lissitzky or Pablo Picasso, the institution seeks to record the upheavals that stem from the 1960s—and perhaps more comprehensively than would have been the case if it had instead purchased more traditional prints made by the same artists the *Art & Project Bulletin* sought out.

Acquiring "contemporary" works of art is not solely a matter of categories. What makes its way into the institution is not simply a new object, but a new way of seeing as well. Hal Foster notes that one of the strategies of postmodern thought is "to deconstruct modernism not in order to seal it in its own image but in order to open it, to rewrite it; to open its closed systems (like the museum) to the 'heterogeneity of texts' (Douglas Crimp), to rewrite its universal techniques in terms of 'synthetic contradictions' (Kenneth Frampton)—in short, to challenge its master narratives with the 'discourse of others' (Craig Owens)."[11]

Fig. 4. Stanley Brouwn, *This Way Brouwn*, 1962. One sheet from a set of two. Felt-tipped pen, rubber stamp, ink, 9⅝ × 12⅝ in. (24.4 × 31.9 cm). Cabinet des estampes, Geneva

Thus between modern and postmodern works opposite positions emerge that the museum must make coexist and interact, while taking care not to reduce art production to the mere expression of genres.

For the curator in charge of a graphic-arts collection, a work by Stanley Brouwn from the series *This Way Brouwn* (fig. 4) raises questions that are for the most part new. Each piece in the series, which was begun in 1960 and came to an end in 1964, obeys the same procedure: "Brouwn is standing somewhere on a square. He picks at random a pedestrian and asks him to explain on a scrap of paper the ways [*sic*] to another point in the town."[12] The result is a sheet of paper titled *This Way Brouwn* bearing the passerby's sketch indicating directions. As is pointed out in the artist's catalogue, "There are no good *This Way Brouwns*. There are no bad *This Way Brouwns*."[13] The usual criteria governing the acquisition of a modern work of art are rendered inoperative here, for the drawing is not the artist's, nor is it formally interesting or expressive. It exists first and foremost in the artist's relationship to the other, the outside. Its lines trace a verbal explanation: they do not represent the city, they testify to the help the artist received in getting from one point to another. To include Brouwn's work in a collection is thus tantamount to also including a bit of the discourse of that other, unknown and unspecified, that anonymous passerby. The work is chosen not for any inherent qualities, but for what it symbolizes.

Fig. 5. John Miller, *Untitled*, 1990. Pencil on paper, 7⅞ × 9 in. (20 × 23 cm). Cabinet des estampes, Geneva

By raising in such a direct way the issue of the relationship between the author of a work and the world surrounding him, the piece questions the collection in its entirety—and its limits. And so it goes for many contemporary works that are put under the authority of one department rather than another, mainly for reasons of convenience (notably, to facilitate conservation). When the artist John Miller (fig. 5) considers his "drawings to be *pictures of pictures*, in other words, [to be] quotational,"[14] their inclusion in a drawing department inevitably raises certain issues. It amounts to recognizing neither their complexity (drawing is used to appropriate photographic images, for instance, and so cannot be defined by the rules of either photography or drawing), nor their strategic place in the artist's body of work. Like a good number of other artists today, Miller employs a wide range of media (painting, drawing, photography, video, sculpture, installation), but in most cases he uses each sporadically, for specific ends.[15] His situation is radically different from that of an artist seeking—as was customary in the first half of the twentieth century—to transpose a discourse from one medium to another, or to develop several parallel lines of research by employing

engraving and painting simultaneously. To break down Miller's work into categories would amount to dismembering it in order to better package it.

On what grounds does a print room or drawing department choose works in the field of contemporary art? The question may never have been more complex than it is today. It is a matter of not limiting oneself to traditional media, as well as not singling out one aspect of an artist's body of work, which would become unreadable in isolation. It means not imposing on works a preconceived idea of what art should look like or how it should operate. If many artists today do not define themselves as printmakers (nor as sculptors, painters, or draftsmen), as they would have at the turn of the twentieth century, the museum has to take this into account. This does not make the old classifications irrelevant, but it does force us to admit that the usual divisions of art into media is only one of many possible approaches.

Since the early 1960s procedures such as the delegation of fabrication[16] and the conceptualization of the art work have drastically altered the museum's ability to register the variety of art production through the filters of its different departments and habitual realms of expertise. Today's answer to this problem is largely empirical: each print room and drawing department manages somehow to cram such-and-such a work into its drawers, when in my opinion it is the "drawers" themselves that could be abandoned from time to time. At stake is our ability to integrate—without having to stretch categories, play on words, or pretend to look somewhere else—both Sol LeWitt's recent aquatints and Felix Gonzalez-Torres's stacks of free offset posters. It is by openly accepting that museums should be as much at the service of the artists as they are of the objects that artists produce, that graphic-arts departments—and museums in general—will be fully able to meet today's new challenges.

NOTES

This chapter was translated from French by John O'Toole, with the help of Madeleine Goodrich Noble.

1. Sybil Gordon Kantor, *Alfred H. Barr, Jr. and the Intellectual Origins of the Museum of Modern Art* (Cambridge, Mass.: MIT Press, 2002), 362. Kantor's book has inspired the present article in a number of respects.

2. Ibid., 366.

3. Given that numerous museums never, in fact, adapted to modernism, the challenge often goes beyond "simple" transformation.

4. Rosalind Krauss, "Sculpture in the Expanded Field," *October* 8 (spring 1979): 42–43.

5. Ibid., 13.

6. The binders' contents were published in 1997. See Christophe Cherix, ed., *Mel Bochner/Working Drawings and Other Visible Things on Paper Not Necessarily Meant to Be*

Viewed as Art, with essays by Laurent Jenny and James Meyer (Geneva: Cabinet des estampes, Musée d'art et d'histoire; Cologne: Verlag der Buchhandlung Walther König; Paris: Picaron Editions).

7. The artist described these events to me in a meeting in December 2003.

8. It owns all issues, with additional copies that allow for recto-verso presentation.

9. In all, the *Bulletin* comprised 156 issues and included contributions by Bas Jan Ader, Alighiero Boetti, Marcel Broodthaers, Stanley Brouwn, Hamish Fulton, Imi Knoebel, Richard Long, Allen Ruppersberg, Lawrence Weiner, and many others.

10. I have borrowed part of the present description from an earlier text. See Christophe Cherix, "Print Imprint," *25th International Biennial of Graphic Arts* exh. cat. (Ljubljana: International Centre of Graphic Arts, 2003).

11. Hal Foster, Introduction, in *The Anti-Aesthetic: Essays on Postmodern Culture* (New York: New Press, 1998), xi.

12. Unsigned preface to Stanley Brouwn, *This Way Brouwn: 25-2-61, 26-2-61* (Cologne: Verlag Gebr. König, 1971), 7.

13. Ibid., 17.

14. John Miller, e-mail communication, 24 February, 2004.

15. The artist states, for example, that, "the drawings came to an abrupt halt when I started doing the photos." Ibid., 28 January, 2004.

16. Delegation of fabrication is a standard practice in traditional printmaking, in which artist and printer work side by side in order to produce an engraving.

Keeping Time:
On Collecting Film and
Video Art in the Museum

Chrissie Iles
CURATOR, WHITNEY MUSEUM OF AMERICAN ART, NEW YORK

Henriette Huldisch
ASSISTANT CURATOR, WHITNEY MUSEUM OF AMERICAN ART, NEW YORK

The medium of film, born out of the photograph, is now more than a century old, and video, an invention of radio technology, emerged as a viable mass medium during the technological revolution that took place in the early 1960s. Artists have incorporated both media into their art-making almost from the moment of their inception. Yet art museums have been slow to integrate film and video art into their collections and have only recently begun to fully address the complexities involved in caring for them.

The emergence of artists' film and video in the 1960s and 1970s took place as part of a radical redefinition of art in which the discrete object was replaced by an ephemeral, process-based approach to art-making, incorporating the body, the land, the street, the typed page, and the moving image. Many of the moving-image works made during this period were never intended for institutional display, or conventional collecting. Artists working in other, usually sculptural media—such as Robert Morris, Dan Graham, Richard Serra, Lawrence Weiner, Ana Mendieta, Dennis Oppenheim, Walter De Maria, and David Lamelas—used film as one of many media with which to expand the parameters of sculpture and physical space. Other artists—including Joan Jonas, Marina Abramović, Peter Campus, Vito Acconci, Hannah Wilke, and Bruce Nauman—used video to record performative actions, sometimes in relation to live feedback. As a result, an institutional commitment to collecting historical artists' film and video means embracing work that was indifferent,

or conceived in opposition, to the values of collectability, immutability, and objecthood.[1]

By contrast, during the 1980s and in particular the 1990s, two subsequent generations of artists developed a new language of moving-image installation, which participated in the exhibiting and collecting structures of museums and private patrons, and constructed stable moving-image environments. Artists such as Gary Hill, Bill Viola, Nam June Paik, and Susan Hiller began showing video installations in galleries, and in major museum exhibitions in which video installations were no longer considered to be a separate genre of work that was noisy, distracting, and, often, relegated to the basement. Instead, these installations were exhibited in the main galleries of museums and in large, prestigious exhibitions such as Documenta and the Venice Biennale.

In the 1990s a younger generation of artists including Stan Douglas, Douglas Gordon, Shirin Neshat, Eija-Liisa Ahtila, Gillian Wearing, Steve McQueen, Pierre Huyghe, Isaac Julien, and Doug Aitken made projective video installation a primary medium, yet did not define themselves as video artists. Most also made work in other media and some, such as Douglas, Tacita Dean, and Liisa Roberts, worked specifically in film, making installations using 16 mm film projectors and film loopers.

Video and film installations have been collected by museums since their appearance in the late 1960s—two of the earliest examples being Les Levine's video and fluorescent tube installation *Iris* (1968), which was bought by a private collector and donated to the Philadelphia Museum of Art, and Dan Graham's film loop *Two Correlated Rotations* (1970–72), which was acquired from the Lisson Gallery by the Tate Gallery in 1973. But it was in the 1990s that private collectors and museums began collecting moving-image installations in earnest. In the flurry of selling and collecting that followed, an often contradictory array of arbitrary procedures emerged. Works were sold on VHS videotapes—sometimes signed by the artist—on specially editioned laser discs and, later, on DVD (which was mistakenly interpreted as a medium in its own right). Film loop works were acquired often with no clear agreement regarding preservation, access to the original negative, or the potential migration of film to video.

Years later, as museums and collectors began to turn their attention to the long-term implications of what they had bought, confusion ensued. Signed "unique" VHS tapes had been lent to exhibitions without taking into account that a VHS tape is a fragile, low quality, throwaway format, which would be destroyed by repeated showings. Laser discs, now obsolete, were suddenly unplayable, and had no submasters. Super-8 film loops could not be projected, due to the fact that no negative existed and the unique print ran the risk of being torn at each

projection on unreliable (and largely unavailable) super-8 film projectors. Some installations were run by computer programs, which threatened to become outdated as computer technology soared to ever-more sophisticated heights. Most confusingly, the distinction between film and video became blurred, as artists attached the term *film* to projective video works engaging with ideas of the cinematic, which, in the 1990s, became the dominant mode of projective installation.

Within this increasingly hybrid moving-image environment, as greater experience is being amassed by galleries, collectors, and museums alike, the questions now being asked regarding the durability of any artwork comprising celluloid, or a data carrier and electronic playback device, take on a new urgency. Dependent on the vagaries of domestic consumer electronics and professional equipment, it is clear from the outset that the lifespan of video materials is, in some cases, dramatically limited. Recent years have seen a proliferation of conferences and publications addressing the management and preservation of technology-based art in art museums.[2] This surge in interest is a recognition not only of the fact that artists' use of celluloid, electronic, and digital media is here to stay, but also that many works of film and video art are in severe danger of being irrevocably damaged or lost if steps to preserve them are not taken immediately. Curators are obliged to follow where artists lead, even if their art-making presents challenges to the museum's collection procedures and policies. In acquiring these works for a museum's permanent collection, curators are faced with negotiating two difficult and, in certain cases, possibly irreconcilable tasks: to select works based on their historical and formal merit, and to devise ways to preserve them in perpetuity.

In this essay, we will discuss some of the challenges confronted by museums collecting technology-based artworks, drawing on our own experience at the Whitney Museum of American Art in New York. The long-term care of technology-based work, as has been widely acknowledged, requires a team of curators, conservators, registrars, and technicians, with whom we work closely. However, the purpose of this essay is not to discuss the emerging guidelines for the preservation of technology-based art, which has been done usefully elsewhere.[3] Rather, we will focus on certain concerns and practices from a curatorial perspective, and conclude with general reflections on collecting film and video art in the early twenty-first century.

With the advent of digital media, film and video are no longer in the vanguard. Moreover, commercial film and video are in the process of being irrevocably altered by digital production and exhibition. Artists' engagement with moving-image media, by contrast, adheres to a different set of motivations and influences. Many artists work in the near-obsolete technology of 16 mm film

and are often concerned with exploring the specific conditions of the film medium's materiality. It seems almost certain that, in the future, art museums will become the sole stewards of artworks using media and equipment whose active commercial life is long past, and whose long-term maintenance will become part of the artworks' preservation. Museums should be equipped to recognize and meet this daunting task.

COLLECTING FILM AND VIDEO:
PRACTICAL OBSERVATIONS

Film and video collections in art museums have developed quite separately from those in film archives. Many film archives deal exclusively with celluloid film, and house large numbers of moving-image materials, from Hollywood feature films and silent movies, to newsreel footage, documentaries, and films of general cultural or historical significance. The film archives often distribute film prints for screenings and include in their holdings the associated original materials, including A and B rolls, negatives, and internegatives, from which they provide prints for screening venues.

By contrast, in art museums film and video works are collected as fine art and tend to be accumulated in smaller numbers, often including equipment and other installation elements that have to be maintained and preserved. The majority of the installations collected by museums and collectors are video rather than film, and museums do not, generally speaking, distribute single-screen works. For the most part, works collected by museums are unique or editioned rather than in uneditioned distribution.

Artists' engagement with the moving image has evolved into two different strands, whose separation has to do with the context of exhibition and constituency as well as with content. Art history has focused on the emergence of film and video art out of the process-based practices of the 1960s and 1970s, and almost completely ignored the tradition of what is known as Experimental or avant-garde film. This distinction has emerged from a difference in training and in conceptual and aesthetic concerns. Gallery artists working in film and video were trained in art school and came to film or video as a result of an intermedia approach to art-making during their training, while many Experimental filmmakers trained as painters, then moved to the craft of filmmaking, and its specific technical properties—some of which, in the case of abstract, hand-painted, or hand-processed film, parallel painting itself.

For the most part, gallery artists have embraced the history of Hollywood as a conceptual or narrative strategy, while avant-garde filmmakers have deliberately rejected commercial cinema and conventional narrative forms. As

John G. Hanhardt observes: "The inter-textual relationship of [Experimental film] to the other arts and the history of classical cinema places it outside traditional film and art history."[4] It is ironic that Experimental films tend to receive short shrift in both art museums and film archives, and these works have few other stewards, apart from a small number of nonprofit institutions and museums, or resources for preservation, at their disposal.

Exhibiting in screenings at cinema spaces committed to avant-garde work and in film and video festivals rather than showing films continuously in the gallery, Experimental filmmakers operate quite separately from those artists established on the gallery circuit. Private collectors interested in film and video tend to focus on work exhibited in galleries, and artists tend to remain fairly ignorant of Experimental film history. The art world has recently been more responsive to the idea that certain works do not lend themselves to continuous projection. Films and videos are shown on a schedule in the gallery, as in the case of Documenta 11, which also included a separate film program, in which the same films were shown in scheduled screenings. However, in spite of this trend, the work of Experimental filmmakers is still rarely acknowledged in art galleries or museums.

The film and video collection of the Whitney Museum presently encompasses 150 video installations, single-screen videotapes, film installations, and single-screen films, as well as a small number of slide installations and audio works from the 1960s to the present. Since 1997, the collection's special focus has been to build a preeminent collection of artists' film and film and video installations from the 1960s and '70s, many of which were preserved by the museum for exhibitions and subsequently brought into the collection. This section of the collection constitutes the largest grouping of its kind, including works by Vito Acconci, John Baldessari, Peter Campus, Walter De Maria, Simone Forti (fig. 1), Jack Goldstein, Dan Graham, Michael Heizer, Joan Jonas, Mary Kelly, David Lamelas, Anthony McCall (fig. 2), Robert Morris, Bruce Nauman, Dennis Oppenheim (fig. 3), Lucas Samaras, Richard Serra, Paul Sharits, Robert Smithson, Andy Warhol, and Jud Yalkut.[5] Some of the films in this group have been acquired as part of a strategy to reconstitute Castelli-Sonnabend tapes and films as a special collection at the Whitney.

The Whitney's collecting policy for moving-image work began modestly. Nam June Paik's *V-yramid* (1982) was the first video installation acquired by the museum, in 1982, nearly twenty years after Paik made his first video sculpture (fig. 4). Throughout the 1980s, only three other technology-based works were brought into the collection: two video installations by Paik and Mary Lucier and one audio installation by Oppenheim. Twenty-nine works were acquired during 1990s. Only one was a film: a limited edition 16 mm print by Walter De Maria, acquired as a gift from Virginia Dwan. The vast majority of moving-image

Fig. 1. Simone Forti (American, born 1935), *Striding Crawling*, 1977. Integral hologram (Multiplex), Plexiglas support, polymer protective covering, candle, candle dish, and bricks. Holography by Lloyd Cross. Whitney Museum of American Art, New York. Purchase, with funds from the Film and Video Committee

works in the Whitney's collection have been acquired since the formation of a film and video acquisition committee in 1998. It is fair to say that the Whitney's collection history is illustrative of a general institutional lassitude toward collecting moving-image art, or art that is dependent on technology.

The Whitney Museum's collecting policy is committed to the acquisition of work produced in an art-world context and by avant-garde or Experimental filmmakers, including both established and younger, emerging artists. This practice places us in an unusual position as an art museum, navigating two historically separate areas, and deliberately crossing traditional boundaries between film and art history. Our approach reflects an acknowledgement of the under-recognized relationships among different media in artists' practice, and between artists and filmmakers. For example, we have restored and brought into the collection Robert Morris's films from the late 1960s, which complement other important works in different media made by the artist during the same period, including prints, drawings, and sculptures. Similarly, we have acquired a print of Paul Sharits's film environment *Shutter Interface*, an important Structural film installation from the 1970s that is not editioned, and

Fig. 2. Anthony McCall (British, born 1946), *Line Describing a Cone*, 1973. Black-and-white silent 16 mm film, 31 minutes. Whitney Museum of American Art, New York. Purchase, with funds from the Film and Video Committee

Hollis Frampton's film *Nostalgia*, whose structure echoes the conceptual strategy of his artist friends in the early 1970s, including Carl Andre and Robert Barry, and whose content depicts many of the artists whose work is included in the Whitney Museum's collection, including Andre, James Rosenquist, and Robert Frank.

Fig. 3. Dennis Oppenheim (American, born 1938), *Echo*, 1973. Four black-and-white 16 mm film loops with sound transferred to video, projected simultaneously on four walls; dimensions variable. Whitney Museum of American Art, New York. Partial gift of the artist and partial purchase, with funds from the Film and Video Committee

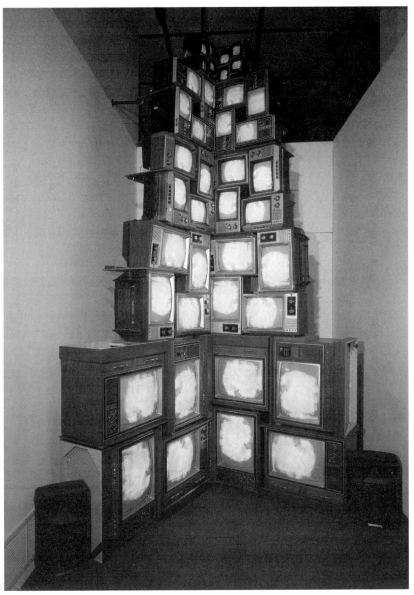

Fig. 4. Nam June Paik (South Korean, born 1932), *V-yramid*, 1982. Forty televisions and videotape; 186¾ × 85 × 74 in. (474.35 × 215.9 × 187.96 cm). Whitney Museum of American Art, New York. Purchase, with funds from the Lemberg Foundation, Inc., in honor of Samuel Lemberg

Aside from the philosophical issues of medium-based collecting policies, many of the technical difficulties faced by museums collecting technology-based works are those posed by contemporary art in general. Artists often use materials that are volatile and ephemeral. Works may be conceptual in nature, or take the form of an event or experience. Some are refabricated for every installation and may be altered considerably according to the spatial and architectural parameters of a particular venue. Upon deinstallation, all that may remain of a work is its record in photographic, video, and written form, and a set of instructions according to which the work is to be re-created. As Justin Graham and Jill Sterett state, "[These works] require what we refer to as an institutional memory; that is, an accurate account of the *experience of the art* from which it can be faithfully re-created at any time in the future."[6] None of these are, of course, exclusively recent phenomena. In fact, "[f]or large numbers of twentieth-century artists, the durability of their art is entirely subordinate to its power of expression," observes Ysbrand Hummelen.[7]

The kind of work alternately termed "time-based," "electronic," or "media art" is further distinguished by its dependence on mechanical or electronic equipment in order to function. Any given work consists of the medium—a DVD or a film print, for example—the equipment it is played on, and any additional installation components. Like a Dan Flavin installation, the work ceases to function when the power is switched off, and, as with a Flavin, films and videotapes are reproducible media. However, while theoretically any number of copies of a work can exist at the same time, often a strict control is exercised by galleries, museums, and collectors on the components of each edition. Unlike objects, technology-based works are durational, requiring the viewer to watch them unfold over a period of time. In reference to video, Bill Viola in fact states: "[T]he essence of the medium is time."[8]

But how does one collect works that exist at the nexus of time, light, and motion? A subset of questions is less poetic but no less pertinent: when purchasing a video installation, for example, what exactly is being acquired, i.e. what materials, media, equipment, and written instructions are included in the purchase? Is the equipment part of the work, or not? What kind of video formats or backup equipment should be brought into the collection? And how do you justify the acquisition of works whose life span is potentially limited?

Technology-based art is, by definition, ephemeral. The problem is exacerbated in the case of historical works, many of which have already deteriorated or are stored on obsolete media that are retrievable only at great expense. Magnetic videotape, for example, lasts only a few decades, and much less if tapes are exposed to very warm or humid conditions. Even when they are stored appropriately—upright under cool, dry, dust-free conditions—deterioration

can only be delayed, not stopped entirely. Moreover, artists and collectors are dependent on a commercial equipment market with a great interest in technical obsolescence.[9] Advanced or new versions of media and playback equipment are, in some instances, launched every few months.

Some artists embrace the impermanence of their work and fully expect it to disappear eventually. However, many more hope and expect that their artworks will last forever, as James Coddington points out: "The greater danger to contemporary art is not the experimental materials but rather embracing too broadly the notion of transience and thereby constructing rationales for assigning to oblivion art that was conceived with the idea that it would, in fact, be preserved."[10] In the absence of an artist's stated intentions, it is imperative to err on the side of permanence, he writes. In other words, institutions are obligated to make every effort to preserve their ephemeral artworks.

Guidelines for the acquisition and preservation of technology-based work in the art museum are still evolving, with no single standard yet in existence. However, there is an emergent set of broadly accepted procedures, as noted above, that is being put into practice at the Whitney Museum. While *film* and *video* are often used in the same breath as if they were interchangeable, the two media are fundamentally different, and the museum's procedures vary accordingly. Both media share the characteristic of recording movement in time, but film is a mechanical recording medium, whereas video is electronic. Video is, furthermore, a coded system; the information stored on magnetic or digital tape can be retrieved only with a specific electronic playback device.[11] The photographic frames on a film strip, on the other hand, have a material, physical presence and are legible on their own, with the projector providing only the mechanism by which they are put into motion.

When a video—whether it is a single videotape or DVD, or a part of an installation—is brought into the collection, the Whitney Museum always acquires at least one submaster along with the exhibition copy. The submaster should be in a digital format, since, unlike magnetic videotape, digital video does not deteriorate when copies are made. Analog video suffers from what is called "general loss," in which the picture quality of every copy is slightly inferior to the one that preceded it.[12] If a work originated on an analog format, we have recently begun to acquire both an analog archive copy and the digital submaster, whenever possible.[13] Since the quality of the image may change considerably when transferred from analog to digital tape,[14] a second analog archival master provides an additional record closer to the source material.

The digital submaster is used to make new exhibition copies of the artwork. Eventually, when the format of the submaster approaches obsolescence, it is upgraded to a new format. Conservators such as Pip Laurenson recommend

that medium upgrades take place every five years.[15] Duplication thus becomes a strategy of conservation. Bill Viola writes: "In a world where the conditions are constantly changing as new systems replace the old (the consumer's nightmare), where material recorded on older formats may not be able to be played or recovered (the conservator's nightmare), the key to survival seems to lie with an endless cycle of reproduction—*copying as preservation*."[16]

Rather than performing frequent upgrades, another preservation strategy focuses on the playback equipment itself, as Laurenson notes. However, due to rapid changes in video technology and the high cost involved in maintaining and storing the equipment, it is in general impractical for museums to pursue this option.[17] At the Whitney, exceptions are made when specific pieces of equipment are integral to the appearance or the image of the work overall. One example of this is Liisa Roberts's film installation *Blind Side* (1997), in which a special triple film lens was made by hand to ensure a large image size close up to the screen onto which the film projector projects the image (fig. 5). Another example is Michael Heizer's projective installation *Actual Size: Munich Rotary* (1970), which includes six custom-made steel projectors designed by Maris Ambats, each comprising three obsolete army lenses and slots for glass plates of still black-and-white photographs; their presence is a critical part of the installation.

Unlike video technology, film formats and equipment have remained remarkably stable. Thirty-five mm film was one of the first stocks manufactured and continues to be the standard for practically all commercial filmmaking. In an art context, it is far less commonly found, as costs for 35 mm camera rentals and film stock are for the most part prohibitively expensive outside the realm of commercial production. Smaller-gauge formats, such as 16mm (introduced in the 1920s) and super-8 (first marketed in the 1960s) are more commonly used by artists. Neither is a commercially viable format, and neither cameras nor projection equipment has been manufactured in many years. The result is a relative stability of materials and equipment in the tiny, specialized realm of art filmmaking.[18]

Given these specific demands, the Whitney Museum preserves film equipment along with the films themselves. Unlike video equipment, which is kept up to date by purchasing new formats, film equipment does not change and can be maintained by a small group of experts. Over the past five years, the museum has acquired a large number of 16 mm film projectors and film-looping mechanisms, or "loopers," for continuous film projection in the galleries. To ensure that films like these can be shown for many years to come in their original format, the museum continues to acquire vintage film projectors and continues to service and repair existing film equipment. In certain cases, projectors and loopers

Fig. 5. Liisa Roberts (American and Finnish, born 1969). *Blind Side*, 1998. One 16 mm silent film loop in color (viewer activated); live outdoor sound (between film screenings); 16 mm film projector adapted with film looper, motion detector, and project/audio trigger device; one microphone, speaker, and cables; glass screen sandblasted on one slide; constructed room with mirrored wall; existing architectural space. Whitney Museum of American Art, New York. Purchase, with funds from the Film and Video Committee

are dedicated to a particular installation, either because they were purchased together with the film or because the equipment has been customized for a specific work.

Both are the case with Paul Sietsema's *Empire* (2002), a twenty-four-minute film shot on super-16mm stock. Super-16 mm is a production format that is not normally projected. Rather, it is used for television production or blown up to 35 mm for theatrical distribution. Standard super-16 projection equipment does not exist. Sietsema, however, used the stock since he considered the particular aspect ratio[19] of super-16 to be essential to the look of the projected film. He has made super-16 mm exhibition prints and has had 16 mm film projectors customized for super-16 projection. One such customized projector was acquired by the Whitney Museum along with the film.

When acquiring a film or film installation for the collection, the Museum will obtain an internegative (or duplicate negative) as well as at least one film

print, in order to ensure that new exhibition copies can be made. It is generally rare for an artist to give the original negative as it was exposed in the camera to an institution (the Whitney has only one in the collection), and some are reluctant to make an internegative available. If an artist chooses to keep possession of all printing materials, the Whitney acquires one archive print, which is to be kept pristine and never projected, plus one exhibition print, as well as the right to obtain new exhibition prints for continuous exhibition or when the quality of the original exhibition print is no longer satisfactory.

Ektachrome slide film, favored by artists in the early 1970s due to its low cost, accessibility, and ease of projection, presents a unique set of issues regarding preservation, falling somewhere between photographic and film preservation. Like film, a slide installation—which depends on the interval between one slide and the next, or, as in the case of Nan Goldin's *Ballad of Sexual Dependency* (1976–92), on several slide projectors in a complex synchronized sequence—relies for its aesthetic meaning on an equipment format that is rapidly becoming obsolete.[20] While the simple solution might appear to be the transfer of each slide to a computerized electronic projection sequence, the physical properties of the slides, their dense color, are not yet achieved by digital imaging, and the mechanical rhythm and the sound of the carousel projectors in the gallery space all serve to define the artwork and are not necessarily transferable.

Whatever the problems of obsolete equipment, any effort at preserving either the medium or the equipment is futile if not complemented by rigorous documentation of technology-based works, particularly installations. These works are, as William Real points out, "especially threatened by technological obsolescence and amnesia."[21] The presentation of single-screen videotapes or films in an art museum is a good example of the importance of capturing even seemingly obvious details.

One important distinction is whether an artist prefers the work to be shown as a continuous projection in the white cube of the gallery or as timed screenings in a black-box cinema auditorium. For some, such as Tacita Dean or Matthew Barney, both are acceptable. If a work is projected continuously, there will be specifications as to the maximum or minimum size of the image, the size of the space itself, the wall color, and the viewer distance. An artist may insist that a video be shown on a monitor only. Installations involving multiple screens, for example, or architectural components that are to be fabricated with every presentation, should be documented with floor plans, wiring diagrams, construction instructions, photography, and/or video documentation. Often, practical decisions or changes are made in the process of installing a particular work and can too easily be forgotten once a piece is up and running. To ensure

that all pertinent details are recorded, Laurenson recommends documenting works during the process of accessioning as well as installation.[22] Records should be regularly updated, especially whenever upgrades of media or equipment are performed.

Detailed conversations with the artist form the core of the documentation and conservation process. Carol Mancusi-Ungaro, the Whitney's Director of Conservation, has initiated a procedure whereby artists working in all media are interviewed on videotape, to determine how each artwork was made and how it should be preserved in perpetuity. Artists' approaches to the conservation of moving-image works and projective installations vary immensely. One artist may have no qualms about transferring a work initially shot on film to video, while another may insist that the meaning of the film would be completely lost if transferred to another format.[23]

At the Whitney Museum, all original records—such as installation instructions, diagrams, equipment lists, production notes, and correspondence—are kept in the central registrarial object files, where they remain accessible to future generations of scholars and curators. In order to fully understand and properly document the work, it is critical that artists, curators, conservators, registrars, and technicians work as a team to compile this information and act on it; as Real points out: "a healthy 'ecosystem' consisting of shared knowledge, philosophy, expertise, and ethics among allied professionals" can ensure that technology-based works of art are adequately preserved.[24]

Whereas artists exhibiting in galleries most often issue their work in editions, the majority of Experimental filmmakers work within a distribution model derived from that of commercially released film. Films or videos exist, at least theoretically, in an unlimited edition, for rent or purchase by the artist or distributor.[25] Unlike commercial companies, however, many distributors specializing in artists' film and video, such as Electronic Arts Intermix and Video Data Bank, are not-for-profit organizations that rent to educational institutions and other nonprofits for modest fees. When purchasing a videotape or a film print of a distributed work, a particular set of rights pertaining to reproduction, duplication, and exhibition is purchased along with it.

An archival digital Betacam videotape, for example, may be copied to any lower-grade copy for in-house exhibition, whereas a ¾ in. tape may not be copied at all.[26] In the case of uneditioned film and video, the acquisition arrangement is actually closer to a licensing model.[27] Just as an individual purchasing a DVD buys the right to exhibit it privately, the institution obtains a certain set of rights. A particular piece may be sold for the life of the material tape only, which would require the institution to purchase a new archival copy rather than transfer it to a higher-grade medium.

Even though the museum generally acquires the rights to exhibit a work in-house and as part of institutional traveling exhibitions, the artist or distributor may still require a screening fee for showing it at an outside venue. And the museum does not loan works that are in distribution to other institutions, as these pieces can be rented. For art museums, the acquisition of time-based media in distribution presents complex problems. In particular, the limitation of purchasing only a work's physical materials, which otherwise could theoretically be preserved through duplication, seems to contradict the purpose of a permanent collection. In the case of film and video works, an added complication is that this model exists alongside the more traditional practice of acquiring a unique or editioned work, for which museums are better equipped. Nonetheless, if a museum does collect artists' film and video works on their artistic merit, simply ignoring those in distribution is hardly an option. Rather, we need to acknowledge that the parameters for acquiring film and video, and by extension all technology-based works of art, are in flux and will have to be constantly re-examined and re-negotiated as technology evolves.

SOME REFLECTIONS ON FILM AND VIDEO IN THE TWENTY-FIRST CENTURY

Since the 1990s there has been an unprecedented flourishing of film, installation, and video art in galleries and museums. This was demonstrated most recently in Documenta 11, which was widely commented upon for its proliferation of black-box screening spaces and the relative scarcity of painting and sculpture. Hal Foster has described film and video as the "default media" of contemporary art.[28] Arguably, some of the most important art of the later twentieth and early twenty-first century is technology based. As this fact is finally being acknowledged by museums' belated embrace of film and video art for collection, the very real challenges of conservation, particularly of historical film and video installations, are only just beginning. The challenges are becoming even more urgent because, with the appearance of each new medium, the older media of film, slides, and vinyl are reasserting themselves with renewed vigor and materiality.

Ursula Frohne notes that, "[M]ost museums have staunchly held on to the historically-based difference between the aesthetic meaning and value of old art genres and new, technologically-produced work."[29] Her observation resonates with Walter Benjamin's argument that a unique original possesses an aura that is lacking in its mechanically produced copy.[30] This contrasts with the Duchampian argument that, since the aura of any artwork falls away after a decade, when the social context within which it was produced has changed,

reproduction re-invigorates the artwork. Duchamp was the first artist to assert this in his own work (which also included film), demonstrating at an early stage that editioning and repeated re-presentation is not specific to film and video installation. Duchamp's observation, practically demonstrated by museums and collectors ever since, applies to "ephemeral" works across the board, including, for example, the wall drawings of Sol LeWitt, the fluorescent tube installations of Dan Flavin, and the Conceptual language works of Lawrence Weiner, as well as contemporary ephemeral installations. Museums rely closely on general collections procedures developed for other reproducible artworks, including prints and photographs, when dealing with film and video installation. Nonetheless, museums by and large have been slower to acquire moving-image works than those other forms; this may be due to their dependence on technology not only as a means of reproduction but for exhibition as well. Different from a photograph, for example, there is no tangible object once the film projector stops running.

There is an increasing investment in outmoded or obsolete equipment and media, including vinyl records and old computer and film equipment. In line with Duchamp's reasoning, when such pieces of equipment are removed from their original context, attaining a nostalgic quality, they are likely to be treated as precious historical objects, or objects of art, themselves. Similarly, while the "cinema" may be in the process of disappearing,[31] film is ironically becoming more present in the gallery space than ever before. Artists such as Tacita Dean, Stan Douglas, and Sharon Lockhart make *film* works to be shown in the gallery, running continuously on a film projector with a looping mechanism. Liisa Roberts has for a number of years made complex film installations that explore the properties specific to the film medium while extending its boundaries. She creates sophisticated spatial configurations that involve multiple custom-made screens and depend on the materiality of the film projector as well the spectator's presence in the gallery. Many young filmmakers are continuing to explore film's material properties and surface by the hand-painting or cameraless exposure of film stock, hand-processing, manual editing, and so forth. In the work of artists such as Bradley Eros, Glen Fogel, Ken Jacobs, Bruce McClure, and Luis Recoder, live film performances integrate the physical mechanics of the projector or use colored gels or the projection booth glass as material elements, redefining the relationship between materiality and time in film.

None of these techniques are new, but it is significant that many younger artists choose to work in a mode that treats film as object. This trend has everything to do with the ready availability on the consumer market of digital recording and editing devices that assert the medium of film as a precious, noncommercial material. In this sense, the new interest in film could be paralleled

with artists' recent, unprecedented assertion of drawing as a major medium. Increasingly, film projection resembles the authentic, original artwork with its qualities of presence and luminosity. While film is older and fundamentally distinct from video, a similar kind of elevation can be observed in the case of video art, which is now itself historical.

In the face of rapidly advancing digital technology, the end of video and film as we know them is a certainty. The idea that film and video art, as they get older, are perceived as analogous to the traditional object does not contradict the fact that both are, in a critical way, immaterial forms, which exist only during the moment they unfold in time. Rather, the point is that film and video art are being embraced in museum collections at the moment when digital technology has begun its ascent. Older forms of technology have a history of surviving in niches—used, collected, and appreciated by a small group of connoisseurs. The continuing widespread use of super-8 film by artists and experimental filmmakers, though long obsolete on the general consumer market, is only one example. Museums are likely to find themselves becoming custodians of otherwise outmoded types of media and technology, which survive in the art world but not on the mass market and are dependent on institutions to care for and conserve them for posterity.

NOTES

1. This is a body of work largely distinct from what is most often termed avant-garde or experimental film, whose historical relationship with the museum has taken a very different course, a point to be discussed below.

2. See overviews in Sherry Miller Hocking, "The Tapes Are Disappearing: Video Preservation, Video Pioneers, Video History," *Squealer* 13 (spring/summer 2002); and William Real, "Toward Guidelines for Practice in the Preservation and Documentation of Technology-based Installation Art," *Journal of the American Institute for Conservation* 40 (2001): 214. Since then, the Bay Area Video Coalition (BAVC) has published the interactive DVD *Playback: Preserving Analog Video* (San Francisco, 2003), a practical guide for curators and conservators.

3. Justin Graham and Jill Sterett, "An Institutional Approach to the Collections Care of Electronic Art," *WAAC Newsletter* 19, no. 3 (September 1997) http://palimpsest.stanford.edu/waac/wn/wn19/wn19-3/wn19-310.html (accessed 27 August 2003); Pip Laurenson, "The Conservation and Management of Time-Based Media Works of Art," paper presented at the panel "New Media Miasma: Registration of Ones and Zeros, Magnetic Tape, Film and Their Machines," at the annual meeting of the American Association of Museums, Dallas, 14 May 2002; and Real, "Toward Guidelines," 218.

4. John G. Handhardt, "The Media Arts and the Museum: Reflections on a History 1963–1973," in *Mortality Immortality? The Legacy of 20th Centruy Art*, ed. Miguel Angel Corzo (Los Angeles: Getty Conservation Institute, 1999), 100.

5. The Whitney Museum has in recent years presented two extensive survey exhibitions on this kind of work from the 1960s and 1970s: Flashing into the Shadows: The Artist's Film in

America 1966–1977, 7 December 2000–1 April 2001, curated by Chrissie Iles and Eric de Bruyn, and Into the Light: The Projected Image in American Art 1964–1976, 18 October 2001–6 January 2002, curated by Chrissie Iles.

6. Graham and Sterett, "Institutional Approach."

7. Ysbrand Hummelen, "The Conservation of Contemporary Art: New Methods and Strategies?" in *Mortality Immortality?*, 171. Note: in this source, author's name is spelled with a *Y*.

8. Bill Viola, "Permanent Impermanence," in ibid., 88.

9. Real, "Toward Guidelines," 212.

10. James Coddington, The Case against Amnesia" in *Mortality Immortality?*, 19–22.

11. Pip Laurenson, "The Conservation and Documentation of Video Art," in *Modern Art: Who Cares?* eds. IJsbrand Hummelen and Dionne Sillé (Amsterdam: Foundation for the Conservation of Modern Art and the Netherlands Institute for Cultural Heritage, 1999), 264.

12. Ibid., 265.

13. This idea was discussed by speaker Stephen Vitiello at the panel "Digital Happy Hour: Archives in the 21st Century," The Kitchen, New York, 12 February 2003.

14. Laurenson, "Conservation and Documentation of Video Art," 265.

15. Laurenson, "Conservation and Management of Time-Based Media Works of Art."

16. Bill Viola, "Permanent Impermanence," 91. Italics added.

17. Laurenson, "Conservation and Documentation of Video Art," 264.

18. It should be added that 16 mm is also a format commonly used in student filmmaking, which is less relevant in this context.

19. Aspect ratio is the ratio of the width to the height of a film or video image.

20. Kodak ceased to manufacture 35 mm slide projectors in June 2004.

21. Real, "Toward Guidelines," 214.

22. Laurenson, "Conservation and Management of Time-Based Media Works of Art."

23. John Ippolito and the staff of the Solomon R. Guggenheim Museum have compiled an extensive questionnaire developing a detailed catalogue of questions for artists working in "variable media." See John Ippolito and Staff of Guggenheim Museum, Variable Media Initiative, 2001, http://variablemedia.net (accessed 1 August 2004).

24. Real, "Toward Guidelines," 218.

25. A number of distribution companies in the United States are devoted to independently produced non-commercial film and video, such as Canyon Cinema, The Film-makers' Cooperative, Video Data Bank, and Electronic Arts Intermix, among others.

26. Examples are taken from Electronic Arts Intermix purchasing guidelines, © 2004, http://www.eai.org/eai/ordering_information.jsp (accessed 3 August 2004).

27. See, for example, Susan Morris, "Museums and New Media Art," October 2001, www.rockfound.org/Documents/528/Museums_and_New_Media_Art.pdf (accessed 14 March 2003); and Real, "Toward Guidelines," 223.

28. Round Table, "The Projected Image in Contemporary Art," *October* 104 (spring 2003): 93.

29. Ursula Frohne, "Old Art and New Media: The Contemporary Museum" *Afterimage* 27 (September/October 1999): 9.

30. Walter Benjamin, "The Work of Art in the Age of Mechanical Reproduction," in *Illuminations*, trans. Harry Zohn (New York: Schocken Books, 1968), 217–51.

31. For an insightful critique of this notion, see John Belton, "Digital Cinema: A False Revolution," *October* 100 (spring 2002): 98–114.

Collecting New-Media Art:
Just Like Anything Else,
Only Different

Steve Dietz
INDEPENDENT CURATOR

[New-media art] questions everything, the most fundamental assumptions: What is a work? How do you collect? What is preservation? What is ownership? All of those things that museums are based upon and structured upon are pretty much thrown open to question.

JEREMY STRICK, DIRECTOR, MUSEUM OF CONTEMPORARY ART, LOS ANGELES

In this comment, Jeremy Strick is both correct and being rhetorical.[1] Lots of contemporary art raises these same questions. New-media art, particularly in its network-based incarnations, does so perhaps more consistently, but none of the questions raised is radically new. In fact, the Variable Media Initiative, one of the results of institutions' early investigations of collecting new media, is significant precisely because of its cross-medium applicability.[2] Nevertheless, there is a kind of crisis of collection—and hence of cultural memory—because of the paucity of new-media art in museum collections and because of the nature of such work—both of which make it difficult at best to create an adequate collection of new-media art.

Even among the few museums making relatively active curatorial efforts in new media, none has a collection that even approaches the scope of its holdings in other media. Yet at the same time—since at least 1977, when Kit Galloway and Sherrie Rabinowitz first presented their *Satellite Arts Project*,[3] and certainly since the invention of the World Wide Web in the early 1990s—there has been an explosion of new-media artistic activity, which is well documented on websites such as Rhizome.org and in the archives of the Ars Electronica Festival,

which celebrated its twenty-fifth year in 2004.[4] What accounts for this discrepancy between artistic activity and institutional collecting?

WHAT IS NEW-MEDIA ART?

In order to understand the issues involved in collecting new-media art, it is reasonable to ask what new media is. Photography and video were both new media at one point, and, in the near future, the Weisman Art Museum in Minneapolis will accession a transgenic work of art by Eduardo Kac, which is synthesized, in part, from his own DNA—a new media of a different sort.[5] This suggests that *new* is simply "too broad a term to be truly useful," as Lev Manovich writes in his influential book, *The Language of New Media*, about the terms *digital* and *interactivity*.[6]

The flip side of nearly generic terms such as *new, digital,* and *interactive* is the attempt to define new media as a set of unique properties—"the formalist rap," as David Antin refers to the hermeneutical process in his seminal essay, "Video: The Distinctive Features of the Medium."[7] Formalism, as Rosalind Krauss has pointed out, is too often "abusively recast as a form of objectification or reification, since a medium is purportedly made specific by being reduced to nothing but its manifest physical properties."[8]

New-media art remains an evolving reference with no permanent definition. In the context of this essay, I use it to refer to artworks that use computation as more than just a production tool and/or use the Internet as more than merely a means of delivery. The model I prefer is new-media art as a process, as the artist Jim Campbell has usefully abstracted in this diagram (fig. 1), which he refers to as a "formula for computer art."[9]

This diagram can be read as a narrative: first, there is some kind of input. It can be the click of a mouse, the striking of a key, or the weather. With the necessary interpreter, the input can be literally anything. What the interpreter does is convert, or "quantize," the input into a number, usually expressed to the computer in the language it can read—a series of ones and zeros. Once quantized, the input is inside the black box of the computer and algorithms instruct the computer how to process it. Algorithms, for our purposes, represent the set of instructions that the artist provides about how the computer software and hardware—which also invoke various algorithms—should act upon the external input. It is at this level that the artist is making important choices, although they are not always observable. Once the algorithms are executed, they are reconverted to the specified output, whether that is an image on a screen or some other stimulus perceivable by the human sensorium, such as a sound or a puff of air.

Fig. 1. Jim Campbell (American, born 1956), "Formula for Computer Art," http://www.jimcampbell.tv/, 1996/2003

A few things should be noted about this diagram of new media. First, it is recursive. Any output can become input, and in regard to network-specific art, or net art, the Internet can constitute the input and/or output of an artwork and even act as a kind of distributed computer system itself. Net art, as perhaps the most virtual form of new-media art, helps identify boundary issues in terms of collecting new-media art, but network-specific art is not coterminous with new-media art, nor is new-media art always networked. Second, output that is homologous to the input is not new-media art. For example, to digitize a photograph of a painting and post it on the Internet is not new-media art, even though it technically conforms to the diagrammed process, because it simply and faithfully re-presents the source material without any aesthetic intentionality. Finally, the digital art process is not about purity or exclusivity and is best considered in light of anthropologist Gregory Bateson's definition of information as a "difference that makes a difference."[10] If one can make the argument that the computational process makes a difference to the work as art, then it is arguably new-media art.

One of the ongoing debates in the institutional art world is whether new media should be thought of as a distinct field or whether it is best to consider it as "just art." There are valid points of view on each side of the debate, but for the purposes of collecting it doesn't matter. Some institutions have departments of photography or video curators and others don't, but both types may collect photographs and video art. Regardless of institutional structure, it is

important to consider how to integrate new-media art into the museum's collection practices as well as to consider the conceptual issues and pragmatic concerns raised by its distinctive features.

There are many new-media artists and artist groups for whom the museum is a specific site of contestation. Work by Knowbotic Research, Critical Art Ensemble, Graham Harwood, and others often uses the museum context to make its point, and in this sense it is similar to the socially and politically engaged practice of Hans Haacke, Andrea Fraser, and Fred Wilson, each of whom engages the institution of the museum with at least some of their work.

Many network participants, however, would agree with Australian artist Melinda Rackham that there is a more general issue at stake, which she articulated in an online discussion: "[T]he reasons people started making net art . . . to connect on a network and route around the censorship of the institutional and corporate world, mean that they (museums) will never want to treat it seriously—it's still in opposition to their structure."[11] Whether or not these are the reasons that many museums don't collect new-media art as conscientiously as other art forms is debatable, but there is a fundamental tension between the wide-ranging and open structures of the Internet and the traditional role of the museum as gatekeeper. One example of this gap in practice is that often an institution collecting new-media art is in fact collecting a production platform or set of algorithmic parameters with constantly changing content rather than a fixed entity.

Mark Napier was commissioned by the Solomon R. Guggenheim Museum in New York to create *Net.Flag* (2002), a dynamic online work that allows viewers to modify the look of a virtual flag in real time. The Guggenheim also acquired the work—the software with its dynamically changing content—for its permanent collection. In addition, as part of the purchase agreement, Napier insisted that the work "always be on view."[12] This is a condition that could never be accommodated for any physical work of art, but that, though still ambitious, is not unattainable online.

The primary issue regarding collecting "anti-institutional" net art ultimately isn't its content, but the general desire by many new-media artists for their work to continue to be freely and easily accessible—and appropriately displayed. Potentially, the museum can help enable this, especially over the long term, by taking on some of the burdensome support functions, recognizing that such freely available and often easily replicable work may also impact the museum's traditional insistence on uniqueness or limited availability for objects in its collection.

A lot of new-media art is ephemeral. Generally this issue can be divided into two separate categories: time and materiality. Stelarc's classic *Ping Body*, which

allows remote participants to actuate his body by "pinging" it via the Internet, causing his limbs to involuntarily twitch through remotely activated electrical stimulators, is a performance that first took place on 10 April 1996.[13] Like Jean Tinguely's *Homage to New York* (1960), it can have a cascading influence on the field, but even when repeated, it would still be classified as a performance, like any musical event, and its documentation would generally become part of an archive or study collection. The performance itself is unlikely to go into a museum's permanent collection.

The distinction between art and the documentation of an artistic event begins to blur a bit, however, when the art is instruction based. For instance, Sol LeWitt's *Four Geometric Figures in a Room* was commissioned by the Walker Art Center in Minneapolis in 1984. Technically, the artwork is the following set of instructions: "Four geometric figures (circle, square, trapezoid, parallelogram) drawn with four-inch (10 cm) wide band of yellow color ink wash. The areas inside the figures are blue color ink wash, and the areas outside the figures are red color ink wash. On each side of the walls are bands of India ink wash."[14] As the contextual information states, LeWitt's instructions are something that "anyone may execute, in any location, any number of times." The parallels to new-media art are striking. In a sense, the input is the room's dimensions, the algorithms are LeWitt's instructions, and the output is the drawings on the walls.

Lisa Jevbratt's *Stillman Project* (fig. 2) was also commissioned for the Walker Art Center but for a virtual "room"—the online Gallery 9.[15] Jevbratt, too, wrote a set of instructions, only they were in a computer language known as Javascript. These instructions were placed on every page of the Walker website (in the source code, not visible to the visitor) and caused a number of things to happen when a visitor viewed the website. On the first viewed page only, they generated a set of simple questions (each in a different color). Based on how visitors answered, they were "tagged," and as they viewed different pages throughout the website, those pages were also tagged with a color linked to the visitor's answer. Over time, pages of the website acquired a profile, based on who was looking at them: 30 percent of the people looking at this page believe the Internet is primarily informational, etc. The point is that with all net art and significant aspects of all new-media art, as with the LeWitt, the artwork that is collected is the instruction set, and the artwork that is experienced is its execution.

A lot of new-media art, especially network-based work, doesn't have spatial dimensions per se, but nodes and levels of connection. Maciej Wisniewski's *Jackpot* (fig. 3), for example, is an online slot machine that randomly displays URLs (web addresses) contained in a preexisting database. In 1998 the Walker Art Center acquired this work as part of its acquisition of the website *äda'web*. The web

Fig. 2. Lisa Jevbratt (Swedish, born 1967), *The Stillman Project for the Walker Art Center*, http://projects.walkerart.org/stillman/documentation/stillman/error.html, 1998

pages that *Jackpot*'s database of URLs pointed to were not saved at the time, and now when you play it, the majority of results are missing pages. Even though the piece is technically "correct"—the instructions still work—much of the magic of the original experience is gone.

To some extent this is a potential hazard for any work that relies on external input. Calvin Tomkins tells the story of the first time that John Cage presented *Imaginary Landscape No. 4* (1951), a composition that involves operating twelve radios according to a particular script. By the time Cage and his performers took the stage, it was after midnight and the radio spectrum was practically silent. There were no sound streams for the radios to manipulate. The performance was not a great success.[16]

I would argue it is not enough just to say that *Jackpot* is technically intact and that it simply has become a marker of how the World Wide Web has changed.

.net	.org	.com

.net column:

Business Chat Computers
& & Transportation &
Finance Dating Technology

Health & Home & Online Shopping
Fitness Lifestyle Gambling & Gifts

Related topics Roar's bes

Group Sex
Huge Cocks 1. Creamy
Voyeur Get 3 Da
Gay Sex Quality C
Breast Sex Shows
Amateur Sex http://cli
Masturbation
Sex Stories 2. NAPSTEI
Celebrity Sex Free for
Free Porn been reg
 Porn's ea
 video clip
 http://ww

 3. Cumville
ROAR Hardcore
Home Page blowjobs
 http://ww

 4. Fantasti
 Tired of
 you in cir
 Extra Cle
 think you
 http://ww

 5. $4.95/3
 LARRY FL
 introduce
 NEW YEA
 http://ww

 6. You do f

.org column:

Not Found

The requested URL /kind/ was not found on this
server.

Apache/1.3.27 Server at www.igc.org Port 80

.com column:

File Not Found

The requested URL was not found o
server.

Go to "http://www.roar.com/?ad=1&do=&sh=47810&pp=hsokij1e8aaw0n98xz20cww%20%20%20%20%20%20%20&pid=204326;10002408"

Fig. 3. Maciej Wisniewski (Polish), *Jackpot*, http://adaweb.walkerart.org/context/
jackpot/, 1997

That was not the artist's intent. On the other hand, how *Jackpot* should be col-
lected is not obvious. One could simply save its initial set of pages in the data-
base, but when a future user clicks on a link within such a page, it will return an
error message because the links are no longer "live." One could create a script
that periodically refreshes its database of URLs, so that more of them are acces-
sible. One could modify the script to use only URLs that are still operational.
Whatever the decision, it is important to make such future decisions an explicit
part of the acquisition process, not an afterthought. This is one function of the
Variable Media Initiative project, to have the artist specify, in a more systematic
way, which aspects of a given project can be changed and which must remain
fixed for the project to retain the artist's intent.

One constant refrain about the promise of new-media art is that it allows the
viewer to become a participant and even, for many works, a producer. The
artist is creating the context, the platform, the set of rules by which the "viewer"
participates and produces. With a work such as *Apartment* (fig. 4) by Marek
Walczak and Martin Wattenberg, users enter a string of words in order to cre-
ate the floorplan of an apartment. The truth is, some users are better than oth-
ers at generating results that are of interest to other viewers. How are we to

Fig. 4. Marek Walczak (British, born 1957) and Martin Wattenberg (American, born 1970), *Apartment*, http://www.turbulence.org/Works/apartment/, 2001

judge works where the input is the user's? For Kynaston McShine's acclaimed Information exhibition (1970), Dennis Oppenheim created a system for visitors to write a secret on a notecard and put it in a slot. In return, they received someone else's secret. After the exhibition all 2000-plus of the secrets were published, without editing. One would be hard-pressed, however, to argue that the quality of this essentially conceptual work was dependent on what people wrote.

Many new-media artworks are inherently performative. It is important to judge them on the basis of the performance that is possible, not on every person's rendition of *Moonlight Piano Sonata* (1801), so to speak.

There are plenty of ephemeral, instruction-based works in museum collections, from Jana Sterbak's *Vanitas: Flesh Dress for an Albino Anorectic* (1987)[17] to LeWitt's *Four Geometric Figures in a Room.* There are plenty of "anti-institutional" artists collected by museums, from Hans Haacke to Andrea Fraser. There are certainly examples of unbounded and open works, from Ray Johnson's correspondence art

to Yoko Ono's *Scream* score.[18] Why is there so little new-media art in museum collections?

There is no single answer, of course, but push senior curators on this point, and beyond the issues of new-media art being non-collectible, ephemeral, decontextualized, open-ended, and difficult to preserve; beyond frustration with not having the right plug-in or the computer being "down" when they were at an exhibition; they will finally admit two things: never having seen new media they thought was really great art, and not knowing anyone who collects (buys) new-media art.

These are not trivial issues by any stretch of the imagination, but as Linda Nochlin pointed out in her seminal essay "Why Have There Been No Great Women Artists?" (1971), the question, if answered adequately, can "challenge the assumptions that the traditional divisions of intellectual inquiry are still adequate to deal with the meaningful questions of our time, rather than the merely convenient or self-generated ones."[19] It is not my goal with this essay to attempt to answer the question adequately—in Nochlin's sense—of why there have been no great new-media artists, but I do believe that doing so is fundamental to reversing the situation.

One brief speculation, however: With LeWitt's instructions for *Four Geometric Figures in a Room*, a curator, even though she may not be a trained preparator, can get a pretty good sense of the results of the instructions just by reading them. And, of course, there is a thousand-year history of drawing that can be referenced in evaluating the experience of the actual work. With Jevbratt's Javascript instructions, however, most curators, including myself, have a hard time reading the code in any meaningful way. I don't think this means that curators must become coders, but a different level of familiarity and accessibility is needed. In terms of the resulting web pages—Jevbratt's "rooms"—the conceptual nub is not the visual experience but the interactive experience. The history of such interactivity is much more truncated, and most of it is borrowed from different forms, such as the theater, or based on usability studies that may be more appropriate for E-commerce sites than works of art. In the words of Leo Steinberg: "One way to cope with the provocations of novel art is to rest firm and maintain solid standards. . . . A second way is more yielding. The critic interested in a novel manifestation holds his criteria and taste in reserve. Since they were formed upon yesterday's art, he does not assume that they are ready-made for today. . . . He suspends judgment until the work's intention has come into focus and his response to it is—in a literal sense of the word—sympathetic; not necessarily to approve, but to feel along with it as with a thing that is like no other."[20]

Sympathy isn't necessarily the best criterion for make a lasting commitment but neither is mere similarity to one's previous relationships.

COLLECTING NEW-MEDIA ART

The distinctive features of new-media art do challenge many of the conventional notions about art, but many respected—and collected—non–new-media artists have used these same strategies in their work. I have no doubt that eventually new-media art will be as much a part of institutions' collections as photography, video, and installation art have become. In the meantime, however, there is a crisis at hand. We are in danger of losing thirty years of new-media art history. It is important to learn how to collect new-media art now, if there is to be any hope of preserving its recent past.

If magnetic tape has a half-life of approximately thirty years—the point at which it starts to significantly deteriorate—the half-life of digital media can be days. In 2002 the average life span of a web page was just seventy-four days. In addition, the software that drives many new-media applications may change every six months—and it is not always backwards compatible. The artist duo Jodi's famous 404-object page can still be displayed, but only by looking at the source code can you tell that hundreds of the words on the page are supposed to create a virtual Times Square of blinking.[21] Current web browsers, however, no longer support the blink tag, so the experience of the work is radically different from what the artists intended.

Museums traditionally are concerned with the selection of precious, rare, or unique objects. Libraries are traditionally concerned with expanding access to generally available objects. Many digital artworks are easily replicable, and artists are more interested in making them accessible than rare. In this context, some of the differences between a museum collection of digital artworks and a library collection of digital objects begin to converge. As Jon Ippolito, progenitor of the Variable Media Initiative, provocatively put it in regard to the non-uniqueness of certain digital artworks: "For museums to acquire open-licensed art would require them to transform from collecting institutions to circulating institutions."[22]

According to the National Information Standards Organization's framework for digital collections, "A good digital collection is created according to an explicit collection development policy that has been agreed upon and documented."[23] While this may seem obvious, it is not always true. To date, several approaches have been taken at U.S. museums.

The clearest process may be to place new-media works in the museum's permanent collection, under whatever existing mission that collection has. According

to Ippolito: "[T]he Guggenheim is bringing a particularly long-term vision to collecting online art, acquiring commissions directly into its permanent collection alongside painting and sculpture rather than into ancillary special Internet art collections as other museums have done. The logic behind the Guggenheim's approach, known as the Variable Media Initiative, is to prepare for the obsolescence of ephemeral technology by encouraging artists to envision the possible acceptable forms their work might take in the future."[24]

The Guggenheim is focused on the important issue of lasting stewardship and the particular requirements of new-media art, and it takes the position that works should not be segregated by medium. This is a principled position. At the same time, Ippolito acknowledges that he is constrained, with such a policy, in what he can show and especially acquire because it must "succeed." As Steinberg warned, however, judging such success—or failure—is too often based on the norms of existing media.[25]

The American Museum of the Moving Image has a material culture collection. In the digital realm, it has collected film sound effects files, video games, and the dancing-baby animation. For AMMI's collection, "artistic merit is one among many characteristics that make something worthy of being collected. There are many others as well, such as considerations of its importance and influence at the time, or being part of a chain of influence for later developments and innovations, or even that it was an intriguing dead end." As curator Carl Goodman puts it: "We as a museum are free to recognize artistry and artistic achievement but are not tyrannized by it—it is not the singular characteristic uniting all of our objects."[26]

At the Walker Art Center, where I was curator of new-media (1995–2003), the new-media collection policy specifically states that the Walker's is "a hybrid Collection that shares similarities with the Permanent Collection, the Study Collection, and the Archives Collection" and is intended "to provide a permanently and publicly accessible record and context for understanding the telematic and new media artwork of our time, document major tendencies in the field, and increase local and remote visitors' appreciation of new media art."[27]

There was a two-step process for collecting new-media art at the Walker. It could be acquired for the Digital Arts Study Collection and then later accessioned into the permanent collection. This allowed me to collect work that I felt strongly about but that the institution was not necessarily fully equipped to deal with at that point. More important, however, the Study Collection allowed me to preserve work that provided a context for the artwork I was collecting, such as the *Art Dirt* webcasts, which included interviews with many of the artists in the digital art collection.[28]

Friedrich Kittler, in his essay "Museums on the Digital Frontier" (1995), argues strongly that one of the significant opportunities for museums in the digital age is to create digital collections that are the artworks *and* the context for the artworks, from related cultural artifacts to contextual materials to the technical notes that underpin the creation and presentation of the work. Whether these collections are called "permanent" or "study" or "archives" makes a difference in terms of what they can ingest and how, but in terms of access, integration, and hybridity are practically a mandate for Kittler—with whom I agree: "What looms ahead or rather what has to be done is the reprise of the wonder chambers. Johann Valentin Andreä, the founder of the Rosicrucians, once advocated an archive that would include not only artworks, tools, and instruments, but also their technical drawings. Under today's high-tech conditions, we have no choice but to start such an archive or endorse millions of anonymous ways of dying."[29]

Museums are moving toward such integration of their collections, archives, and libraries, at least intra-institutionally. It remains a goal to expand accessibility inter-institutionally.

PRESERVING NEW-MEDIA ART

Collecting a work of art brings with it the core responsibilities of research, presentation, and preservation. There are many reasons why preservation is problematic for new-media artworks, primarily having to do with the variability of both their input and output, the fast pace of change for underlying hardware and software, and the physical deterioration of components. At the moment, there are very few solutions to these issues, but a number of interesting approaches are being attempted. For the time being, some combination will be necessary until there is common conceptual agreement as well as the supporting technical capabilities. In the meantime, collecting this important cultural heritage is a critical and necessary first step.

For many media-based acquisitions, museums will purchase the equipment necessary to run them as protection against the equipment not being available at some future date. This approach has generally been downplayed for digital art because the potential variations boggle the mind. On the other hand, given the very few number of works actually collected, and given their cost compared to works by similarly established artists in parallel fields, I believe that equipment purchase, broadly defined, is worth considering.

If, for instance, a project requires Netscape 4.01 or later with the Flash 5.0 plug-in, there is no reason it wouldn't be possible to store a computer with this and its related configuration. If it also requires a server running Apache 3.02,

Perl 4, etc., I don't think it's unreasonable to have a separate server running for this project that maintains this configuration. Other projects requiring the same configuration could also, in theory, be served from the same machine, but once a new acquisition requires a setup that requires changes to the existing setup, then a new server is purchased ($1,000 plus installation of mostly free software). Eventually, of course, the hardware itself will fail, and it may not be possible to replace it, but at least one has bought anywhere from five to thirty years until more robust solutions need to be implemented.

Because media fail physically and because software and hardware systems change radically, preserving digital media is an eternal migration at this point. There are two main components to the process: refreshing and migration.[30]

Refreshing: Like paper, film, magnetic tape, or any other physical substrate, the media that digital files are stored on, such as CD-ROMs, floppy disks, hard drives, will inevitably fail. Before this happens, it is important to refresh their contents to new storage media—even if the physical format remains the same (i.e., hard drive to hard drive).

Migration: Refreshing moves a particular file—and the format it is encoded in—from one physical storage medium to another. But that is no guarantee that the file itself can be read or executed. Very few institutions can still read Word-Star word-processing files, even if they have been refreshed from their original 5 ¼ in. floppies to brand new DVDs. Migration involves not only refreshing these files but converting them to currently readable formats. Migration is time consuming, and it doesn't guarantee that the formatting from one software format is preserved in the next (for example, current browsers can read and display Jodi's page, but they ignore the blink formatting). Nevertheless, migration is critical for the content of files to remain readable.

Emulation is perhaps best known as a way to use contemporary software, such as a Java applet, to emulate the way older software and/or hardware ran, such as a video arcade game. It is possible to download an applet that allows one to play the very first video game, *Space War* (1962), more or less as it would have been played at MIT, where it was invented, on a time-sharing mainframe computer. The idea with emulation is that if you can encode a way for a contemporary machine to run older software—including a computer's operating system—then you can skip migration, as the original software will always be playable—as long as it has been refreshed and hasn't physically deteriorated.[31]

Documentation, of course, is a critical part of any collection. There are three important strategies regarding documentation of new-media art.

Print it out: We know how to preserve paper. Although it is not common, and we did not do it at the Walker Art Center, if I had to do it again I would print out all of the software instructions, especially the artist's code. It may not

be possible to actually print out the source code of Flash or other proprietary software, but it is definitely possible to print out the lingo script the artist used in Flash. It is not a difficult process, and it adds an extra layer of security.

Document the context: As discussed regarding Wisniewski's *Jackpot*, there is legitimate debate over how much context to try to preserve for any given project. Having collected several pieces that have now lost their original context, I regret not having been more assiduous in documenting, by whatever method possible, materials that might have been linked to the work. This would never be the same as a contemporaneous experience, but it would be far better than another "404 Not Found" message. It is also part of the cultural heritage that institutions can and should preserve to help provide a context so future generations can better understand and, one hopes, experience this important work.

The Variable Media Initiative (VMI): One of the most promising reconceptualizations of collecting, which affects collecting contemporary art in general, not just new-media art, is the Variable Media Initiative originated by Ippolito at the Guggenheim Museum and now the work of a consortium of institutions and funders.[32] At the core of VMI are the twin assumptions that the nature of much contemporary artwork is variable and that it is important to document the artist's intentions regarding that variability as clearly as possible at the time of acquisition. Museums have interviewed artists about their work before, but the VMI is radically explicit about the mutability of much contemporary art and attempts to provide a standard framework for both artists and museum personnel to understand what really matters to the artist for any particular work of art.

> To what degree do knowledge formations and institutions (museums, universities) transform in relation to the unfolding of their emergent subjects (new art) and alter their relationship to all that went before in the history of art and the collections that sediment that history?[33]

Abstract Expressionist painting changed the size of museum galleries. Video installation introduced the black box to the white cube. Examples abound of how contemporary art practice has changed institutional practice at both pragmatic and conceptual levels. Even as institutions begin to collect new-media art more diligently and to concern themselves with its preservation, it is unlikely that every museum will have the resources necessary to fully support its collections. However, because networked new-media art is not dependent on physical location for viewing it is possible for institutions to share infrastructure, such as servers, technical staff, and hosting. It is imperative for museums to find a

scaleable, sustainable solution to issues of preservation if they are going to feel confident in building collections of new-media art. Finding such a solution is unlikely to happen at the level of the individual institution.

Collecting new-media art is first and foremost a curatorial issue. The medium poses challenges to traditional notions of collecting, but not that much more so than other contemporary art. Ultimately, the ability to preserve and conserve new-media art will be irrelevant—at least for museums—unless curators take the first step and begin to collect, critically and assiduously.

NOTES

1. The quotation is taken from Susan Morris, *Museums and New Media Art: A Research Report Commissioned by the Rockefeller Foundation*, October 2001, 4. Available for download at http:// www.rockfound.org/Documents/528/Museums_and_New_Media_Art.pdf (accessed 30 August 2004).

2. For more about the Variable Media Initiative, see the Variable Media Network website at http://www.guggenheim.org/variablemedia/ (accessed 30 August 2004). See the website for the exhibition *Seeing Double: Emulation in Theory and Practice* (2004), organized by the Solomon R. Guggenheim Museum in New York in partnership with the Daniel Langlois Foundation for Art, Science, and Technology at http://variablemedia.net/e/seeingdouble/home.html (accessed 30 August 2004).

3. Kit Galloway and Sherrie Rabinowitz, "Satellite Arts Project," 1977, http://www .ecafe.com/getty/SA/index.html (accessed 30 August 2004).

4. The Rhizome Artbase is accessible to members at http://www.rhizome.org/artbase/ (accessed 30 August 2004). The Ars Electronica archives for the Prix Ars Electronica are accessible online at http://www.aec.at/en/archives/prix_einstieg.asp (accessed 30 August 2004).

5. Correspondence with Shelley Willis, Curator of Public Art, Weisman Art Museum, University of Minnesota, 16 February 2004.

6. Lev Manovich, *The Language of New Media* (Cambridge, Mass.: MIT Press, 2001), 55.

7. David Antin, "Video: The Distinctive Features of the Medium," in *Video Art*, ed. Ira Schneider and Beryl Korot (New York: Harcourt Brace Jovanovich, 1976), 174. See my "Beyond Interface: net art and Art on the Net II," 1998, for further analysis of the idea of distinctive features in relation to new media, http://www.yproductions.com/writing/archives/000190.html (accessed 30 August 2004).

8. Rosalind Krauss, *A Voyage on the North Sea: Art In the Age of the Post-Medium Condition* (New York: Thames and Hudson, 2000), 7.

9. Jim Campbell, "Formula for Computer Art," 1996/2003, http://www.jimcampbell.tv (accessed 30 August 2004).

10. Gregory Bateson, *Steps to an Ecology of Mind* (Chicago: University of Chicago Press, 2000), 457.

11. Melinda Rackham, 17 April 2002, "[-empyre] Forward from ippolito re gift economy vs art market #1," [-empyre-] listserv, http://lists.cofa.unsw.edu.au/pipermail/empyre/2002-April/ 000379.html (accessed 30 August 2004).

12. Interestingly, the contractual agreement between the Guggenheim and Napier does not guarantee that *Net.Flag* will always be on view, but if it isn't via the Guggenheim,

Napier has the right to re-host the work. (Correspondence with Jon Ippolito, 16 February 2004.)

13. Stelarc, "Ping Body," 10 April 1996, http://www.stelarc.va.com.au/pingbody/ (accessed 30 August 2004).

14. Sol Lewitt, "Four Geometric Figures in a Room," 1968, http://collections.walkerart.org/item/object/245 (accessed 30 August 2004).

15. Lisa Jevbratt, "A Stillman Project for the Walker Art Center," 1998, http://www.walkerart.org/gallery9/jevbratt/ (accessed 30 August 2004).

16. Calvin Tomkins, *The Bride and the Bachelors: Five Masters of the Avant-Garde* (New York: Viking Press, 1965), 113–14.

17. Jana Sterbak, "Vanitas: Flesh Dress for an Albino Anorectic," 1987, http://collections.walkerart.org./item/object/957 (accessed 30 August 2004).

18. Yoko Ono, "Voice Piece for Soprano," 2001, http://sonicflux.walkerart.org/ono/index.html (accessed 30 August 2004).

19. Linda Nochlin, "Why Have There Been No Great Women Artists?" *Artnews* (January 1971): 22–39. See also Steve Dietz, "Why Have There Been No Great Net Artists?" 1999, http://www.yproductions.com/writing/archives/000189.html (accessed 30 August 2004).

20. Leo Steinberg, "Other Criteria," in *Other Criteria: Confrontations with Twentieth-Century Art* (New York: Oxford University Press, 1972), 63.

21. Jodi website, nd, http://404.jodi.org/bcd/ (accessed 30 August 2004).

22. Jon Ippolito, 12 April 2002, "Nettime-bold why art should be free 2/3: the digital sanctuary," nettime-bold listserv. See http://amsterdam.nettime.org/Lists-Archives/nettime-bold-0204/msg00403.html (accessed 30 August 2004).

23. National Information Standards Organization, "A Framework of Guidance for Building Good Digital Collections," 6 November 2001, http://www.niso.org/framework/forumframework.html (accessed 30 August 2004).

24. Jon Ippolito, "Ten Myths about Internet Art," 2002, http://www.guggenheim.org/internetart/internetart_index.html (accessed 30 August 2004).

25. Ippolito, correspondence with the author, 16 February 2004.

26. Carl Goodman, correspondence with the author, 16 February 2004.

27. Walker Art Center Digital Arts Study Collection policy.

28. G. H. Hovagimyan, "Art Dirt," http://www.walkerart.org/gallery9/dasc/artdirt/ (accessed 30 August 2004).

29. Friedrich Kittler, "Museums on the Digital Frontier," in *The End(s) of the Museum* (Barcelona: Fundació Antoni Tàpies, 1996), 78.

30. Three excellent articles on the preservation of new media are: Richard Rinehart, "The Straw That Broke the Museum's Back? Collecting and Preserving Digital Media Art Works for the Next Century," posted 14 June 2000, http://switch.sjsu.edu/nextswitch/switch_engine/front/front.php?artc=233 (accessed 30 August 2004); Howard Besser, "Longevity of Electronic Art," submitted to International Cultural Heritage Informatics Meeting, 2001, written February 2001, http://sunsite.berkeley.edu/Longevity/ (accessed 30 August 2004); and Peter Lyman, "Archiving the World Wide Web," in *Building a National Strategy for Preservation: Issues in Digital Media Archiving; Library of Congress*, April 2002, http://www.clir.org/pubs/reports/pub106/web.html (accessed 30 August 2004).

31. Jeff Rothenberg, "Avoiding Technological Quicksand: Finding a Viable Technical Foundation for Digital Preservation," January 1998, http://www.clir.org/pubs/reports/rothenberg/contents.html (accessed 30 August 2004).

32. "Archiving the Avant-Garde: Documenting and Preserving Digital/Variable Media Art," http://www.bampfa.berkeley.edu/about_bampfa/avantgarde.html (accessed 30 August 2004).

33. Barbara Kirshenblatt-Gimblett in "Museums of Tomorrow: An Internet Conference," 2003, sponsored by the Georgia O'Keeffe Museum, http://www.okeeffemuseum.org/cgi-local/ultimatebb.cgi?ubb=next_topic&f=2&t=000019&go=newer (accessed 30 August 2004).

Beyond the "Authentic-Exotic": Collecting Contemporary Asian Art in the Twenty-first Century

Vishakha N. Desai

PRESIDENT, ASIA SOCIETY

Not too long ago, I was invited by one of the leading American art museums to talk to the curatorial staff about the "issue" of contemporary Asian art acquisitions. To my surprise, the talk was very well attended, not only by the staff of the Asian and contemporary art departments but also by members of other curatorial and administrative divisions. That such a museum had to at least think about collecting contemporary Asian art was not in question. There was an intellectual awareness that they could no longer afford to have selective amnesia about the creative expressions in the non-Western world in the twentieth and twenty-first centuries, as had been the case for most of the last century. Beyond that awareness, however, there was no agreement about what the next steps should be. Nor was there a collective sense of urgency about translating that general awareness of contemporary Asian art into action.

I was struck by the questions and the comments: "If we begin to look at contemporary Asian art for acquisitions, we will have to include the whole non-Western world. We simply do not have the resources or the expertise to devote to such an enterprise," warned one contemporary art curator. "Since much contemporary art from the non-Western world is part of the international art scene, but often deals with culturally specific histories, who should have the right to acquire such works? And where should they reside? Since the traditional Asian art curators have the expertise of a particular region, shouldn't they be the final decision-makers in the collection-building process?" Not surprisingly, this was a comment made by a curator of traditional Asian art. Implicit in these statements was uneasiness about the very hybrid nature of contemporary

art coming from Asia and other non-Western regions. It was clear that the cura-
torial divisions established over the last century in America's art museums were
being questioned and that the staff was both unsure and uneasy about con-
fronting the very system that had given them a particular status. It was also
interesting that there was greater willingness to contemplate temporary exhibi-
tions of contemporary Asian work than to think about ways that such art could
enter the permanent collections of encyclopedic museums.

Given the history of American art museums over the last century, it is not
surprising that there should be resistance to the idea of incorporating twentieth-
and twenty-first-century arts of Asia into "mainstream" collections. Up until
the early 1990s, the very idea that there could be contemporary art in Asia wor-
thy of any serious consideration was beyond serious curatorial thinking. This
sentiment was aptly described by the *New York Times* critic Holland Cotter in
1996 in his preview article for the Asia Society exhibition Traditions/Tensions:
Contemporary Art in Asia (fig. 1).[1] "Contemporary art in India? There is no con-
temporary art in India. So an academic friend tartly reminded me a few years
ago. How could avant-garde art exist anywhere in the "timeless" cultures of
what we monolithically call Asia? If it did, it could not be any good. Too West-
ern, or too Asian. Or too little of one or the other."[2] Implied in this comment
are long-held perceptions and practices, related to Asian art on one hand and
contemporary art on the other, that have made it difficult for most art institu-
tions to consider contemporary Asian art in any serious way. One has to go
back to the beginning of the last century, when Asian art collections were being
built at major institutions, to appreciate the depth of prejudices about mod-
ernist and contemporary art in Asia. Warren Cohen has traced this develop-
ment well in his study of early collections of East Asian art.[3] Developed by
individuals such as William S. Bigelow, who sought to find the "essence" of
Japanese art in its earlier incarnations and who considered the modernization
phase of the Meiji period a great degradation of Japanese culture, these early
collectors and curators privileged the premodern artistic expressions of Asia.
For example, when one of these early scholar-curators, Ernest Fenellosa, organ-
ized a series of exhibitions of Japanese art in the 1890s, he began with an exhi-
bition of paintings by the Japanese artist Hokusai, who had become well
known in the West for his prints and who could be seen as a contemporary
artist of the era. Significantly, Fenellosa began with Hokusai both because
he was popular but especially because he wanted to show what he disdained
about the artist and to lead audiences away from the "debased" late work of
Hokusai to the arts that Fenellosa considered superior—those from the early
periods, in which Western viewers could connect with the spiritual dimensions
of Asian art.[4]

Fig. 1. Ravinder G. Reddy (Indian, born 1956) , *Head IV*, 1995. Gilded and painted polyester-resin fiberglass, 47¼ × 29⅛ × 40½ in. (120 × 74 × 103 cm)

Similarly, the writings and curatorial efforts of Ananda K. Coomaraswamy, who also was connected with the Museum of Fine Arts in Boston, contributed to a somewhat essentialist and spiritual definition of Asian art, especially Indian art. For scholars like Coomaraswamy, steeped in the serious critique of the modern age, the notions of spiritual, "non-changing" Asian art provided a much-needed

alternative to the emphatic insistence on individual creativity and temporal change that were part of the early twentieth-century rhetoric about art. While such arguments augmented the status of traditional Asian art in American art museums, they also omitted any mention of the realities of art-making in early twentieth-century Asia. This kind of privileging of the ancient past was an important aspect of the Orientalist legacy, where the "non-changing," distant, and "pure" non-Western civilizations could provide a perfect foil for the dynamic, ever-changing, progressive, and industrialized West and serve to justify the colonial presence of the "superior" West in Asian countries.[5]

In such a dichotomous dialogue, there has been no room for the hybridity that was an integral part of the art practices in most of Asian countries in the twentieth century. Just as the masters of modern art in the West, from Claude Monet to Pablo Picasso, were looking to non-Western art for their inspiration, artists throughout Asia, from China and Thailand to India and Indonesia, were engaged in art-making that included Western techniques as well as culturally specific nationalist agendas.[6] However, in the Western discourse, much of this development remained ignored for most of the twentieth century. A few twentieth-century Asian works entered some collections, but they were of no importance either to Asian art departments or to the twentieth-century sections of major art museums.[7]

In the last fifteen years or so, there has been a dramatic change in the status of contemporary Asian art. Major exhibitions have been presented throughout the U.S., and a select number of Asian artists have achieved star status with solo exhibitions. (fig. 2).[8] In large international shows as well, Asian artists are now often included, though this usually means that a small number of artists are repeatedly invited and they are the only ones who get seen on the global circuit. Nonetheless, there is still no corresponding activity in the area of acquisitions, at least not at the same pace. In the encyclopedic museums, often there is the question of territoriality, as mentioned earlier. Who has the expertise, the authority, and the funds to buy such works? These questions, rather than instigating a new process, actually become impediments to acquisitions.

In modern and contemporary art museums, at times there is prejudice born of ignorance. I remember well a discussion with a colleague in a major New York institution during the mid-1990s. We were discussing art trends in Southeast Asia, and he said there could not possibly be anything of importance coming from that part of the world. After all, if there were anything of value, he would have known about it! The basic assumption was that if he had not seen it in New York, it was not worth looking at, or worse yet, it couldn't possibly exist.

Such prejudices notwithstanding, there is some forward movement, especially at museums of modern and contemporary art. Several collectors have

Fig. 2. Xu Bing (Chinese, active United States; born 1955), *Book from the Sky*, 1987–91. Installation with hand-printed books, dimensions variable. Installed at the North Dakota Museum of Art, 1992. Collection of the artist

amassed significant collections of contemporary Chinese and Japanese art and have given some works to museums.[9] Some institutions have bought individual works of significance by Asian artists, and others have made a commitment to enhance their collections by identifying artists with whom they can develop long-term relationships and purchase works in some depth (fig. 3).[10] Sometimes this is done at the suggestion of a director; at other times, a curator is committed to the idea. Once in a while, a collector/trustee makes a recommendation. In this sense, the pattern of building public collections through gifts, customary for American art museums from their inception, continues.

It is interesting that, in terms of exhibitions as well as acquisitions, there is a considerable bias toward contemporary Japanese and Chinese art, with some exceptions for artists of South or Southeast Asian origin. To a great extent, patterns of acquisitions are also tied up with the gallery system. Thus, it is not surprising that Asian artists who are picked up by major "mainstream" art galleries also end up in major museums. Since most of the major galleries that have shown Asian artists tend to focus on Japan and China,[11] the fact that these artists also fetch much higher prices than the artists shown in ethnically specific galleries says volumes about the economic ecology of contemporary art in the U.S.

Fig. 3. Cai Guo-qiang (Chinese, active United States; born 1957), *Borrowing Your Enemy's Arrows*. Originally commissioned by Asia Society, New York, for the exhibition Inside Out: New Chinese Art, 1998. The Museum of Modern Art, New York

As museum boards become more diverse, and as these institutions make more of an effort to include new, immigrant communities, further complexities arise. For example, many of the South Asian immigrants to the U.S. are beginning to come into leadership positions in various professions. They are also becoming a major force in the world of collecting, especially contemporary Indian art. Auctions of modern and contemporary Indian art have consistently broken records, primarily because the works by established artists are gobbled up by the Indian diaspora community.[12] As museums try to engage these new collectors, the latter, in turn, try to influence the institutions to look at modern and contemporary Asian art. However, these groups often collect the kind of work that has a strong resonance in the home country but does not fit the notions of strong contemporary art as defined by curators in American museums. Consequently, such pressures actually backfire and tend not to result in new purchases. These new stakeholders are also not always cognizant of professional curatorial practices and feel that they should have some recourse if their ideas, and their objects, are not accepted.[13]

At the same time, these new immigrant leaders can also raise useful questions about acquisitions and encourage the institutions to think seriously about acquiring non-Western contemporary art. This was made evident to me recently when a major Chinese-American civic leader on the West Coast was asked to join the board of a major art museum by a prominent collector of contemporary Western art. The Chinese-American leader pointed out that he was struck by the museum's lack of any contemporary work by an Asian or Asian-American artist. He turned down the request to join the board. The more such leaders in powerful positions demand support for contemporary artists, the more visibility the artists will set at mainstream institutions.

As we contemplate building major collections of modern and contemporary Asian art, it is useful to compare the current context for collecting with that of the last century. At the turn of the twentieth century, when large collections of traditional Asian art were being formed by American collectors (and by extension, by American art museums), most Asian countries were not in the position to counter or combat wholesale transfers of their cultural heritage. At the same time, as an integral part of nascent nationalist aspirations, twentieth-century works by major Asian artists *were* being collected in the region. These "modern" works formed the beginnings of national art galleries throughout Asia.

With the rise of economic power in many Asian countries, there continues to be a robust and flourishing market for twentieth-century modern masters in Asian countries. Thus, such modernist artists as Affandi (Indonesia), Fernando Amarsolo (the Philippines), and Amrita Sher-Gil (India) are well represented

in Asian collections and continue to fetch high prices in regional auctions as well as in sales that cater to the diaspora market. Consequently, American museums potentially interested in building comprehensive collections of modern and contemporary art need to pay closer attention to developments in Asia and cultivate Asian private collectors as potential donors.

The current reality, however, suggests that American museums are more likely to first acquire contemporary Asian art that is being circulated on the international art scene. Works by artists such as Xu Bing, Cai Guo-qiang, Tatsuo Miyajima, and Ravinder Reddy are being acquired by American museums, typically by contemporary art museums or departments, but there is almost no interest evident in the acquisition of twentieth-century Asian masters. There are several reasons for this pattern. First and most obvious is the greater familiarity with contemporary artists; there have been far more exhibitions of contemporary art in the West than those dealing with earlier artists.

At a more complex level, we have to look at the patterns of globalization and the visual language used by contemporary Asian artists who are prominent in the international arena. Most create works with a successful mix of culturally specific references and international formal vocabulary. In other words, they give a nod to their culture of origin while simultaneously speaking to the broader contemporary art world. It is also significant that most of them arrived on the world stage just as postmodern discourse questioned the very notion of modernist centers and as multicultural debates began to critique prevailing artistic practices. Thus a number of factors, ranging from globalizing patterns and the relatively easy flow of information and artistic practices to the decentering of Western artistic hubs, have made it possible for at least some contemporary Asian artists to be collected by American museums. Another factor may be that many of the contemporary artists who are successful in the international art world did not have a domestic market, or at least not until they began to be collected in the West. This has made it easier for Western dealers and other interested parties to develop direct relationships with artists.

The West's lack of interest in most twentieth-century Asian art can also be attributed to the fact that the myth of the avant-garde, associated with the development of modernism, is hard to reconcile with artistic patterns in twentieth-century Asia. As John Clark has pointed out in his seminal work, *Modern Asian Art*, modernist discourses in Asia, especially during the first half of the twentieth century, are more accurately situated in broader cultural histories and in the development of nationalism than in the more typical modernist narrative that privileges the struggle of the individual creative spirit against society. Even great national heroes who helped usher in a modernist era in individual Asian

countries are perceived only as pale reflections of Euro-American artists and have been readily dismissed or ignored.[14] If we are to create a full narrative of the development of modern and contemporary Asian art, understanding the specific twentieth-century histories of Asian countries will be crucial to a less prejudiced reading of earlier masters. As has been the case with contemporary art, more sustained efforts may be required to develop exhibitions and scholarship before institutions will focus on acquisitions of early-twentieth-century Asian art.

Traditional curatorial divisions, especially in encyclopedic museums, have placed Asian art apart from that of other areas of the world. In academic circles as well, "Asian art" generally means art from the geopolitical region that includes South Asia, Southeast Asia, East Asia, and often Central Asia. In the context of contemporary art practices as well as globalization trends, it is important to recognize that arts with an "Asian" touch or by "Asian" artists can be found all over the globe. For example, artists such as Xu Bing, Wenda Gu, and Navin Rawanchaikul go back and forth between their countries of origin and their current countries of residence. Should they be seen as diaspora artists or as Chinese (in the case of Xu Bing and Wenda Gu) or Thai (in the case of Navin) artists? Or should they simply be included in the international contemporary art section? Even immigrant Asian-American artists, such as Yong Soon Min, signify the problems of classification. Born in Korea, Yong Soon Min has lived in the U.S. for most of her adult life, and her work has often addressed issues of Korea and Korean identity in the diaspora.

Should the materials of these works be organized by ethnicity, subject matter, or technique? For example, if an artist uses a "traditional" technique, the work would likely go to the Asian art department, but if a work is created in an "international," Westernized style, it would usually be placed in the contemporary art department. Such categorizations could apply to non-Asian artists as well. A Euro-American artist using Chinese ink style, could be placed in the section with Chinese ink paintings. For contemporary art museums, such distinctions would be less of an issue, since their collections are typically organized more along chronological lines and less according to geopolitical divisions. The fact remains that, given the mutability of current art practices and the fluidity of migration, the very meaning of the word *Asian* in "Asian contemporary art" begins to get more complex, demanding novel approaches and unorthodox solutions.

Pico Iyer, a noted author who has poignantly described the predicament of "global souls," has written that the notions of "home" or "cultural identity" or "Asianness" are no longer fixed in time or place. "For the Asian Diaspora, 'home,'

like everything in the modern floating world, has gone global and fragmented, portable and underground."[15] We could easily apply Iyer's description of "home" to contemporary art practices, which increasingly demand more imaginative and less linear ways of understanding creative work.

Let us go back, then, to the beginning of this discussion and reconsider the questions raised by those museum colleagues. To address the issue of where modern and contemporary Asian works should reside in an encyclopedic museum, or who should have primary responsibility for the acquisitions in the first place, it may be useful to develop a fresh, hybrid approach that parallels the reality of the works themselves. Recognizing that contemporary Asian art is simultaneously situated in a specific culture of Asian origin and in the Western-ized international culture, Asian scholars and contemporary art specialists may need to come together to consider an acquisition. How refreshing it would be if two different curatorial departments combined their scholarship and their acquisition funds to purchase contemporary Asian art. Similarly, it should be possible to house such works in either of the two departments, depending on the medium. For example, Wenda Gu's earlier calligraphic scrolls might be better kept under the care of the Asian art department. But the photographs and video works by another Chinese artist, Zhang Huan, might be kept in the photography or contemporary art section. It would depend on the scholarly expertise of the curators and the conservation needs of the works.

For museums of modern and contemporary art, new patterns of acquisition will require that their curators have greater exposure to non-Western parts of the world and that, as they hire the staff to prepare for the twenty-first century, they give special attention to young people who can combine knowledge of Western contemporary art with studies of culturally specific narratives. An informal survey of topics of doctoral theses in Asian arts at major universities reveals that there is a sharp increase in students looking at both twentieth-century and contemporary art practices in Asia. This bodes well for the future.[16]

Ultimately, the biggest obstacle may be the lack of funds to create the com-prehensive collections of twentieth- and twenty-first-century Asian art needed to make serious study of the material possible. Again, it is exciting to think about new models of acquisition and study. It should be possible for a select group of interested museums to come together and make a commitment to acquire works jointly, as well as to promote exhibitions and studies in the field.[17] Such a model will require that institutions go beyond the usual rivalry and oneupmanship. It may not be easy, but it could be a refreshing new way of operating that befits the complexities of the twenty-first-century world and art practices. And it may be the only way to close the gap in our knowledge of Asian art of the past century and to catch up on its future developments.

NOTES

1. Holland Cotter, "The Brave New Face of Art from the East," *New York Times*, 29 September 1996, Arts and Leisure.

2. For further discussion of the reception of contemporary Asian art in the United States, see Vishakha N. Desai, "East in the West: Presentations of Contemporary Asian Art in the United States," in *Asian Contemporary Art Reconsidered*, a symposium publication, organized by the Japan Foundation Asia Center, Tokyo, 1997.

3. Warren I. Cohen, *East Asian Art and American Culture* (New York: Columbia University Press, 1992).

4. Cohen, *East Asian Art*, 41.

5. For further discussion, see James Clifford, *Predicament of Culture* (Cambridge, Mass.: Harvard University Press, 1988); and Edward Said, *Culture and Imperialism* (New York: Alfred A. Knopf, 1993).

6. For a more detailed discussion, see John Clark, *Modern Asian Art* (Honolulu: University of Hawaii Press, 1998).

7. When I worked at the Museum of Fine Arts, Boston, in the 1980s, I came across some accession records for works on paper by Gaganendranath Tagore and Nandlal Bose, important figures in twentieth-century Indian art. When I tried to locate them, it was not clear whether they were in the Print Department or the Asian Department. No one had tried to see them in more than seventy years, and they remained in a small box that took me the better part of a month to locate. When such works did enter the collections of American museums, they were normally acquired as gifts, almost never as serious purchases.

8. Asia Society has played an important role in the presentation of such exhibitions. Some notable exhibitions of modern or contemporary Asian art are Against Nature: Contemporary Japanese Art, curated by Kathy Halbreich, et al., Grey Art Gallery, New York, 1989; Scream against the Sky: Japanese Art after 1945, curated by Alexandra Munroe, Yokohama Museum of Art, 1994–95; Traditions/Tensions: Contemporary Art in Asia, curated by Apinan Poshyananda, Asia Society, New York, 1996; A Century in Crisis: Modernity and Tradition in Twentieth-Century Arts of China, curated by Julia Andrews, Solomon R. Guggenheim Museum, New York, 1997; Inside Out: New Chinese Art, curated by Gao Minglu, Asia Society, New York, and San Francisco Museum of Modern Art, 1998; Transience: Chinese Experimental Art at the End of the Twentieth Century, curated by Wu Hung, David and Alfred Smart Museum of Art, Chicago, 1999. There have also been exhibitions focusing on individual artists, primarily Chinese artists who reside abroad, and Asian artists are now being included in larger international shows.

9. Kent and Viki Logan have given more than forty works of contemporary Chinese and Japanese art to the San Francisco Museum of Modern Art. Richard Cooper in Chicago is collecting contemporary Chinese art with the intention of giving it to a museum.

10. For example, the Museum of Modern Art, New York, purchased Cai Guo-qiang's *To Borrow the Enemy's Arrows*, which was commissioned by the Asia Society for its exhibition Inside Out: New Chinese Art. The Walker Art Center in Minneapolis has made a commitment, as part of its overall goal to become more global, to purchase works by Asian artists, just as it tries to include them in its ongoing program of exhibitions. The most notable development in the acquisition arena has been at the Queensland Art Gallery in Brisbane, Australia. Along with presenting the Asia Pacific Triennial exhibitions, the gallery has amassed one of the most significant collections of contemporary Asian art. It now has more than 800 works.

11. In 2002 a preliminary study of contemporary Asian art in New York during the previous decade showed clearly that there had been exponential growth in the representation of Asian and Asian-American artists (from 238 in 1992 to 993). But most of the artists picked by major art museums, contemporary or encyclopedic, were represented by such mainstream galleries as Max Protech, Deitch Projects, Jack Tilton, and Barbara Gladstone. See Melissa Chiu, Miwako Tezuka, and Linda J. Park, *Asian Contemporary Art: The Last Decade, 1992–2002: A Preliminary Study of Contemporary Art Trends in New York* (New York: Asia Society, 2002).

12. See recent sales of contemporary art from Sotheby's and Christie's for better understanding of the diaspora market. See, for instance, Sothebys 1998–99, and Christies, 2002–3, results.

13. One of the smaller New York–area institutions organized a show of contemporary Indian art from local collections and found that they were lobbied hard to include works owned by collectors who had supported the show. There was no awareness or understanding that such efforts could be construed as conflicts of interest and that museum curators actually need to exercise independent professional judgments in organizing exhibitions.

14. For a detailed discussion of the avant-garde tradition in the Asian context, see Clark, *Modern Asian Art*, 220–26.

15. Pico Iyer, "The Asian Journey Home," *Time* (Asia), 18 August 2003.

16. Interestingly, there is greater openness among senior academics about the need for more studies of modern and contemporary Asian art, even if they feel somewhat ill-equipped to help their students. Many senior curators of Asian art, on the other hand, feel more threatened by the new developments.

17. In the contemporary art world, there have been instances of joint acquisitions of major works by such artists as Bill Viola.

The Unconscious Museum: Collecting Contemporary African Art without Knowing It

Pamela McClusky

CURATOR OF AFRICAN AND OCEANIC ART, SEATTLE ART MUSEUM

There was no ten-year plan to collect recent African art at the Seattle Art Museum as the twentieth century turned. Nonetheless, collecting happened. As international art practices shifted and as art historical categories were being pushed to accommodate them, new choices for how to collect emerged. A look at these shifts and stretched categories is coming, but first is a case in point.

Two shipments of art were received at the Seattle Art Museum. Shipment number one arrived in 1999 in a large crate that conformed to the standard for international shipping practices: it was wood, painted yellow with bolted fixtures and a return address from a gallery in Chelsea. Inside were four mannequins without heads adorned in flamboyantly colored and impeccably tailored costumes. A receipt listed the title as *Nuclear Family* (fig. 1); indicated the artist's name, Yinka Shonibare; and included instructions for installation. The entire shipment was spotless and odorless, the costumes in pristine condition with not a thread out of place. As a result, the curator of contemporary art was not required to consult on any aspect of its receipt.

Shipment number two was hand-delivered in 2001 by an agent (Andrew Frankel) for a group of artists, Ayan Agalu (May the Spirit of Drumming Carry One Aloft). It consisted of several irregularly lumpy sacks (once used to ship rice in Nigeria) tied up with multicolored cloth strips. Eyebrows raised, members of the staff asked if this was the art or if the strips needed to be cut open to reveal something else. (Experienced art handlers assume nothing.) The curator of African art helped the agent cut the sacks open. Out tumbled an array of

Fig. 1. Yinka Shonibare (British-Yoruba, born 1962), *Nuclear Family*, 1999. Mixed media installation. Seattle Art Museum. Gift of Agnes Gund and Daniel Shapiro in honor of Bagley and Virginia Wright

costumes, many sewn out of the very same type of cloth as the first shipment. However, most had no resemblance to any garment known to fit humans. A few came with internal armatures that enabled performances of expanding height. Others were two-sided and used to perform complete inside-out transformations of cloth. As the unpacking evolved, the evidence of wear and tear on the costumes became clear. Before long, an overwhelming aroma of sweat permeated the air. It became apparent that a magenta velveteen body suit was the prime source of the odor. Questions circulated about the long-term care and handling of textiles with this degree of accumulated perspiration. No written instructions for installation were provided. Andrew Frankel helped sort out the costumes and assign translated names such as *Turning around Cloth* (fig. 2), *The Lengthening Thing, The Owner of the Mouth That's in Constant Celebration,* and *Wife.*

Two shipments of art enter the museum through different curators, each with a different agenda. The curator for contemporary art had been given a fund to honor a couple famous for their appreciation of challenging modernist aesthetics.[1] A glimpse of Shonibare's unusual family in Chelsea is enough to convince

Fig. 2. Ayan Agalu (Nigerian, c. 1950s–1990s), *Egungun (Beings from Beyond) Costumes: Egun Posada (Turning around Cloth)*, 2001. Appliqued broadcloth. Seattle Art Museum. General Acquisition Fund

the curator that this is a fitting tribute to courageous patronage, and he asks the dealer to send the assembly to the museum. The curator for African art is trying to collect a set of complete costumes worn in masquerade performance. When Ayan Agalu, a troupe with whom the curator had worked in Erin Osun, Nigeria, in 1990, plans to visit as part of an international tour, negotiations begin. A commission is placed under the direction of Lamidi Ayankunle, the leader of Ayan Agalu. He agrees to have the costumes created and blessed in Erin Osun so that the human carriers are able to become repositories for the spirits of returning ancestors. He oversees their use in performances across the United States. Once the tour is over, Mr. Ayankunle packs up the costumes in a bag, and the agent brings it to the museum.

Two art acquisitions then find their way into museum classification and presentation. Shonibare's *Nuclear Family* enters the database under the artist's name, with his nationality as British (since place of birth is thought to determine nationality). Ayan Agalu's costumes enter the database as "Nigerian, Yoruba culture," with the overall title of *Egungun (Beings from Beyond)*, and the curator of

African art begins a process of documentation. Interviews are taped with the sixteen members of the group under the direction of Lamidi Ayankunle. Performance recordings are arranged, translations of the interviews are reviewed with different Yoruba speakers, and each step is double checked with their agent.

Both sets of costumes are placed in an exhibition in 2002 that explores notions of collecting and narrating art.[2] *Nuclear Family* is set on a platform specified by the artist, with the family members all turning toward each other as if in conversation (without heads). The *Egungun* costumes take the appearance of an otherworldly family, with a video projection of one of their performances as a backdrop. Written profiles of Shonibare and Ayan Agalu are generated. An audio tour provides interviews with the artists. In his comments, Shonibare clarifies that he considers himself British-Yoruba, that the headless mannequins are a "joke about the French revolution and the English aristocracy," that the cloth is "made in England and Holland, but has become a way of celebrating new African nationalism." He also explains why the family is wearing outrageously colored Victorian outfits and offers numerous other insights about his parody of a conventional family.[3] Ayankunle speaks about how he is "from the house of Oje, as is my mother, my father, as well as my great great grandmothers and my great great grandfathers." He describes his family troupe as being "trained in the history of each town that makes up the Yoruba kingdom . . . and careful to wear masks because they may expose some not so funny facts." He concludes, "We come from a culture that is rich, deep, and with a sweeping spontaneity."[4] Through this installation, audiences see how two artists who both speak of themselves as Yoruba use the same cloth in drastically different costumes.

Nuclear Family doesn't smell; *Egungun* does. Why bring this up? Crudely put, the smell serves as a reminder that a first impression of this duality may be seen as hip versus hick, urban versus rural, individual versus communal art. As such, the smell signals the need for a museum to help audiences leap over the swamps of stereotypes and think carefully about art in its original context. In the city of Erin Osun, Ayankunle is an artist whose performances unmask the corrupt with satire and metaphorical uses of drumming speech. While he oversees the intensive training of drummers and dancers whose skills must be maintained, he also watches out for changes in the power structures within his community. His messages also come through association with the *Egungun*—as witnessed during the appearance of *Egun Posada* (*Turning around Cloth*). He commands their entrance through drum language, and their ambiguous bodies step high until his drums accelerate. Suddenly, they bend forward and peel off their backs, eventually turning completely inside out without exposing any human form beneath. This confirms that beings who are not tied to human limitations are present. A review of perplexing personalities—like the person whose mouth

is in constant celebration or the woman whose vanity disrupts her maternity—are then scrutinized. Physical exertion is essential to the performance, and sweat is its signature. Through getting to know this work, more ideas about the provocative Yoruba core of Shonibare's family come to light. Deposited in the midst of a general art museum, they shout back at the Victorian era—at its usurping of people and resources from colonies, at the ornately decorative cocoon of status, at the evolution of a stiff social hierarchy and the insularity of the nuclear family. Skilled use of satire permeates both works, and each finds novel ways to focus on the intersection of past and present.

Nuclear Family and *Egungun* challenge categories and so reflect the creative questioning that recent African art has generated. Exhibitions are often cited as the benchmarks of this creativity, and a brief look back reveals the range of opinion that has surrounded them. A heavy blow to the presumptions of modernism was struck when the Museum of Modern Art in New York unveiled Primitivism and Modern Art in 1984. That a museum would reinforce the outdated notion that African and Oceanic art was a voiceless, anonymous enterprise in opposition to progressive modernism sent shockwaves through art historical circles. Magicians of the Earth in 1989 at the Centre Pompidou in Paris unleashed a fury of debate about just who decided what was magic and what was calculation—and in what context. Africa Explores: Twentieth-Century African Art, organized by the Center for African Art in New York in 1991, established a framework for artists of different schools and orientations. Africa: Art of a Continent, assembled by the British Museum in 1995, aired two premises. One was the goal of comprehensive collecting—looking at Africa as a Cairo-to-Capetown, Asante-to-Zulu survey (an approach many regarded as one last measure of colonial domination.) It also gave sharp focus to a long-lingering prejudice among many collectors and museums in favor of an art of the pure past—reinforcing the idea that African artistry had climaxed in the era of traditional culture but was corrupted by contact with the West.

Eyes turned toward South Africa as the 1997 Biennale in Johannesburg became a beacon of decisive change. Fueled by the recent toppling of the last minority government in Africa, the Biennale brought together new notions of civic engagement, of exhibitions as laboratories for ideas, and encouraged the use of art in unexpected places. It became the arena for new curators led by Okwui Enwezor to dismantle as many presumptions about Africa as possible and to change the cultural landscape from nationalistic to global in scope. Their reviews of what was cutting edge became exemplified in the journal *NKA*, numerous exhibitions, and publications.[5] Agitation for change has filled many pages; for instance, Olu Oguibe indicted the illusion of a cyberutopia, calling for the awareness of the designation of PONA, or people of no account.[6] In the

Short Century exhibition of 2001, a vision of artists as investigators of the governments, economies, and social processes of their time was on full display. By 2002 Enwezor's position as director of Documenta 11 put him at the top of a pyramid of decision making about what contemporary art was seen—art not only from Africa but from the whole world.

It has been a long decade of extraordinary exhibition effort, perhaps coming close to fulfilling the artist David Hammons's recommendation that, "We need parades, elephants, balloons, big bands! Medicine shows! Sky writers! That's what we need, sky writers!"[7] Indeed, Enwezor is the sky writer for contemporary African art. Traversing continents, constantly collaborating and unveiling new platforms, he has innovated an unprecedented sequence of exhibitions. But, just as there is Enwezor, there are the rest of us—curators who are a bit more earthbound, predominantly non-African, working within non-African museums, attracting largely non-African audiences, but trying to turn no audiences away. There is also the factor of approaching audiences whose minds have been destabilized by visual assaults from reports about recent African history. During the decade just described, these have included genocide in Rwanda, warfare in Sudan, atrocities in Sierra Leone, rebellion in the Côte d'Ivoire, a dissolving government in Liberia, turmoil in Zimbabwe, drought in Ethiopia, AIDS across the continent in epidemic proportions—and the list continues. Horrifying images play on, for some people crowding out the willingness even to consider African creativity. Exhibitions counterbalance the desperate news, but cannot keep it completely at bay.

While the exhibition circuit has been representing recent African art, the collecting arena has hardly kept pace. Hard-earned visibility has been established at the Venice Biennale and other exhibitions around the world, but how much patronage results from that attention, particularly in the United States? Only one position in the entire country has been designated as a curator of contemporary African art—at the National Museum of African Art in Washington, D.C. That position generates the most extensive collecting in any public museum here.[8] Artists have numerous champions in print, but not in patronage (again, this is primarily the case in the United States). When museum patronage does occur, it is most often in the form of commissions for temporary installations, residencies for a set period of time, or inclusion in an exhibition—not purchases for the permanent collection. As a result, vehement rhetoric flourishes. There is ongoing debate about how a museum decides who is the perfect African to exhibit and collect. Indeed: "Can anyone be enough of an authority on Africanity to authenticate what or who qualifies as African?"[9] Or, as Simon Njami summarized: "This domain has gradually turned into a huge strategic

absurd battlefield where all kinds of mercenaries and adventurers rage."[10] With dispute so prevalent, how does one collect?

As stated earlier, there was no ten-year plan for the African collection at SAM. Collecting a continent is hardly possible. Africa's eight hundred language groups and fifty nationalities defy a homogeneous approach. Initially, exhibitions were catalysts, putting new artists in the spotlight for consideration. *Africa Explores* provided a survey that encouraged patronage for newly recognized artists—among them Kane Kwei, Seydou Keita, and Chéri Samba—each of whom had art purchased for the museum. All three initiated artistic styles in response to the needs of their friends, families, and communities. Kane Kwei's sculpture originated in a carpenter's shop as a provision for a common need—to create a memorable funeral. His grandmother's dream had been to fly in an airplane, and so when she died, he carved one to take her out in imaginary flight. The notion of a functional container that paid a visual compliment to the life of a revered relative struck an immediate chord of appreciation in Ghana. Kwei's sculptures were unique hybrids, being both familiar in subject and novel in function. After a Mercedez Benz coffin was on display in New York, it was selected for donation by two collectors of African sculpture. Through this role-playing switch, a coffin initiated SAM's contemporary African collection.

Corruption was the focus of the next purchase. The painter Chéri Samba offered another mix of recognizable imagery put to new uses. He set out to cast a spotlight on contradictions that permeated Kinshasa, the capital of the Democratic Republic of the Congo. In the 1980s he created an artist's persona that suited his time and place. Calling himself Chéri (dear) signaled that he was a *sapeur*, or a member of SAPE, Société des Personnes Élégantes, or elegant people who were endowed with charisma and confidence.[11] In this persona, he loaded his paintings with indictments of human folly and misery. Staging imaginary encounters between people, he laid out a host of issues: malaria, hunger, public roads, the morality of churchmen, the fight against AIDS. His painting *Les Années Nineties* was purchased by the museum in 1993. In it, his proclamation that "the Western World now accuses us of corruption while it is they who have implanted these values here"[12] is played out by two characters. The first is a dictator, pockets stuffed with cash, who turns to talk to the second, a Euro-American wearing a letter jacket and carrying a briefcase. Implied is the story of a last payment to the dictator by a Western offical whose stance indicates that he's no longer interested in Africa and is now moving on to the crisis of the day, somewhere in Eastern Europe. It is a painting that indicts the kleptocratic government of then Zaire and simultaneously questions Euro-American indifference to business practices that sustained that government.

As a prophecy of the 1990s, it provides a harsh reality check of inequities between continents.

With many choices of African art to collect and little funding to do so, an experimental installation was devised later in the decade at SAM. Entitled *Passion for Possession: Visitors Buy African Art*, it filled a gallery with nine different potential ways to spend money from a deaccessioning effort. The choices were a strategic spread, balancing several new arenas for collecting with those that were more established. Visitors were asked to select which art or creative process they deemed most vital for future viewing in the museum. Did they want

1. the vision of an artist to confront controversy,
2. a survey of the current African carving industry,
3. a monkey mask from the Dogon of Mali,
4. etchings that encourage remembrance of apartheid,
5. documentation from archives assembled over two generations,
6. a rickshaw driver's costume from South Africa,
7. photographs of Africans by Africans,
8. flags that fight proverbial battles,
9. four hundred male figures alluding to the brutal conditions of the slave trade?

Each day for a year, visitors were transformed into museum patrons with $10,000 to spend, weighing what appealed to them as individuals against what an institution should represent. Visitors marked ballots with an explanation of why they made the choice they did. Votes and comments were continually tallied and updated for visitors to see. The contemporary pieces were the most popular, and comments by their many advocates transformed the balloting into a reflection of the visitors' serious thought. Six *Apartheid Scrolls*, by Rudzani Nemasetoni (etchings based on his father's passbook), and six photographs by Malick Sidibé and Seydou Keita were acclaimed. However, the choice that received the most votes was an installation by Marita Dingus entitled *400 Men of African Descent* (fig. 3). The label stated: "Four hundred miniature headless bodies made out of rags may seem playful. Zipper tops, Christmas light bulbs, and dangling threads are casual in form, but their repetition is obviously a conscious statement. In fact, *400 Men* was inspired by the artist's visit to Elmina Castle, a Ghanian fort where slaves were stored and loaded into ships. Visitors to Elmina witness rooms where two hundred women and four hundred men were kept, often for months. Small and stuffy, the rooms are a haunting reminder of a concentration-camp existence. Dingus talks about repetition as a form of prayer. She spent one-and-a-half years on this assembly. It twists a playful first impression into a serious vision of a disturbing historic episode."[13]

Fig. 3. Marita Dingus (American, born 1956), *400 Men of African Descent*, 1994. Multimedia installation, 9 ft. 11 in. × 21 ft. 7 in. (3 × 6.6 m). Purchased with Funds from Deaccessioned African Art

In ballots cast for the *400 Men*, comments included the following: "It seems at first funny and trivial. I overheard a young girl say something about Barbie dolls. But when you look closely and note that each of these is unmistakably male and when you read the explanation, the power of it and the tragedy of it strike you very strongly. Thanks for asking our opinions." "Makes a statement

without preaching." "The work has an emotional impact regarding lessons we should not forget or repeat."[14] As a result of this public vote, *400 Men* entered the collection in 1998. It turned the selection from art being by an African to being about an African issue that has a profound relation to American life.

The Contemporary Art Department later found the funds to purchase photographs by two Malian photographers: Seydou Keita and Malick Sidibé. Several collectors vied for the opportunity to buy other choices. Another gift to the collection came from the selection. As an effort to involve public participation, this experiment laid out a more transparent process for museum collecting than ever before. It prompted further inventive exchanges with Kenya and South Africa and later was echoed by a collecting consortium.

In a parallel to the two contrasting works of Yoruba art described earlier, two purchases said to be Kenyan occurred at SAM in 2001 and 2002. A young man, Kakuta Ole Maimai Hamisi from Kenya, introduced a new process for collecting based on his critique of museum practices. After looking through storage rooms filled with African art, and at publications about his own culture, he began reacting to the voyeuristic approach. His outrage was audible when he saw illustrations of Maasai morans, whom he asserted would never have allowed such images to be taken if they had known how they would be used. Searching through books, he found not one moran mentioned by name, and few images that went beyond safari clichés. From this experience, he formulated a question: "How would Maasai collect Maasai art?"

Given the lack of a cash economy in his home base of the Merrueschi community, a proposal was formulated for an exchange that would involve no individual profit. He returned to Kenya with enough funds ($10,000) to build and equip a one-room primary school, a project that the Kenyan government and missionary organizations had promised but never delivered. A month of intensive effort resulted in a room of concrete blocks arising for everyone to witness, with a Maasai instructor ready to teach several grades. In return, an open call was issued to members of the community to donate art for the museum. Hamisi had to explain what a museum was. "I called it a place where *wazungu* (white people) keep things from around the world. That I had been to this place in Seattle where they had some Maasai things. They wanted to know what Maasai would take them there. This is a place where tourists don't stop so they don't know how that can happen."[15] Each "age set" responded with different types of donations, and Hamisi documented each artist or owner who contributed and recorded his or her comments.

A few months later, he brought in an aromatic bundle that was tied up with strips of rubber cut from discarded inner tubes. Wood smoke smells permeated the museum's storage rooms as the art was unpacked. When an art handler

playfully asked where the barbeque was, Hamisi replied with assurance, "It's not a barbeque, it's my home." He then curated the collection by overseeing each step of its presentation. Objects entered the database with an artist's name and an explanation of the work's use and aesthetic orientation. Color choices, mount orientation, audio recordings, video and website production were all enacted under Hamisi's scrutiny.

Another version of what could be called Kenyan art came in 2002. It arrived in a pristine crate from London. Entitled simply *Vessel*, with the artist's name Magdalene Anyango Namakhiya Odundo, it was entered as a sculpture by a Kenyan, since that was her place of birth. However, during Odundo's residency at the museum, she shared her observations about vessels of antiquity as well as ceramics from Pueblo mesas, Japan, and England. References to African pottery mixed in with her exploration of aesthetic premises, regardless of their cultural source. Stating that, "It's what you do not put in the piece that makes the piece,"[16] and that she tries to make the most of the hint of suggestion, Odundo creates timeless shapes. In forging her own path through a multitude of influences, she has encouraged recognition of evocative cultural fluidity.

Extreme dichotomies of national identity continue. Members of the Merrueschi community and Odundo may all have been born in Kenya, but their art reflects largely different world views and experiences. This same pattern emerged in the selection of two works of art from South Africa. Both were based in artistic activism but took entirely different routes in coming to the museum.

Leftover latex wall paint (collected from the museum's design department) was the medium for the first contemporary art work from South Africa, acquired in 2001. While the medium was straightforward, the project set out a complex agenda for a mother and daughter on their first travels away from their home in the Ndebele region. Ndebele women painters are muralists of international renown, who formerly used wall painting to assert their identity and express their unwillingness to submit to the National Party Government's homeland assignment and apartheid policies. Brilliant facades of intricate patterning declared their resiliency in the midst of a barren landscape that had been forcibly made their home.

Mrs. Nythela Ngodela and Zodwa Mahlangu were invited by Evergreen State College, in Olympia, Washington, to enact a public art project that involved not only wall painting but also extensive community relations.[17] Mrs. Ngodela was a master painter selected by the new government for this unique assignment. When she, her daughter, and a translator arrived, they found a community waiting for a chance to learn not only about wall painting but about how to use art to make symbols of identity. Workshops were given to determine how everyone from Vietnamese immigrants to civil rights activists, from gang members

to medical doctors, could add a visual component to their walls. That had been a daunting assignment, so Mrs. Ngodela was openly relieved when a blank wall and house paint were all that she was asked to deal with at the Seattle Art Museum. She supervised a crew of assistants, experienced her first stay in a hotel, and repainted every one of the black lines involved in setting up the painting grid. The resulting wall is one form of South African resistance re-created for a museum context.

In 2002, a gift of art arrived from another South African source. It came not in a crate but in an envelope from a gallery, with the artist's name and title on a DVD. *Shadow Procession* (1999), by William Kentridge, was acquired through funds raised by several patrons of contemporary art. It employs what the artist calls "stone age video production" to strike out against the Technicolor realism that permeates the world of media, challenging an audience to determine if the sophistication of the story isn't more important than the special effects. In this procession, there is a mixture of archetypal characters: miners enacting back-breaking labor, cripples, people carrying entire cities, a cat who just yawns, and a parody of authority—the everyman's bumbling dictator who wags an over-sized finger at the world. This parade of bizarre contradictions could exist any-where, but the opening track of Alfred Makgalemele's rendering of "What a friend I have in Jesus" evokes the setting of Johannesburg. Two visions of resis-tance from South Africa thus enter the collection.

Private collecting of contemporary art was given new parameters in Seattle from 1999 to 2002 and resulted in donations that included work by two artists from Africa. The Contemporary Art Project (CAP) was designed by a former gallery owner named Linda Farris to engage patrons in an experimental art enterprise.[18] She asked eighteen patrons to pool funds to purchase art from an international group of artists who had emerged within the last ten years. Each patron lived with a work in his or her home, but agreed to divest it after voting for which museum would receive the art. When the Seattle Art Museum was selected, it acquired thirty-three works of art that included painting, photogra-phy, and video, with a strong leaning toward female artists. Through CAP, two new works by African artists entered the collection. *Black Series: Couleures Noires* (2000), by Ghada Amer, is accessioned as Egyptian. Through a canvas overlaid with embroidery and acrylic drips, the "female subject is literally unraveled."[19] An image lifted from a pornographic magazine is caught beneath threads, revealing a woman's body as would never be publicly allowed in the artist's Muslim culture. *Untitled* (fig. 4), by Julie Mehretu, presents a swirling vision of urban and imaginary spaces, in which she also charts the evolution of her diverse family tree. Since the artist was born in Ethiopia, this drawing becomes the first contemporary work on paper from Africa in SAM's collection.

Fig. 4. Julie Mehretu (Ethiopian, born 1970), *Untitled*, 2001. Ink and pencil on mylar, 21 1/2 × 27 3/8 in. (54.6 × 69.5 cm). Seattle Art Museum. Gift of The Contemporary Art Project

There was no ten-year plan, and so improvised solutions prevailed. What has come into the museum mixes decidedly contrasting views of contemporary art, as seen in the selections cited from Nigeria, Kenya, and South Africa. A conceptual seesaw is in motion, with one end being artists who are a part of the art world circuit and the other, those who are not. Curating in what some might call the cybercapital of the world, there has been an effort to pay attention to a gap in the global network. There are still a multitude of places in Africa where an artist can spend a lifetime without logging on or being selected for a Biennale. Awareness of their existence might never find its way into a museum without extended personal contact through alliances like those forged with Lamidi Ayankunle or Kakuta Hamisi.

Wherever the dangerous dichotomy of West versus the Rest conjures up endless boundaries, it's time to create alternatives. Vaporizing generalizations is one step. As stated in an *African Arts* article, "The west refers to twelfth century French villages, horror movies, the Industrial Revolution, the theology of St. Augustine, New Zealand public education, the international banking system, modern toy retailing, medieval concepts of disease, Thanksgiving dinner,

electronic mail, Gregorian chants, Linnean botany, napalm, the Chopin etudes, and bar codes—as though the values and ideologies found therein can be the subject of useful generalization."[20] To define the contemporary African art that has recently been collected at the Seattle Art Museum, one could say it refers to Victorian decoration, five hundred years of the Yoruba kingdom, industrial cloth production, slavery, antiquity, new uses for house paint, apartheid, tourist safaris, pornography, new uses for Christmas-tree light bulbs, satire, social engineering, the French Revolution, family life, Barbie dolls, castles on the West African coast, new methods of enacting prayer, artistic forms of resistance, and friends of Jesus. May the seesaw of creativity keep us all free from rigid definitions of how to collect and from whom.

NOTES

1. The curator was Trevor Fairbrother and the funds were given by Agnes Gund and Daniel Shapiro in honor of Virginia and Bagley Wright.

2. *Art from Africa: Long Steps Never Broke a Back* was on view at the Seattle Art Museum in spring 2002. It travels to the Philadelphia Museum of Art, the Wadsworth Atheneum, Hartford, and the Frist Center for the Visual Arts, Nashville, in 2004–5.

3. Yinka Shonibare, interview by Acoustiguide Corporation, tape recording and transcript, London, January 2002.

4. Lamidi Ayankunle, interview by Carol Hermer, trans. Toyin Ajayi, videotape, Seattle, May 2001.

5. A short list of influential publications featuring contemporary African art include the following: Okwui Enwezor, *Reading the Contemporary: African Art from Theory to Marketplace* (Cambridge, Mass.: MIT Press, 1999); Enwezor, *The Short Century: Independence and Liberation Movements in Africa 1945–1994*, exh. cat. (New York: Prestel USA, 2001); Enwezor, *Documenta 11_Platform 5: The Exhibition and the Catalogue*, exh. cat. (Ostfildern, Germany: Hatje Cantz Publishers, 2002); Shannon Fitzgerald and Tumelo Mosaka, *A Fiction of Authenticity: Contemporary Africa Abroad*, exh. cat. (New York: Distributed Art Publishers, 2003); Salah Hassan and Olu Oguibe, eds., *Authentic/Ex-Centric: Conceptualism in Contemporary African Art* (Ithaca, N.Y.: Forum for African Arts, 2002); Pep Subrios, ed., *Africas: The Artists and the City: A Journey and an Exhibition*, exh. cat. (Barcelona: ACTAR, 2002); Gilane Tawadros and Sarah Campbell, eds., *Fault Lines: Contemporary African Art and Shifting Landscapes*, exh. cat. (London: inVA [Institute of International Visual Arts], 2003). Journals include Third Text (London), *NKA: Journal of Contemporary African Art* (New York), and Revue Noir (Paris).

6. Olu Oguibe, "Cyberspace and the New World Order," in *Trade Routes: History and Geography*, ed. Okwui Enwezor (Johannesburg: Greater Johannesburg Metropolitan Council, 1997), 46–51.

7. David Hammons, "Forum: African American Artists on Issues of Museums and Representations of African American Art," *NKA: Journal of Contemporary African Art* (spring/summer 1995): 39.

8. The website offered by the National Museum of African Art reviews the collection gathered by Elizabeth Harney in the course of the last decade. See "On-line Collection: 'The

Diversity of African Art—Modern and Contemporary Art,' " n.d., http://www.nmafia.si.edu/pubaccess/pages/divfrm.htm (accessed 10 August 2004).

9. Ery Camara, "Demystifying Authenticity," in *A Fiction of Authenticity: Contemporary Africa Abroad*, ed. Shannon Fitzgerald, exh. cat. (St. Louis: St. Louis Contemporary Art Museum, 2003), 84.

10. Simon Njami, "Introduction to African Contemporary Art," *Theoretical Anthropology* 3 (May 1997) web publication of the Institute Fur Volkerkunde, University of Vienna, http://www.univie.ac.at/voelkerkunde/theoretical-anthropology/njami.html (accessed 10 August 2004).

11. Bogumil Jewsiewicki, *Chéri Samba: The Hybridity of Art*, exh. cat. (Quebec: Galerie Amrad African Art Publications, 1995); and Michela Wong, "A Question of Style," *Transition* 80 (2000): 18–31.

12. Chéri Samba, from a 1991 quote, as published in ibid., 96.

13. Label from the exhibition A Passion for Possession: Visitors Buy African Art, Seattle Art Museum, 13 June 1997–21 June 1998.

14. Transcripts of written comments from *Passion for Possession.*

15. Notes from interview with Kakuta Ole Maimai Hamisi, Seattle, Washington, 22 April 2000. His version of this collecting experience is also available through his website: http://www.maasai-infoline.org (accessed 10 August 2004).

16. *Ceramic Gestures: A Conversation with Magdalene Odundo*, prod. Marla Berns, Regents of the University of California, 1995, 9-min. video cassette.

17. For further description of this project, see "Ndebele Wall Painting Project," n.d., on the website of Tacoma's Evergreen State College, http://academic.evergreen.edu/projects/wallpainting/ndebele.htm (accessed 10 August 2004).

18. Tara Reddy Young, "What Ifs: Constructed Identities and Imaginary Places in the Contemporary Art Project Collection," in *SAM Collects Contemporary Art Project*, exh. cat. (Seattle: Seattle Art Museum, 2002), 11–61.

19. Candice Breitz, "Ghada Amer: The Modeling of Desire," *NKA: Journal of Contemporary African Art* (fall 1996): 14–16.

20. Denis Dutton, "Mythologies of Tribal Art," *African Arts Magazine* (summer 1995): 35.

The Accidental Tourist: American Collections of Latin American Art

Gabriel Pérez-Barreiro

CURATOR OF LATIN AMERICAN ART, JACK S. BLANTON MUSEUM OF ART,

UNIVERSITY OF TEXAS AT AUSTIN

Since Abby Aldrich Rockefeller donated three works by José Clemente Orozco and Diego Rivera to the Museum of Modern Art in New York in 1935 and 1936—starting a major, albeit sporadic and inconsistent, Latin American project there—the institutional collecting of art from Latin America has largely been a sub-product of the United States' own political agenda rather than an intellectual engagement with the material and its historical or artistic significance. For most of the twentieth century, this political agenda was hemispheric diplomacy, wrapped in the "good neighbor" policy and the Cold War. After the multiculturalism of the 1990s, the agenda shifted to a concern with the nation's changing internal demographics. In both cases, the U.S.-centric way the art of Latin America has been viewed, and its instrumentalization within a domestic agenda, is the background against which the insertion of Latin American art into the United States should be viewed. Perhaps more than any other region, Latin America has been perceived as the other for the United States. A recent example can be seen in the continuing success of the cult of Frida Kahlo, the latest episode in a love story between Hollywood and its neighbor to the south. The twentieth-century creation of a binary opposition between the U.S. and Mexico, in which the former's assumed modernity, formalism, and intellect found its counterpart in the latter's equally assumed timelessness, realism, and passion, continues to haunt our perceptions of the whole of Latin America. The result is the patronizing manner in which many institutions approach the region, either as an enchanting world of timeless splendor and magnificence or

as a historical burden to be piously addressed. In either case, Latin American art is clearly viewed as different from the real stuff of art history with which mainstream museums write and rewrite the History of Art.

This politicization has created challenges within the field of museum collecting. First of all, we must recognize that museum collecting does not occur in a vacuum, but is rather at the center of a complex and sophisticated set of relationships between dealers, critics, magazines, auction houses, collectors, trustees, art historians, funding bodies, and many others, who constitute a broad consensus of which artists, movements, and styles warrant acquisition and presentation. In the case of Latin American art, such consensus, if it exists at all, is extremely fragmented. The market, with its core of Mexican masters (Diego Rivera, David Alfaro Siqueiros, Rufino Tamayo) and Magical Realists (Fernando Botero, Armando Morales), has increasingly been identified as the enemy by curators who have tried to advance a more sophisticated model.[1] In other curatorial fields the relationships among collectors, dealers, and museums tend to be close, but there is a mutual distrust between collectors and curators that has been one of the practical problems hindering the insertion of Latin American art into museum collections.[2]

This unilateralism and short-sightedness is one of the reasons that so very few museum projects are genuine collaborations between U.S. and Latin American institutions. Part of this is due, of course, to the political and economic instability of the region, and the lamentable state of some Latin American museums, but it is also emblematic of the need in the U.S. to constantly "discover" the art of Latin America.[3] The idea that Latin America has its own art history, fully part of the Western canon, often earlier and richer than that of the United States, is still a long way from being understood or acknowledged.

FROM THE "BACKYARD" TO THE BASEMENT

A surprising number of major U.S. museums have significant collections of Latin American art. It is perhaps remarkable that MoMA, so often characterized as the darling of the U.S. mainstream and the agent of European/U.S. hegemony in the arts, was the first institution outside of Latin America to aggressively collect Latin American art. The catalyst for this interest was the Rockefeller family, who made the first gifts of Latin American art to the museum in the 1930s and created the "anonymous" Inter-American Fund in 1942. The person chosen to spend this generous gift was Lincoln Kirstein, cofounder of the American Ballet and General Director of the New York City Ballet, who traveled extensively in South America in 1942, buying at such a rapid pace that by the following year some two hundred works from Latin America had been added to the permanent

collection. Kirstein had no qualifications to put together such an ambitious collection from a region in which he had little or no expertise. The declared aim of the Fund was to acquire "works of interest or quality, quietly and without involvement in official complication or compromise",[4] but Kirstein was also on a parallel mission, reporting on U.S. diplomatic missions to Nelson Rockefeller, President Roosevelt's Coordinator of Inter-American Affairs.[5] In 1943 the museum exhibited The Latin-American Collection of the Museum of Modern Art, after which most of the collection returned to storage and has rarely seen the light of day since.[6] Several years later, Alfred Barr acknowledged the speed with which the collection had been put together, and its political imperative: "Perhaps [we] might not have taken any great interest in South America had it not been for the war, the state of emergency, the necessity of establishing closer relations with the countries to the south. . . . I know that we here in the Museum of Modern Art worked in considerable haste. Already we begin to see that we made a good many errors, both of policy and taste."[7]

Hindsight reveals that MoMA's interest, although early and committed, was absolutely one-sided. Curatorially, the museum approached its Latin American venture as little more than a shopping trip. Kirstein's taste, as refined though uninformed as it was, was considered a sufficient filter and guarantee of quality. As Kirstein wrote in 1943, "It might be fair to say that the United States is responsible for much of the fame of Mexican painting, inasmuch as the patronage of our museums, collectors and tourists, and ardent propagandizing by many of our critics and dealers, have provided a solid basis for prestige."[8] This statement reinforces the mind-set that it was only in the U.S. that reputations could be meaningfully established and that everything of aesthetic value would be made available to the American visitor. The inclusion of "tourists" alongside museums, collectors, critics, and dealers is also characteristic of the belief that all the art of the region was readily accessible, denying the complex institutions, histories, and conduits that already existed in these countries. The patronizing tone of Kirstein's remark speaks volumes about attitudes toward Latin America from the "specialist" in the area.

After the 1943 exhibition, Latin America virtually vanished from MoMA's priorities, although a recent exhibition of MoMA's collection at El Museo del Barrio in New York exposed a surprising range to a Latin American collection that was never conceived or organized as such.[9] It was not until 1992, with the quincentenary of the "discovery" of the Americas that Latin America again appeared as a political imperative in the museum's activities. This time, the International Program organized a major exhibition, Latin American Artists of the Twentieth Century, which traveled through Europe before concluding in New York. Coming four years after the London Hayward Gallery's encyclopedic

Art in Latin America, and the Indianapolis Museum of Art's 1987 exhibition Art of the Fantastic: Latin America, 1920–1987, this exhibition was the focus of a critical backlash against generalizing exhibitions in which all of Latin America was presented as a whole, seemingly unconnected to artistic developments anywhere else, and with an essentialist agenda. The debates surrounding this exhibition showed how the academic and curatorial worlds had set other priorities and paradigms as a result of revisionist agendas and the rise of multiculturalism.

MoMA was not the only U.S. museum to form a significant collection of Latin American art. Other museums with similarly fitful collections, and similar fates, include the Solomon R. Guggenheim Museum in New York, which put together a significant collection in the 1970s, under the leadership of its director, Thomas Messer. Messer had become involved with Latin American art through the Center for Inter-American Relations (now the Americas Society) in New York. The Center was a Rockefeller-founded policy institute, with an art gallery on the ground floor and an important literary magazine, *Review*. As Special Advisor for the Arts starting in the 1960s, Messer helped to shape an exhibition program of historical and contemporary Latin American art at the Center's galleries. In 1966 he organized an exhibition of contemporary art from Latin America, The Emergent Decade: Latin American Painters and Painting in the 1960's, at the Guggenheim Museum. Like Kirstein before him, Messer traveled through Latin America, but he also included Latin American artists living in the U.S. and Europe, such as José Antonio Fernández Muro and Jesús Soto. He also made a point of visiting Latin American artists' studios in New York on a regular basis.[10] The exhibition catalogue consists of letters exchanged between Messer and critics in each of the countries he visited. Messer's tone has been criticized as high-handed, but he did at least acknowledge the need to consult with local experts. The Guggenheim then purchased many of the works from the exhibition, creating a significant nucleus of Latin American art, although one that is underexposed even by MoMA's standards.

The Latin American Collection of the Jack S. Blanton Museum of Art at the University of Texas at Austin (formerly the Archer M. Huntington Museum) deserves special mention. As with so many other museums, the origin of the collection was a series of gifts from a private donor, in this case Barbara Duncan. Duncan was exposed to Latin America during the 1950s, as she traveled with her husband, John, and she used her time there to make many studio and gallery visits. From the outset, Barbara Duncan recognized the importance of combining research with acquisition. Throughout her life she collected material on the artists she visited, maintained correspondence with them, and tried to stay current with research. Between 1971 and 2002, Barbara Duncan donated over three hundred works to the museum, and her archive constitutes one of

Fig. 1. Abel Barroso (Cuban, born 1971), *Internet de madera (Wooden Internet)*, 2000. Wood, ink, and paper; 21^{11}/$_{16}$ × 22^{1}/$_{4}$ × 15 in. (54.3 × 55.6 × 37.5 cm). Jack S. Blanton Museum of Art, University of Texas at Austin. Gift of Fran Magee, Austin

the most complete resources on Latin American art in the world. In 1989 the museum hired its first curator of Latin American art, Mari Carmen Ramírez. In her eleven years at the museum, as one of the most crucial advocates for Latin American art, Ramírez further cemented the importance of the collection and its ongoing research program. Perhaps uniquely among U.S. museums, the Blanton was able to carry out a continuous program of research, publications, exhibitions, and acquisitions of Latin American art.

LATIN AMERICAN AND LATINO

In winter 1992 Mari Carmen Ramírez published "Beyond 'the Fantastic': Framing Identity in U.S. Exhibitions of Latin American Art," in which she

Fig. 2. Leon Ferrari (Argentinean, born 1920), *Planta (Plan)*, 1980. India ink and letraset transfer images on plastic film; 37⅝ × 36¾ in. (94 × 91.9 cm). Jack S. Blanton Museum of Art, University of Texas at Austin. Gift of the artist

deconstructed the sudden "boom" of Latin American mega-exhibitions in the early 1990s, particularly in light of changing U.S. demographics. As she said, "The elaboration of an effective agenda for the 1990s . . . requires that we step beyond denunciation of the neocolonial politics at work in the Latin American/Latino exhibition boom and focus more precisely on the ideological and conceptual premises that guided the organization of these art shows. At the heart of this phenomenon lies the issue of *who* articulates the identity of these groups."[11] The importance of Ramírez's text in defining the curatorial shift in presenting Latin American art cannot be overestimated, as it laid the groundwork for a new generation of curatorial projects and research.

Fig. 3. Jorge Macchi (Argentinean, born 1963), *La flecha de Xenón (Zeno's Arrow)*, 1992. Video. Jack S. Blanton Museum of Art, University of Texas at Austin. Archer M. Huntington Museum Fund

Since the 1990s, two vectors, pulling in opposite directions, have defined the field of Latin American art. On the one hand, the idea of Latin American identity became a powerful tool in an increasingly fragmented and identity-based art system. Part of this was a growing acknowledgment of the Latino presence in the United States, with its own history of political struggle and issues of self-representation. On the other hand, we began to see the mainstream contemporary art world diversify and move toward a more global sensibility. Contemporary art museums began to collect artists from Latin America without necessarily paying attention to their national origin, and the traditionally hostile world of New York galleries began to include a regular roster of artists from Latin America and elsewhere. The Latin American field is currently divided between these *Weltanschauungs*, each of which aspires to a fundamentally different role for Latin American art within the history of art and ideas, thereby affecting its presentation within museums and institutions.

While most Latin American projects of the mid-twentieth century were initiated as cultural diplomacy of one kind or another, the impact of civil rights

Fig. 4. Antonio Berni (Argentinean, 1905–1981), *Detras de la cortina (Behind the Curtain)*, 1963. Collagraph with relief halftone and hand inking; 20 × 26⅝ in. (50 × 66.5 cm). Jack S. Blanton Museum of Art, University of Texas at Austin. Gift of the Museum of Modern Art

and the emergence of a Latino political consciousness in the U.S. shifted the agenda from an internationalist to a domestic one. The currency of multicultural debates in the 1980s was identity politics. As the United States came to terms with its racial and ethnic complexity in a way it had not done since the 1960s, the art world seemed to fragment into numerous ethnic and hyphenated-ethnic bodies. Many critics within the U.S. and Latin America have noted how this seeming democratization ultimately preserved the right of the mainstream to articulate these identities and to continue to present itself as "beyond identity."[12] The fact remains that identity became a powerful tool, and the rise of the Latino population into majority status was to have a huge impact on the field of Latin American art, and by extension, on museum policy.

Although the terms *Latin American* and *Latino* are regularly used as equivalents, or as quasi-equivalents, particularly in the language of museums and foundations, their meanings are quite different. Both terms are imperfect and inaccurate, but *Latin American* usually refers to the countries south of the Rio Grande and the Spanish-speaking Caribbean, whereas *Latino* refers to a U.S. resident of Latin American origin.

The emergence of Latino art and culture has been a grass-roots movement for visibility and self-representation. A number of institutions were created specifically as centers for self-definition and assertion, including the Museo del Barrio in New York and the Galería de la Raza in San Francisco.[13] The civil rights origins of these institutions places them firmly within a U.S. discourse and history, which is alien to most Latin American countries. In addition, the discussions around minority politics are often disturbing to Latin Americans, who do not consider themselves part of a minority and who are, more often than not, of a higher social class than the immigrants who make up much of the Latino population. To further complicate the issue, the relationship of many Latinos to their original nation-states is tenuous at best. In the words of Tomás Ybarra-Frausto, "As these immigrant, Spanish-speaking families settle in, their children enroll in local schools, begin learning English, and embark on immersion into the 'American way of life'; thus they move from being 'indio' to being 'gringo' without passing through being 'mexicano'."[14] This observation should serve as a warning signal to museum officials who present Mexican art as a well-meaning outreach initiative to their local Latino communities, running the risk of a double alienation from their "communities," for whom government-sponsored proclamations of *mexicanidad* can be as distant as the WASP American dream.

So, while the acknowledgment of an important and under-recognized demographic group becomes a political priority for institutions, Latin American art, which is increasingly visible through the international gallery, biennial, and art fair circuit, becomes a useful stopgap. George Yudice has explained the difficulty: "U.S. minorities therefore face a damned if you do, damned if you don't situation. When institutions seek 'traditional' forms they are likely to choose a Latin American artist over a Chicano or Puerto Rican. When they do choose a Latino, they are likely to relegate the artist to a 'marginal' category that is irrelevant to the art market. But the situation is not very easy for Latin American artists either. They too, especially those who do not have mainstream market representation, face a damned if you do, damned if you don't situation. They have the choice of representing the exotic that mainstream institutions have traditionally sought from them, on the one hand, or, on the other, of entering alternative exhibitions as quasi-Latinos, which is likely to raise the ire of the 'real' ones."[15]

For museums eager to jump onto the "Latin American/Latino" bandwagon, the fact that Latino art is a part of U.S. art history seems to slip out of the picture. Rather than encouraging their curators of "American" art to expand their definitions beyond the canon, museums will call on a "Latin American" art curator to bring together a temporary exhibition that will satisfy the "minority" quota.[16] As a result, no U.S. museum has yet seriously engaged with Latino art as a collecting priority, and the small collections of culturally specific or "alternative" museums remain the only option.

A central challenge for Latino artists remains how to negotiate their insertion into the mainstream, alongside their Latin American and U.S. counterparts. The difficulty lies in claiming a meaningful place within an expanded notion of "American" art and culture, while maintaining a conversation with Latin America that goes beyond reductive notions of "blood" and "origins." Museums still tend to package their Latin American and Latino art initiatives with stereotypical language and food references (*color, flavor, caliente, spirit, passion*), creating a straightjacket of well-meaning rhetoric that continues to reinforce the separation of this material from the rest of the museum's activities. Imagine if every Gerhard Richter exhibition were to open with a German sausage and beer fest, or if Robert Rauschenberg shows were packaged with Texan rodeos and cowboy hats.

ARTISTS AND GALLERIES

Curiously, within the Latin American art field, it has been artists and commercial galleries who have provided a powerful alternative to the museums' simplistic packaging of art from the region in ethnic and reductive terms. Since the 1990s, the commercial gallery circuit has been one of the places where the long-yearned-for dissolution of the essentialist category of "Latin American Art" has effectively taken place.

Many artists from Latin America have been living in New York since the 1970s, and they have often been the subject of discrimination or neglect by mainstream galleries and institutions. New York–based artists such as César Paternosto, Luis Camnitzer, José Antonio Fernández Muro, and Liliana Porter were denied the access to the gallery system or the critical circuit that was available to many of their U.S. peers. The exhibition opportunities that were available came through culturally specific institutions such as the Center for Inter-American Relations, the Museo del Barrio, and the Bronx Museum.[17] Many of these artists sold works into the collections of museums like MoMA or the Guggenheim, only to have them relegated to permanent storage.

He practiced every day.

Fig. 5. Luis Camnitzer (Uruguayan, born 1937), *He Practiced Every Day (from the Uruguayan Torture, 2)*, 1983. Photo etching; 8⁹⁄₁₆ × 11³⁄₈ in. (21.5 × 28.5 cm). Jack S. Blanton Museum of Art, University of Texas at Austin. Archer M. Huntington Museum Fund

However, in the 1980s and 1990s, the art market began to respond differently to contemporary artists from Latin America. Against the backdrop of multiculturalism and an increasing fragmentation of art according to ethnic or identity definitions, more and more artists from Latin America began to function within the mainstream. It was precisely the artists who rejected a simplistic sense of their own identity who broke through these barriers with greatest ease. Two artists in particular deserve mention—Gabriel Orozco and Felix Gonzalez-Torres. Both refused to frame their work within closed systems of identity, and their work was ultimately disappointing to anyone searching for traces of *mexicanidad* in the former, or *cubanidad* in the latter. As a result, they tended not to be included in the national or regional surveys that were so much part of the art scene in these decades (New Art from X, Contemporary Art from Y). However, these artists were perhaps the first Latin American artists to cross into mainstream contemporary art collections. The impact of this apparently small shift was huge, as it provided an important role model for artists uncomfortable with the "Latin American" classification, who wanted to be considered contemporary artists along with their international peers. It also introduced collectors and museum curators to the idea that they could acquire work by artists from the region without feeling that it was different from that by other contemporary artists.

So, the gallery system was the first to open its doors to a more global definition of art, but the fact remains that it did so partly because there was a context developing in which the national or ethnic identity of the artist was no longer the passport for entry. This is not to say that New York galleries became true representatives of the global art scene overnight. Artists still had to live in New York, speak English, and conform to definitions of the "contemporary" that were crafted in New York rather than in Buenos Aires, Caracas, or São Paulo. The rise of the biennial circuit in these years further compounded the sense of an "international" style that was global yet suitably readable from the center.

AUCTIONS AND THE SECONDARY MARKET

While the gallery system and the curatorial discourse was globalizing, curiously, the secondary market was becoming ever-more Latin Americanist. The so-called boom of Latin American art in Sotheby's and Christie's was confirmed by record-breaking sales in 1989 and 1990 and continued through most of the decade.[18] The staple of the auction houses was precisely the type of art that was increasingly questioned in revisionist academic and curatorial circles: Mexican masters and Magical Realism. As the Latin American category was being questioned and dissolved in the primary market (galleries), and to some extent in contemporary art museums, the secondary market (auction houses) was reinforcing the same canon of difference, exoticism, and social realism that MoMA had responded to almost fifty years earlier. In most collecting areas, auctions tend to reflect what is happening in museums, exhibitions, magazines, and books; in the Latin American case, almost the opposite happened. According to Jean Baudrillard, the museum functions as the ultimate legitimizer for the auction world, a sort of "federal reserve" guaranteeing value.[19] The Latin American case seems to show the opposite, with collecting and museums literally worlds apart.

The Latin American art departments at Sotheby's and Christie's gained enormous prestige and power during the boom. Although the departmental directors are always careful to say that theirs is a secondary market,[20] and that they are merely responding to what is already in circulation, the fact remains that the Latin American art world, spread as it is among many countries and without a strong gallery or museum system unpinning it, is not comparable to any other. In the absence of primary sources on Latin American art, the auction catalogues became a valuable resource for students and scholars, and carried an unlikely authority. The double-sided aspect of Latin American auctions, as traditional clearinghouses but also as promoters of Latin American art, has been present since the first auction held by Sotheby Parke Burnet in 1979. This auction

was held in collaboration with the Center for Inter-American Relations, a non-profit organization, and indeed the Center took credit for the initiative in a letter reproduced in the catalogue. In the letter, the president of the Center states: "Our intention was twofold. First we felt that an auction was a new way of fulfilling our underlying objective of increasing knowledge in the U.S. of the art of Latin America. . . . We felt that an auction would be . . . a means of bringing Latin American art to the attention of a new and broader constituency. Secondly, we viewed the auction as a means of furthering our ongoing efforts to secure financial support for our programs and activities."[21] Once again, as with Kirstein's early visits to Latin American, Northern engagement with the South is expressed in terms of shopping.

The field of contemporary art has already begun to break down the distinction between American and Latin American art at auction. Certain artists are sold in both departments, the final decision being based on where they reach higher prices. According to Ana Sokoloff of Christie's, younger collectors are no longer interested in Latin America "masters," and tend to want greater international resonance in their collections.[22]

VISIBILITY AND TOKENISM: THE CHALLENGE FOR MUSEUMS

As the contemporary curatorial world becomes increasingly global, with awareness of Latin American art greater than ever before, the fundamental issue facing museums is where to place their Latin American/Latino work. Museum directors who are aware of the transformation of their audience, but who are unable or unwilling to adopt museum-wide strategies, often use Latin American art as an outreach venture. The specific condition of Latino art is where we see most clearly an unwillingness to expand the definition of "American" art to include artists beyond the mainstream. The consistent use of stereotypical language to describe these projects (colors, heat, and food) further reinforces the impression that there is nothing to learn from a consistent and museum-wide engagement with diversity. The common limiting of bilingual text to areas of "Latin American" interest further reinforces the division between the museum as a whole and its increasingly diverse audience.

One case study that merits further attention is precisely back where we started: at the Museum of Modern Art. In 1999 the museum appointed the Brazilian curator Paulo Herkenhoff as adjunct curator in the Department of Painting and Sculpture.[23] By not creating a Latin American department, and not providing a fixed quota of Latin American projects, the museum provided the conditions for a broader engagement with Latin American material while avoiding

the pitfalls of tokenism or political expediency. Ideally, Latin American artists would be considered alongside French, German, or American artists as projects developed. The addition of a Latin American travel fund for the museum's curators further broadened their horizons in an organic and meaningful way.

The exhibitions that Herkenhoff curated at the museum brought together artists from all over the world, thereby providing a rare case of a Latin American curator selecting and presenting "mainstream" works, reversing the typically one-way U.S. engagement with Latin American art. At the New Museum of Contemporary Art in New York, a similar process took place when the Cuban Gerardo Mosquera was hired as adjunct curator. Mosquera's role has not been to curate exclusively Latin American artists but rather to provide another perspective within the curatorial department. Both institutions have firmly moved away from a quota system for Latin American art. In other words, the issue is not how much, but rather where and how.

One of the central issues for curators of Latin American art now must be how to avoid their own instrumentalization. As museums becoming increasingly aware of the demographic changes in their core audiences, Latin American art still runs the risk of being a weapon of political expediency. If the debate is set only in terms of visibility or allocations, the risk of tokenism remains. If the category of Latin America is separated from the other curatorial departments, it will remain a minority project, while "real" art history is articulated elsewhere. Where the process is organic, as in the recent cases at MoMA, the New Museum of Contemporary Art, and the Miami Art Museum, Latin American art at least has the possibility of regaining the contexts and dialogues from which it has traditionally been isolated by short-sighted institutional politics.

NOTES

1. "We have to leave behind the reductive and stereotypical view of Latin American art that became the market-inspired benchmark of the last two decades and instead support work that responds to the authentic explorations of artists across the region." Mari Carmen Ramírez, "Introduction," in *Collecting Latin American Art for the 21st Century*, eds. Mari Carmen Ramírez and Theresa Papanikolas (Houston: Museum of Fine Arts, Houston, 2002), 17–19. "The challenge for . . . twenty-first century collectors is to go beyond the canon that the U.S. market has established." Beverly Adams, "The Challenges of Collecting Latin American Art in the United States: The Diane and Bruce Halle Collection," in ibid., 195. I am especially indebted to Adams's article, which provides a comprehensive overview of American collections of Latin American art.

2. There are some remarkable exceptions, notably the Cisneros Collection, in Caracas and New York which has set institution-building and -support high on its agenda. The quality of the collection and its staff has made the collection a catalyst for U.S. museums to engage with Latin American art. In the international contemporary field, the Colección Jumex in Mexico

City has also become a significant venue for the circulation of Latin American art in an international context. In the United States, the collection of Diane and Bruce Halle in Arizona is emerging as a major force in the redefinition and sophistication of Latin American art collections. Within mainstream contemporary art museums, the Miami Art Museum and the Walker Art Center in Minneapolis have established important collections of Latin American artists.

3. See, for example, Roger Atwood, "Rediscovering Latin America," *Artnews* (June 2003): 98–101.

4. Alfred H. Barr, "Foreword," in Lincoln Kirstein, *The Latin-American Collection of the Museum of Modern Art* (New York: Museum of Modern Art, 1943), 4.

5. Nicholas Jenkins, "Introduction," in *By With To & From: A Lincoln Kirstein Reader*, ed. Nicholas Jenkins (New York: Farrar, Straus and Giroux, 1991), xvii.

6. For a chronology of MoMA's involvement with Latin American art, see Miriam Basilio, "Reflecting on a History of Collecting and Exhibiting Work by Artists from Latin America," in Basilio et al., *Latin American and Caribbean Art: MoMA at El Museo*, exh. cat. (New York: El Museo del Barrio and the Museum of Modern Art, 2004), 52–68.

7. Adams, "The Challenges of Collecting Latin American Art in the United States," 163.

8. Kirstein, *Latin-American Collection of the Museum of Modern Art*, 56.

9. Latin American and Caribbean Art: MoMA at El Museo, March–July 2004. The irony of this exhibition is that collections at MoMA are organized by medium and not by geography, so there is, in fact, no "Latin American collection." See Luis Enrique Pérez Oramas, "The Art of Babel in the Americas," in Basilio et al., *Latin American and Caribbean Art*, 34–43.

10. Thomas Messer, personal communication with the author, 2001.

11. Mari Carmen Ramírez, "Beyond 'the Fantastic': Framing Identity in U.S. Exhibitions of Latin American Art," repr. in *Beyond the Fantastic: Contemporary Art Criticism from Latin America*, ed. Gerardo Mosquera (London: Institute of International Visual Arts, 1995), 230.

12. For further reading on this subject, see *Beyond the Fantastic*.

13. For an overview of Latino museums in the U.S., see Herlinda Zamora, "Identity and Community: A Look at Four Latino Museums," *Museum News* (May/June 2002): 37–41.

14. Tomás Ybarra-Frausto, "Latin American Culture and the United States in the New Millenium," in *Collecting Latin American Art for the 21st Century*, 39.

15. George Yudice, "Transnational Cultural Brokering of Art," in *Beyond the Fantastic*, 212.

16. For example, the highly successful national tour of Ultrabaroque (Museum of Contemporary Art, San Diego, 2001) can be seen in this light. Although the exhibition was self-declared as "post–Latin American Art," it continued to present contemporary Latin American artists, many of who have significant international careers, in isolation.

17. Many of the Latin American artists living in New York in the '60s and '70s were politically active and campaigned against U.S. military intervention in Latin America. A number of artists organized a coalition called MICLA (Movement for the Cultural Independence of Latin America), which boycotted the Rockefeller-led Center for Inter-American Relations in the 1960s, claiming that the cultural program was "window-dressing" for a more sinister political program of military and economic dominance. Again, this international(ist) political agenda was different from (albeit related to) the civil rights concerns of the U.S. Puerto Rican community. I am grateful to Luis Camnitzer for his information on MICLA and for access to his unpublished text. "The Museo Latinoamericano and MICLA" (2000).

18. In the six months between November 1989 and May 2000, total Latin American sales at Sotheby's almost tripled, from approximately $500,000 to $1,500,000. By May 1995 three paintings had sold for over $3,000,000 each.

19. Jean Baudrillard, *For a Critique of the Political Economy of the Sign* (St. Louis: Telos Press, 1981).

20. According to August Uribe, former head of Latin American Paintings at Sotheby's, "The role of the auction house is not to promote the work of artists. That is the job of museums and galleries. It is unfair to the market, to the artist, to the dealer, and to the auction house to put an artist who has never been in a public setting and expect him to sell in the time span of 60 seconds." August Uribe, in informal public conversation at the Americas Society for the Series *Perspectives on the Latin American Art Market*, New York, September 2002.

21. *Modern Latin American Paintings, Drawings, and Sculpture* (New York: Sotheby Parke Burnet, 1979), n.p.

22. Ana Sokoloff, "Perspectives on the Latin American Art Market," (paper presented at the Americas Society, New York, June 2002).

23. An equivalent position is now occupied by the Venezuelan curator Luis Enrique Pérez Oramas in the Department of Drawings.

Collecting the Art of African-Americans at the Studio Museum in Harlem: Positioning the "New" from the Perspective of the Past

Lowery Stokes Sims
PRESIDENT, THE STUDIO MUSEUM IN HARLEM, NEW YORK

Through a discussion of the permanent collection of art by African-Americans in the Studio Museum in Harlem (SMH), this essay takes an institutional approach to collecting. The art of African-Americans (and artists of African descent worldwide) is the mission of the SMH, which was founded in the late 1960s to promote and support African-American artists in the wake of the social and political challenges of the 1960s and '70s.

It is important to make clear at the outset that in discussing this collection I will not offer a definition of African-American art or an African-American aesthetic. This is not to deny that there are many strong opinions about whether there is a definable "African-American art" or "African-American aesthetic."[1] Work by African-American artists, however, is so varied that it is as likely to interface with the mainstream art world as it is to transgress the consensual norms of that world. Over the last few years, we at the SMH have recognized the problematic nature of clustering artists according to race or national origin. But we also acknowledge the interest and/or need on the part of various audiences to tap into whatever shared experiences may be gleaned from the art of African-Americans. This led to an expansion of the SMH mission in 2001 to include in our exhibitions, programs, and acquisitions "work that has been inspired and influenced by African-American culture."

The institutional history of the SMH must be understood in terms of the unprecedented recognition of African-American artists since the 1970s. This period has seen an increase in the number of private collections of this work, as well as an increase in the representation of it in mainstream institutional collections.[2] The era also has witnessed an increase in the inclusion of African-Americans in art history, curatorial work, and art criticism.[3] Collectively, these efforts in curating exhibitions; delivering scholarly analyses at conferences; and writing brochures, catalogues, monographs, and general publications on the art of African-Americans have established a solid specialization within academia, the art market, and museums. As a consequence, there is now greater awareness of both contemporary and historical art by African-Americans and more widespread study of their work, as well as a dramatic increase in the market value of this art.

The core support for African-American artists historically has been within the community of African-Americans nationwide. In fact, collecting their art has been, and still is, an emotional activity imbued with psychological import, viewed by some in the African-American community as tantamount to a "sacred" duty. Collecting art is also a powerful reaction against the exclusion of African-Americans from social, political, and artistic life in the United States, as well as an expression of their economic and social progress in the United States during the last century. The protracted struggle of African-Americans for recognition as full citizens has revolved around their being acknowledged as capable of the highest intellectual and spiritual sentiment and expression. Participation in and recognition of the African-American contribution to the visual arts was essential to that struggle.

The encounter between Africa and Europe and the ensuing legacy of slavery played a powerful role in politicizing the act of making art by Africans. The devaluation of objects created in African societies—specifically, figures that represented ancestors or deities—and the concomitant imposition of religious and cultural conversion (whether enforced or embraced) led to the disposition of these objects as trophies of conquest and colonization, curios in the cabinets of European aficionados. Recent discoveries in domestic archaeology have indicated how the making of objects with symbolic and religious significance proceeded in secrecy throughout slavery, even in the United States. From the point of view of African peoples, then, making and collecting art that was meaningful to them was in direct defiance of the suppression of African religious and cultural retentions in the New World.

For African-Americans, their participation within the visual arts in this country was also marked by challenges in adjusting their creativity to standards lying outside those that had directed creativity in Africa. In this new context

cultural objects transmuted from having primary ritual and civic functions to being more decorative, serving as elusive indicators of "intelligence," "humanity," "higher sensibility"—all qualities that were seen as lacking in their own condition as chattel. African-Americans also had to struggle to acquire training according to the new criteria, learn new subject matter, and adapt new aesthetic criteria to finally gain recognition for their achievements in the visual arts. This struggle is encapsulated in the life and work of the few identified slave craftsmen, such as Thomas Day and Harriet Powers as well as in work by the families of potters in the Carolinas and Texas and anonymous builders and welders in Louisiana. Their indentured creativity contrasts with the example of Joshua Johnston, a freed African-American who made a living as a portraitist working in a limner style at the end of the eighteenth century and with the careers, later in the nineteenth century, of Robert Duncanson and Edward Mitchell Bannister, who painted landscapes; Charles Ethan Porter, a specialist in still lifes; and Edmonia Lewis, May Howard Jackson, and Meta Warrick Fuller, who created sculpture in Neoclassical and impressionistic modes. By the early twentieth century the number of African-American artists was growing, as more individuals had access to training in the post-slavery era. And by the 1920s, the blossoming cluster of historically black colleges and universities—Fisk, Hampton, and Atlanta University, in particular—was offering degrees in the fine arts and forming art collections.[4]

As the careers of African-American artists proliferated, so did dedicated collecting by pioneering individuals. William Shepherd amassed a collection of Kuba art in the last quarter of the nineteenth century while he was a missionary in the Congo, objects that he later donated to Hampton University. Bibliophile and collector Arturo Schomburg's collection of African art and the art of African-Americans formed the basis of the Schomburg Center for the Research and Study of Black Culture. James Herring and Alonzo J. Aden's Barnett-Aden collection,[5] which became the focus of salon life in Washington, D.C., in the 1940s and '50s, featured a multicultural representation of contemporary artists. Very often artists themselves became important collectors as they assumed the role of chroniclers of art by African-Americans. Artist, educator, and curator David Driskell,[6] and artist and writer Samella Lewis are notable examples. Since the 1970s, a group of important African-American collectors has emerged, including Dr. and Mrs. Leon Banks, who have collected widely and variously; Richard Clarke and John Thompson, bibliophile and trustee, respectively, at the SMH and the Metropolitan Museum of Art in New York; Harmon and Harriet Kelley and Walter and Linda Evans, whose collections have traveled nationally; and nationally known figures such as Bill and Camille Cosby and Grant Hill.[7] At several mainstream institutions—such as the Detroit Institute of Arts, the

Museum of Modern Art in New York and the Metropolitan Museum of Art, the Museum of Fine Arts, Houston, and the Virginia Museum of Fine Arts—affiliate groups were instrumental in stimulating and supporting acquisitions of art from Africa and by African-Americans for the permanent collections. As Leslie King Hammond observes: "The extraordinary legacy of a people determined to empower and realize their personhood and humanity in a hostile and alien country far removed from the motherhood of Africa, which they would never see again is a compelling and awesome story. . . . Black patrons have embraced the challenges of not only collecting art but also preserving a vital part of history through the privileges and passions stemming from their own professional achievements."[8]

Such collectors have also played an important part in the early history of the SMH permanent collection. Along with Richard Clarke, Franklin Williams, Major E. Thomas, and E. T. and Audlyn Williams have made timely and bold contributions to the museum. Today newer collectors are being educated by the National Black Fine Arts Fair held annually in New York City, by galleries that promote African-American artists nationwide,[9] especially the June Kelly Gallery (the first African-American–owned gallery to be admitted into the Art Dealers Association of America); by the African-American Art, 20th Century Masterworks exhibitions at the Michael Rosenfeld Gallery (1993–2003); by the annual exhibition Masterpieces of African-American Art: An African-American Perspective, held since 2000 at the M. Hanks Gallery in Santa Monica, California; and by various collecting clubs that have emerged in New York City, Atlanta, and Washington, D.C.[10]

THE PERMANENT COLLECTION OF THE STUDIO MUSEUM IN HARLEM: AN EVOLVING ENTITY

Originally conceived as a space for artist-focused projects, the SMH assumed a more traditional museological profile during the early 1980s, when it moved from a loft at New York's Fifth Avenue and 125th Street to its present facility on 125th Street between Lenox Avenue and Adam Clayton Powell Boulevard.[12] Its permanent collection was inaugurated in the late 1970s and an acquisitions policy adopted by the board in 1979. The formation of the SMH collection was accompanied by a signature public program, The Fine Art of Collecting. These panel discussions, plus tours to public and private collections, have brought together artists, curators, collectors, dealers, art lawyers, and conservators to discuss and dissect the process of collecting work by African-American artists. Consequently, the SMH has played an important role in educating and nurturing the recent generation of collectors and in stimulating the steady growth

of collecting and market recognition of African-American art over the last two decades.

A permanent collection has allowed the SMH to act concretely on its core mission of supporting and promoting the work of African-American artists and artists of African descent around the world. Although not an encyclopedic survey of the history of black creativity in the visual arts, the collection reflects the SMH's history and the initiative and commitment of trustees, collectors, and artists who understood the importance of having a permanent collection to complement the museum's program of exhibitions and education. By 1982 the SMH had opened in its current space and within three years was awarded a citation of merit by the Municipal Art Society for its permanent collection. By 1987 it had received accreditation by the American Association of Museums; to date it is still the only cultural institution devoted to the visual arts of African-Americans and persons of African descent worldwide that has that distinction. Over the next twelve years the museum periodically organized installations of its permanent collection in its galleries and toured exhibitions to other venues in New York City and nationally.[13]

Under the curatorial leadership of Executive Director for Exhibitions and Programs Thelma Golden, the SMH has continued to feature the permanent collection as part of its exhibition schedule. Golden's inventive approaches to the permanent collection have included both broad surveys and thematic selections. Her first installation, in winter 2000, showed a variety of works from the collection, including the first presentation of a work dedicated to Martin Luther King by noted American sculptor Louise Nevelson (who was not African-American). Material and Matter (winter 2001) examined approaches to materiality in the work of the featured artists. Red, Black and Green (summer 2001) focused on the occurrence of colors associated with black nationalism in the work of the featured artists (fig. 1). Collection in Context: Recent Photography Acquisitions (winter 2002) presented works purchased through the SMH Acquisitions Committee (formed in 2001), and the installation for the fall of 2002 featured unlikely pairings of works from the collection by different generations of artists. This new approach to the permanent collection reflects trends in museums nationwide to accommodate public interest in masterworks and images identified with local institutions, and to complement the special exhibition, or "blockbuster," with exhibitions from the museum's own resources.

The SMH permanent collection currently comprises approximately sixteen hundred objects in all media by artists working in the United States, the Caribbean, and Africa. The works in the collection range from the irreverent figuration of Robert Colescott and Kerry James Marshall, to surreal dramas by Hughie Lee Smith and the politically redemptive work of Jeff Donaldson. There

Fig. 1. The Studio Museum in Harlem, installation view, *Red, Black and Green*, July 12–September 16, 2001

are abstractions by Charles Alston, Norman Lewis, Merton Simpson, Alma Thomas, Jack Whitten, and William T. Williams (fig. 2). It also includes carved and constructed sculptures by Alison Saar; work by David Hammons, Terry Adkins, and Chakaia Brooker featuring recycled materials; evocative welded forms by Mel Edwards; and Richard Yarde's large installation commemorating the Savoy Ballroom. Various techniques on paper are well represented in the collection: collages by Romare Bearden, drawings by Benny Andrews, lithographs by Jacob Lawrence, screenprints by Gwendolyn Knight, woodblock prints by Martin Puryear, monoprints by Sam Gilliam, and digital images by Isaac Julien. Photography is also a strong component of the collection. Since 1975 the SMH has housed an extensive archive of work by the photographer James VanDerZee, chronicler of the Harlem community. Harlem is also featured in the photographs by Gordon Parks; those by Jules Allen and Malick Sidibé chronicle the dynamics of life in contemporary Africa.

Within this variety the collection is also distinguished by random concentrations of works by various artists such as sculptor and printmaker Elizabeth Catlett; collagist Romare Bearden; painter and collagist Benny Andrews; painters Hale Woodruff, Beauford Delaney, Norman Lewis, Richard Mayhew, Sam Gilliam, and Al Loving; photographers Dawoud Bey, Frank Stewart, and Jules Allen; and printmaker William Majors. Works that have entered the SMH

Fig. 2. William T. Williams (American, born 1942), *Trane*, 1969. Acrylic on canvas, 108 × 84 in. (274.3 × 213.4 cm). The Studio Museum in Harlem. Gift of Charles Cowles

permanent collection since 2000 have greatly expanded its scope with work by young, cutting-edge artists who represent the global extent of the black presence. These include videos by Rico Gatson and David McKenzie; drawings by Gary Simmons and Chris Ofili; Glenn Ligon's evocative scripts laid on with coal dust; conceptual photographic works by Lorna Simpson; abstracted reality in the work of Kori Newkirk and J. D. Ojeekere; recent portraiture by Dawoud Bey; silhouetted cut-outs by Kara Walker; and the found imagery of Sanford Biggers.

As this overview indicates, until the new millennium collecting at the SMH had largely proceeded without a coherent plan. Like that of a fledgling collector, the SMH's collection includes a number of "hits" and "misses," a situation that calls for careful strategies of culling and refining—the kind of deaccessioning and "trading up" that would be done by any private collector. The particular onus on the SMH, however, is that it be mindful of its responsibility to the public, operating with transparency and according to the guidelines of the American Association of Museums[14] and the laws of the State of New York. While most of the objects in the collection were by twentieth-century African-American

artists—and particularly those working in the 1960s and '70s—the collection also included several related concentrations, including a substantial selection of African art (including a large number of Ashanti gold weights), and a distinctive collection of Haitian art (beaded banners, paintings, decorated gourds, and ceramics). Evaluations by experts in these fields noted the distinctiveness of this last collection in its representation both of well-known masters—such as Wilson Bigaud, Murat Brierre, Philomene Obin, Serge Jolimeau, Georges Liautaud, and Fortune Gerard—and of art forms that were no longer being produced on the island or being done only in a much reduced manner.

A collection of photographs of churches in Ethiopia presented an accessioning dilemma—should they be part of the collection or an archival element—and a selection of art by children posed the question of whether a collection of modern art should encompass works by unformed talents, whose naïve spontaneity had been one of the primary sources of modernist idioms. Numerous posters—often the bane of serious collectors of African-American art—were initially presumed to be prime candidates for removal from the accessioned portion of the collection. On close consideration, however, it became clear that out of this collection could be formed an important body of ephemera documenting the history of art exhibitions, performances, and political gatherings by African-Americans in the last quarter of the twentieth century. In this respect the posters form an important complement to the archive assembled by artist Benny Andrews and donated by him to the SMH. (Andrews's pivotal role in the Black Emergency Cultural Coalition and the Art Workers Coalition in the 1960s and '70s is reflected in this archive.) There was also the issue of works by successive classes of artists-in-residence at the SMH, who had been part of the institutional history since the early 1970s but whose work had never been consistently and proactively collected until 2001—much of the earlier work seems to have been left behind by individuals at the conclusion of their residencies.[15]

The disposition of the permanent collection at the SMH had been a particular preoccupation of mine since I assumed directorship of the museum in 2000. I subsequently secured the services of Leslie King-Hammond as a consultant to work with SMH registrar Shari Zolla on an assessment of the collection. This process encompassed a number of distinct but interrelated tasks: identifying the strengths of the collection; identifying objects in the collection that were not consistent with the museum's mission; identifying and prioritizing works in need of restoration and conservation; identifying thematic modules in the collection that might be exhibited at the SMH and made available for rental by other organizations.

As the curatorial and registrar staff at SMH grappled with the realities of the permanent collection, other tasks were identified that would become essential

components in professionalizing and updating the collection management. In addition to devising a program to conserve and restore works, a key task was to transfer collection records from an antiquated database system to one that would make available more complete records on each work. Dr. King-Hammond's assessment of the permanent collection positioned it as central to the impending strategic planning that would establish priorities for the facility, staff, programs, and technology. What became patently clear was that the museum's commitment to a permanent collection, and to being an active participant in the preservation of the art of African-Americans, was as palpable an issue as it had been for our predecessors at the beginning of the twentieth century.

As decisions are made about the SMH collection, it will be important to consider its relationship to others in New York City and the United States. Part of this process will be the need to determine the place of categories such as folk art, self-taught art, architecture, and design in our collecting priorities. Only then can we consider our collection in relationship to the institutional missions of other organizations in New York, such as the Museum for African Art, the American Folk Art Museum, and the Cooper Hewitt National Design Museum, which has a large archive chronicling representations of African-Americans in architecture and design. These considerations will also predicate the priorities that the SMH will set in terms of future collecting.

In her report on the permanent collection Dr. King-Hammond also introduced the possibility of taking a more thematic approach. This concept presents many interesting opportunities to "customize" the SMH collection, and it parallels a strategy that many private collectors come to over time as they become more familiar with the different aspects of the art of African-Americans and discover what complements their own particular interests and temperaments. While the SMH is held to more civic standards, the collection does reflect the museum's history, the individuals who have been associated with it—be they artists, collectors, or curators—and the initiative and commitment of the trustees, collectors, and artists who understood early on the importance of developing a collection to complement the museum's exhibitions and education programs. The collection could therefore be reframed from the more macrocosmic approach of presenting a survey of the history of African-American artists from the eighteenth and nineteenth centuries, represented in the permanent collection by single works by Joshua Johnston and Edward Mitchell Bannister. If we were to continue our focus on the twentieth century, there are many possibilities to consider: post–World War II to the present, the period encompassing the history of the SMH itself (1968 onward), or artists and movements in Harlem from the Harlem Renaissance to the present. This last is made all the more feasible by the fact that the SMH has already begun to acknowledge

its special relationship to Harlem through periodic installations of the Van-DerZee archives (particularly in conjunction with the SMH's new youth program, Expanding the Walls: Exploring the Relationship between History, Community and Photography); the *Harlem Postcard* series, which presents photographic images of Harlem by different contemporary artists each exhibition quarter; and an occasional series, generically dubbed *Harlem Views*, which will present photographs of Harlem by historical photographers such as Helen Levitt, Henri Cartier-Bresson, and Gordon Parks. This series was inaugurated in fall 2003 with the installation of Aaron Siskind's *Harlem Document* (1930) as part of a nationwide celebration of the centennial of Siskind's birth. Within all these themes the museum can direct attention to the contributions made by the SMH Artists-in-Residence Program, which is going to get even richer in the future. However the collection is ultimately framed, it will also consider the range of demands and expectations on the institution itself. While other museums and historically black colleges and universities have more comprehensive African-American art collections, the SMH's permanent collection may be more accessible to the public, particularly in its function of providing the seminal museum experience for students and adults, and providing their first exposure to the art of African-Americans.

ART BY AFRICAN-AMERICANS: WHAT TO COLLECT NEXT?

Having determined parameters for its permanent collection, the SMH will be faced with deciding how to focus its collecting and—in a related way—determining what to retain of its current collection. As we move forward, we cannot pretend that collecting African-American art is still enshrouded in noble, emotional intentions to provide opportunities to African-Americans in the art world or respond to obligatory social agendas. Each artistic career encapsulates a story that is indicative of the political, social, and economic as well as cultural history of African-Americans. Collecting the work of African-American artists nonetheless involves a number of debates concerning the need to define a "canonical" African-American art.

The SMH has helped to fuel that dialogue in the exhibitions it has presented, particularly between 2000 and 2004. The 2001 exhibition Freestyle[16] and Black Romantic: The Figurative Impulse in Contemporary African-American Art (2002),[17] both curated by Thelma Golden, revisited the debates of the 1960s and '70s about what exactly constituted the art of African-Americans. At that time divergent artistic tendencies—generally described as figurative versus abstract—were posited as measures of the "authentic" versus "assimilated" African-American aesthetic, in a critical ambiance that favored the suppression

of content and meaning and in the midst of the civil rights and black power movements. Value judgments about artists' works were made according to their adherence to one or the other approach to art. This figurative/abstract dichotomy also determined, by implication, how an individual artist interfaced with the mainstream art world. Figurative tendencies defiantly took the moniker "blackstream," crediting them with political and social relevance to the black experience.

By the 1980s such distinctions lost their relevance, and the tide of critical legitimacy turned to favor cultural relevancy, identity, and racial nuance. In that context, *Freestyle* and *Black Romantic* represented dichotomous tendencies by virtue of their approach to the notion of the vanguard. *Freestyle* (fig. 3) examined the global black experiences—e.g. identity, transnationalism, cosmetology, and engagement with electronic media—shaped by conceptual and theoretical approaches. The work in *Black Romantic* (fig. 4) featured elements of desire, dreams, determination, and romance particular to the black experience, presenting a viewpoint opposed to modernist conceptualizations of blackness flavored by exogenous notions of exoticism, stereotype, caricature, and abstract manipulation.

In determining a point of view for an institutional collection of art by African-Americans, then, the question will be posed: which vision of blackness is the "authentic" one? In fact, most critics and art historians and curators who watch developments in the work of African-American artists recognize that there is no clear-cut divide along the lines of generation, age, or politics with regard to the creators and audience of both artistic genres. They may chose to privilege one or the other, but in a broader phenomenological sense both genres—like the "mainstream" and "blackstream" of two decades ago—represent the dual aspects of the African-American defined in 1905 by W.E.B. DuBois as "warring entities" in a single entity. To position them as diametrically opposed to one another is to amputate the full expression of the black experience. Indeed, the notion of blackness would be seriously blunted if the capacity for desire, dreaming, and conformity were to be isolated from a talent for irony, conceptual experimentation, and transgression.

Therefore an ideal collection of African-American art—be it institutional, corporate, or private—would accommodate the best from a range of artistic techniques, media, and philosophies. The relative significance or importance of an artist is adjudicated by many variables: exhibition history, market viability, artistic skill, relationship to other artists and movements. The challenge for African-American artists is that the industry that supports these elements is still relatively new. Although the history of African-Americans in the visual arts is two hundred years old, and the formulation of a significant concentration of

Fig. 3. Adler Guerrier (American, born 1975), *Flaneur nyc/mia*, (detail), 2000. C-print, 8 × 10 in. (20.3 × 25.4 cm). Collection of the artist

artists one hundred years old, the position of African-American art in the mainstream marketplace has solidified only since the early 1990s. Before then the solidification of the art of African-Americans in the mainstream market place was sporadic and supported largely by African-American collectors. Collections are also determined by individual curatorial visions, although there are still few of those in play at this point. As African-American art has invaded the curriculum and the scholarly arenas in universities, we have began to witness a certain democratic hindsight in establishing the criteria for evaluating emerging as well as historical artists. This in turn has resulted in more transparent and democratic perspective, on the part of art institutions.

Over the last thirty years the position of art by African-Americans has benefited from increased interest by mainstream institutions and the expansion of African-American–focused institutions in the 1960s and from research intended to identify and examine the career of every African-American who ever made art. This was followed by a phase of assimilation, integration, and recognition by the mainstream in the context of multiculturalism and deconstruction in the 1980s. And that led the way for the art market to reevaluate the work of historical artists and tendencies that were formerly underrated. Currently there is a move toward defining "masters" out of the crowd of contenders, even as fresh research provides new criteria for evaluating individual careers. In the final analysis, what is needed is the ability to balance an encyclopedic overview with commitment to a perspective that is provocative and advances dialogue about

Fig. 4. Keith Duncan (American, born 1964), *Cain and Abel*, 2001. Photo collage, oil and marker on canvas, 16 × 12 in. (40.6 × 30.5 cm). Collection of the artist

the work of African-American artists. This becomes an important impetus for establishing a context for the values and ideas that circulate in the world of African-American art.

The Studio Museum in Harlem, therefore, becomes a site where ideas about African-American art are debated, discussed, and understood by a wider public. The challenge is to keep the level of discourse constructive and advantageous for the artists in terms of disseminating information about their work, so as to influence the way that people perceive and think about it. Thus, it will be necessary to move beyond narrow categorization and determine how to think about that art from the point of view of the artist, the African-American perspective, and how what African-American art expresses has an impact on the global experience of African-American Culture. In that sense there is a very

direct relationship between exhibitions, publications, public programs (lectures, dialogues, symposia, etc.), and collecting, because they become key institutional devices by which to introduce broad as well as specific ideas about the work of African-American artists and to stimulate a large audience to think about more definite directions for collecting African-American art.

NOTES

1. Richard J. Powell, *Black Art and Culture in the 20th Century* (London: Thames and Hudson, 1997); and Sharon F. Patton, *African American Art* (New York: Oxford University Press, 1998).

2. See, for example, Regenia A. Perry, *Free within Ourselves: African American Artists in the Collection of the National Museum of American Art*, exh. cat., with introduction by Kinshasha Holman Conwill (Washington, D.C.: National Museum of American Art, Smithsonian Institution; San Francisco: Pomegranate Artbooks, 1992); Lisa Mintz Messinger et al., *African American Artists: 1929–1945: Prints, Drawings and Paintings in the Metropolitan Museum of Art*, exh. cat. (New York: Metropolitan Museum of Art, 2003).

3. These individuals include David Driskell, Carroll Greene, Samella Lewis and Ruth Waddy, Frank Bowling, Lizzette LeFalle Collins, Jacqueline Day Serwer, Alvia Wardlow, Leslie King-Hammond, Lowery Stokes Sims, Sharon Patton, Richard Powell, Deborah Willis, Kelly Jones, Thelma Golden, Franklin Sirmans, Cheryl Finley, Camara Holloway, Andrea Barthwell, Darby English, and Gwendolyn DuBois Shaw.

4. Richard J. Powell and Jock Reynolds, *To Conserve a Legacy: American Art from Historically Black Colleges and Universities*, exh. cat., with introduction by Kinshasha Holman Conwill (Andover: Addison Gallery of American Art, Phillips Academy; New York: Studio Museum in Harlem, 1999).

5. *The Barnett-Aden Collection*, exh. cat., with foreword by John R. Kinard and introduction by Adolphus Ealey (Washington, D.C.: Anacostia Neighborhood Museum and the Barnett-Aden Gallery in association with Smithsonian Institution Press, 1974).

6. Terry Gipps, ed., *Narratives of African American Art and Identity: The David C. Driskell Collection* (College Park, Md.: Art Gallery of the University of Maryland, College Park, 1998).

7. See *The Harmon and Harriet Kelley Collection of African American Art*, exh. cat., with an essay by Gylbert Cocker and Corrine Jennings and a preface by Harriet O'Bannion Kelley (Austin: University of Texas Press, 1994); Andrea D. Barnwell, et al., *The Walter O. Evans Collection of African American Art* (Seattle: University of Washington Press, 1999); David C. Driskell, et al., *The Other Side of Color: African American Art in the Camille O. and William H. Cosby, Jr. Collection* (San Francisco: Pomegranate Press, 2001); and Alvia J. Wardlaw, ed., *Something All Our Own: The Grant Hill Collection of African American Art* (Durham: Duke University Press, 2004).

8. Leslie King-Hammond, "Black Patronage: The Preservation, Privilege and Passion of Collecting African-American Art," in *African-American Art, 20th Century Masterworks, IX*, exh. cat. (New York: Michael Rosenfeld Gallery, 2002), 7.

9. For a complete roster of galleries, see Halima Taha, *Collecting African American Art: Works on Paper and Canvas* (New York: Random House, 1998).

10. See *International Review of African American Art* 16, no. 2 (1999).

11. At the 2000 gala, the SMH honored Harmon and Harriet Kelly; in 2001, Texas African-American Photography Collection and Archive, founded by Alan Govenor and Kaleta Doolin; in 2002, Eddie and Sylvia Brown; in 2003, Dr. and Mrs. Walter O. Evans.

12. Azade Ardalil, *Black and Hispanic Art Museums: A Vibrant Cultural Resource*, with introduction by Mary Schmidt Campbell (New York: Ford Foundation, 1989), 37–38.

13. See Kinshasha Holman Conwill and Valerie J. Mercer, *The Studio Museum in Harlem: 25 Years of African-American Art*, exh. cat. (New York: Studio Museum in Harlem, 1994).

14. Association of Art Museum Directors, *Professional Practices in Art Museums* (New York: AAMD, 2001).

15. As of 2001 the museum has been given an annual donation to help purchase works by the current artists-in-residence by a trustee who was also a member of the SMH Acquisitions Committee, formed in 2001.

16. *Freestyle* exh. cat., with foreword by Lowery Stokes Sims, introduction by Thelma Golden, and essay by Hamza Walker (New York: Studio Museum in Harlem, 2001).

17. *Black Romantic: The Figurative Impulse in Contemporary African-American Art*, exh. cat., with foreword by Lowery Stokes Sims and essays by Thelma Golden et al. (New York: Studio Museum in Harlem, 2002).

The Challenges of Conserving Contemporary Art

Glenn Wharton

RESEARCH SCHOLAR, CONSERVATION CENTER OF
THE INSTITUTE OF FINE ARTS AND MUSEUM STUDIES, NEW YORK UNIVERSITY

Contemporary art challenges the underlying values of conservation. Committed to prolonging the physical life of objects in the face of inevitable change, conservators are particularly vexed by Conceptual and other art that questions notions of permanence and deliberately employs ephemeral media.

Clad in white lab coats and armed with instruments of material analysis in museum laboratories, conservators pursue their quest of understanding the physical mechanisms of change. They strive to inhibit chemical and physical degradation with stabilized museum environments and technical interventions such as consolidation and repair. Yet conservators are not just materials scientists and hands-on craftsmen. They work with curators and others to identify symbolic meaning invested in museum collections. Their mission is to conserve not just the object but its cultural significance for present and future generations. The cultural significance of fine arts most typically resides in the conceptual intention of the artist. Thus an aim of fine arts conservation is to preserve the artist's intent by inhibiting physical change.

Conflicts arise when the artist's intent is contrary to the preservation doctrine. This tension makes conserving contemporary art a particularly lively terrain. Debate over meaning turns to action when conservators make decisions and intervene in the physical lives of artworks—including conceptual pieces whose primary value lies in the nonmaterial realm of experience and interaction. The aim of this essay is to examine the conflicts and tensions that arise in conserving contemporary art and to consider recent trends that address the challenges of conserving nontraditional contemporary works.

ETHICS, VALUES, AND MORAL RIGHTS

Conservators work within ethical and professional standards developed by their professional bodies. As conservation increasingly professionalized during the twentieth century, membership organizations formed, with ratified codes of ethics and standards for practice.[1] These guidelines, along with conferences and a growing body of literature, shape the philosophy and practices of the field. They also articulate the underlying values that drive conservation. Two such values that come into conflict with the aims of contemporary art are the "preservation ethic" and respect for the "true nature" of the object.[2]

The preservation ethic is central to the mission of most museums: "*Preservation* is the most fundamental of [a museum's] responsibilities, since without it research and presentation are impossible and collection is pointless."[3] Museums assume that collected artworks have something to offer future generations, as testaments to our time or as expressions of individual genius. As defined by the American Institute for Conservation (AIC), conservation is the "profession devoted to the preservation of cultural property for the future."[4] According to the International Council of Museums (ICOM) in 1984, the task of conservator-restorers "is to comprehend the material aspect of objects of historic and artistic significance in order to prevent their decay."[5] This zeal to preserve conflicts with artists who want their work to deteriorate or who assign greater value to a concept than its material manifestation.

The second conservation value that conflicts with much of the art produced today is respect for the integrity of the object. Conservation literature and guidelines for practice remind practitioners of the importance of the object as an authentic document that represents a culture or an aesthetic expression. Objects are thought to have a "true nature," an essential value that can be identified and preserved: "At the foundation of the conservation ethic lies the precept 'thou shalt not change the nature of the object.'"[6] A 1983 definition of conservation offered by the United Kingdom Institute for Conservation (UKIC) defines conservation as "the means by which the true nature of an object is preserved. The true nature of an object includes evidence of its origins, its original construction, the materials of which it is composed and information as to the technology used in its manufacture."[7]

In fine arts conservation, the integrity or true nature of the object is linked to both the "artist's intent" and the original (authentic) appearance of the work. Conservation research focuses on artistic intentions and the materials and methods used to achieve them. In his influential "Theory of Restoration," Cesare Brandi emphasizes the uniqueness and specificity of artworks, and argues that the material form, and its image, can be restored only through an aesthetic

approach.[8] He further describes a defining principle of restoration as "reestablishing the potential unity of the work of art."

When the artist is alive and actively expressing his or her intentions, the focus shifts toward documenting and honoring the artist's interests. Problems arise when artists change their mind or express interests that are either unachievable or undesirable by current owners. Some artists recommend conservation strategies that dramatically alter their earlier work. Some prefer conserving their own art using methods that contradict conservators' codes of ethics, such as repainting surfaces and changing original elements. Artists claiming continued rights to alter their work can come into conflict with owners, particularly when greater value is assigned to works from an artist's earlier period.

Once art is purchased and enters the domain of a collection, other stakeholders come to the table with their own concerns regarding longevity, integrity, and monetary value. Artists give up certain rights once they sell their work, but retain others that are dictated by copyright legislation or written contracts from the sale. The legal rights relevant to conservation are artists' "moral rights," as defined in national and international copyright legislation. The European Berne Convention, originally signed in Switzerland in 1886, specifically protects artists' rights of "integrity" from any "distortion, mutilation, or other modification" of their work (article 6 bis (1)).[9] Conservation intervention, whether through cleaning, repair, or replacing missing elements, falls into the category of "other modification." The United States belatedly adopted the Berne Convention in 1989, then established its own Visual Artists Rights Act (VARA) in 1990.[10] Through these laws, artists' moral rights are protected for fifty years after their death in the U.S., seventy years in most of Europe, and "forever" in France.[11]

United States law is less protective of artists' rights than European law. VARA specifically recognizes the rights of conservators: "The modification of a work of visual art which is the result of conservation . . . of the work is not a destruction, distortion, mutilation, or other modification . . . unless the modification is caused by gross negligence" (paragraph 106A(c)(2)). This places the burden on the artist to prove reckless activity on the part of the conservator. The statute similarly states: "The modification of a work of visual art which is the result of the passage of time or the inherent nature of the materials is not a distortion, mutilation or other modification. . . ." (paragraph 106A(c)(1)). A critical difference between U.S. and European legislation is that in Europe moral rights legislation protects the artist, whereas in the U.S. it protects the object.[12]

Moral rights legislation is frequently invoked in the removal or destruction of site-specific works. The legislation is rarely invoked in conservation conflicts, however, even in Europe. Perhaps this is because the legal category of "distortion, mutilation, or other modification" is more difficult to prove when

it comes to good-faith efforts to clean and repair works of art. Conflicts do occur, however, and the legislation will no doubt be fully tested in the courts. The Stedelijk Museum in Amsterdam came into conflict with Barnett Newman's recommended conservator after the artist's death, when the conservator used a paint roller during the repair of a vandalized work.[13] In another situation, a conservator replaced a section of fat in a Joseph Beuys sculpture after it melted in an overheated exhibit case in 1977.[14] Unfortunately, the artist was not consulted in this process. Since Beuys incorporated the process of degeneration into much of his work, he might have accepted the melted fat as part of the sculpture's "biography."

Copyright legislation protects artists' moral rights when someone modifies their work, but it does not require conservators to consult artists prior to conservation. Conservators' interest in identifying artists' intent comes from a deep-seated concern for honoring symbolic meaning, embodied by professional codes of ethics. Since neither legislation nor professional codes provide full guidance for navigating the difficult terrain of contemporary art, conservators continually modify their approach according to individual situations; increasingly, they work in collaboration with artists, curators, and others with interests in defining how artworks should or should not be preserved.

PRESERVATION, CHANGE, AND ARTISTS' INTENT

Some contemporary art is doomed to disintegrate because of poor media selection or material incompatibility. Conservators call this "inherent vice." Self-destruction can come from under-engineering or material interaction, as when one metal corrodes in contact with another through galvanic oxidation. Widening the scope of art media in the twentieth century led to material experiments that sometimes failed. In acquiring works with unstable "found" objects, synthesized modern polymers, and other new technologies, museum collections shifted from the predictable to the unknown.

Plastics are a case in point. Synthetic polymers vary enormously in their inherent stability. Many early plastics, such as cellulose nitrate, are now known to decompose both chemically and physically.[15] Plastics yellow, craze, and become brittle as additives migrate within their structure and their long molecular chains break down and cross-link. They react to acidic and alkaline environments, heat, ultraviolet light, and extremes of moisture. Whereas some plastics are notoriously unstable, others (such as many polyethylenes and polystyrenes) are relatively inert and even used for archival museum storage containers. Conservators and conservation scientists devote time and effort to identify plastics in art and their mechanisms of deterioration. They create

micro-environments in exhibitions and in storage facilities to lengthen the lives of fragile plastics, and they research synthetic polymers for use in conservation interventions.

Aside from mending breaks and filling losses, conservators have few options for dealing with structurally deteriorating plastics. Depending on the specific plastic and its physical condition, conservation recommendations are frequently limited to preventive measures such as handling with clean gloves, exhibiting under low ultraviolet light levels, and storing in cool, dark environments with the relative humidity stabilized between 40 and 60 percent. Chemical scavengers and absorbents that reduce the harmful effects of emissions may be added to storage and exhibition environments. Some early cellulose nitrate sculptures deteriorate to the point of no longer representing the artist's intent (figs. 1, 2). Considered effectively "dead," they are not exhibited and are archived in museum graveyards solely for research purposes.

Just as some contemporary artists unknowingly threaten longevity by their selection of media, others make deliberate compromises. Ephemeral materials and unstable juxtapositions may convey symbolic meaning that expresses the artist's intent but also knowingly leads to self-destruction. Unstable works can accumulate monetary or social value, leading to conservation interventions that challenge ethical practice but are sometimes justifiable. In certain circumstances, substitutions may be made for original materials that have degenerated and no longer represent the artist's intent. However, material replacement is in direct conflict with the conservation ethic of respecting the integrity of the authentic object. In such cases of conflict, codes of ethics and legal restrictions provide a theoretical framework for decision-making, but they inevitably fail to give clear direction for practice. Decisions about deteriorated elements take place in collaboration with artists, artists' representatives, owners, art historians, conservators, conservation scientists, and technical consultants.

Conserving Donald Lipski's *Building Steam—190* (fig. 3) involved analysis by an entomologist and collaborative decision-making between the artist, the owner, and the conservator. The sculpture consisted of an industrial neoprene glove filled with rice from China, stretched around the flange of a ship's porthole. The rice was visible through the porthole. The glove developed tears and micro-cracks in areas of stress where it stretched over the porthole. I was asked to conserve the sculpture when cigarette beetles infested the rice. Initial research included identifying the original materials and the insect larvae. I entered into lengthy conversation with the artist and the owner's representative about options for conservation intervention. A joint decision was made in which the artist purchased new Chinese rice and shipped it to my studio. We purchased a new neoprene glove, meeting the artist's specifications. Before placing the new

Fig. 1. Antoine Pevsner (Russian, 1886–1962), *Head of a Woman*, 1923. Cellulose nitrate; 14⅜ × 9¼ × 4⅝ in. (36 × 23.1 × 11.5 cm). Hirshhorn Museum and Sculpture Garden, Smithsonian Institution, Washington, D.C. Gift of Joseph H. Hirshhorn, 1972

rice in the new glove, we exposed it to a cycle of freezing for forty-eight hours, thawing for twenty-four hours, and re-freezing for forty-eight hours to kill any insects or larvae. The treatment satisfied all parties. The solution was temporary, however: two years later book lice infested the glove. After this second infestation, the artist suggested replacing the rice with the plastic "sprinkles" he had originally thought of using when creating the work. This pushed my personal ethics to a new limit, since it meant changing the original materials in the name of preservation. The owner supported the proposal, and I agreed to perform the intervention. The artist purchased the plastic pellets and sent them to our studio. We disassembled the sculpture, cleaned the glove with ethanol, and

Fig. 2. Antoine Pevsner, *Head of a Woman*, 1923. Recent photograph after irreversible deterioration of the cellulose nitrate.

replaced the infested rice with the same volume of "sprinkles." All parties agreed to re-date the piece as follows: 1983 (reconstructed in 1990).

Moving-image and electronic works pose other challenges to conservation values and practice.[16] Most artists working in technology media want their work to survive, despite its lack of fixity. Traditional cellulose nitrate film stock disintegrates and can self-combust. Although recent moving-image media are more stable (e.g. polyester/polyurethane), other risks include the de-magnetization of video work or its simply becoming outmoded as new projection technology develops.[17] Replacement parts, projectors, monitors, and other exhibition equipment become increasingly difficult to find over time. Electronic art faces similar

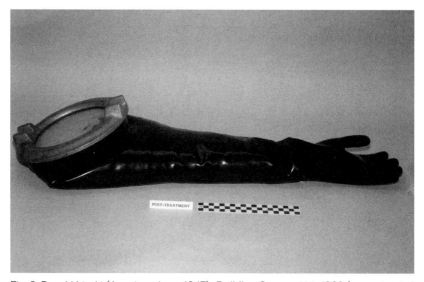

Fig. 3. Donald Lipski (American, born 1947), *Building Steam—190*, 1983 (reconstructed in 1990). Neoprene, metal, glass, and plastic sprinkles; 10¼ × 27 in. (25.6 × 67.5 cm). Private collection

conservation problems. Carrier systems change from floppy to hard discs, CDs, and DVDs. Software needs periodic updating to remain compatible with new computer technologies.

According to Howard Besser, director of New York University's program in Moving Image Archiving and Preservation, conservators of electronic art need the combined skills of archivists and cultural anthropologists.[18] They are charged with documenting and archiving artists' intentions as well as overseeing preservation strategies in the face of ever-shifting technologies. Technicians with up-to-date knowledge from computer industries or the artists themselves conduct much of the hands-on work of preserving video and electronic art.[19] This work includes "refreshing" (transferring onto new storage media), "migration" (upgrading equipment and software), and "emulation" (duplication on entirely new media). Specialized businesses are developing to carry out this technical work for museums. Master and submaster copies are archived for the future, while duplicates are distributed for exhibition. Part of the conservator's role is to insure that highly specialized technicians comply with ethical conservation standards and parameters set by artists.

Documenting the artist's limits on acceptable change for each work includes recording their opinions about changing media from analogue to digital or about changing the projection format from cathode ray tube to liquid crystal or

flat panel digital display. Paul Kos didn't mind migrating his video work *Chartres Bleu* (1983–86) from analog to digital for a recent exhibition at the University of California's Berkeley Art Museum, but he insisted on using round television monitors rather than flat panel screens to better simulate the look of medieval stained glass.[20] Nam June Paik established minimal conceptual criteria for reinstalling his video work *TV Garden* (1974–2002), including the juxtaposition of plants and televisions (nature and technology). He allows curatorial flexibility in choosing the televisions, programming, and surrounding plants: "I don't like to have complete control—that would be boring. What I learned from John Cage is to enjoy every second by decontrol."[21]

Temporary installations and performance art present other conservation concerns when they enter permanent collections. At issue is what, exactly, the buyer is purchasing.[22] Certainly this includes the right to reinstall the work. Typically the collector acquires some, if not all, of the primary installation materials, along with secondary documentation, such as still or moving images and notes from the artist. Conservation can become a matter of archiving the secondary materials and documenting the essential elements of the work for reinstallation, including acceptable substitute materials and tolerance for change in the exhibition environment.[23] Collectors of Sol LeWitt wall drawings archive his instructions and photographs of temporary works for later reinstallation. He is specific about who can re-create the drawings and suggests that conservators should always be in touch with those who did them originally.[24] This will inevitably cause problems when the original installers are no longer around.

Not all art is meant to survive. This certainly isn't new—artists have always created ephemeral works for consumption at public festivals, in spiritual practice, and through other social and personal activities. What is new is that many of these works are collected and exchanged on the open market. They are valued as testament to an ephemeral moment, or for their association with a well-known artist. Also new is the conceptual significance of loss. Original installation materials may be "used up" in the course of an exhibition. Felix Gonzalez-Torres invited viewers to take pieces of stacked papers and candies in his installations: "The fact that someone could just come and take my work and carry it with them was very exciting."[25] Collectors of his ephemeral works purchase certificates that give them the rights (and responsibilities) of decision-making on issues of authenticity, such as purchasing new candies when the original make and color are no longer available.

Some artists use deterioration as an element of process in their work. Anya Gallaccio is interested in the degeneration of her organic media: "Some people find it repulsive, but I think it's quite beautiful and fascinating how things decay over time."[26] Joseph Beuys expressed a similar sentiment: "The nature of my

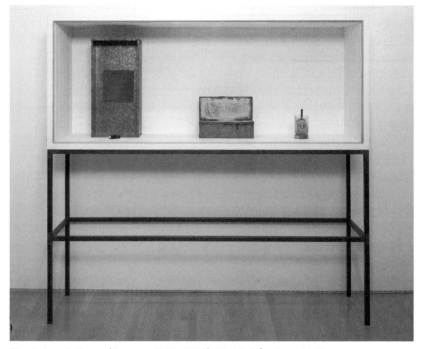

Fig. 4. Joseph Beuys (German, 1921–1986), *Untitled (Vitrine with Four Objects/Plateau Central)*, c. 1962–83. Mixed media (sausage covered with zinc ointment; galvanized box with sheet of lead, glass front and paint; galvanized box filled with fat; glass jar filled with dry battery cell and copper sulphate crystals) in painted wood, steel, and glass vitrine; 81 1/8 × 19 11/16 × 86 5/8 in. (202.8 × 49.3 × 216.5 cm). San Francisco Museum of Modern Art. Fractional Gift of Norman and Norah Stone

sculpture is not fixed and finished. Processes continue in most of them: chemical reactions, fermentations, colour changes, decay, drying up. Everything is in a state of change."[27] Janine Antoni originally created *Gnaw* (1992) by sculpting a six hundred–pound cube of chocolate and a five hundred–pound cube of lard with her teeth.[28] Conservators at the Museum of Modern Art in New York store the chocolate in specially lined crates. The lard is re-cast for each exhibition, using aluminum molds that replicate the artist's teeth marks. The lard cube is packed in dry ice until the exhibition opening, then slowly self-destructs on display. The deliberate deterioration of some contemporary works forces museums to reconsider their preservation doctrine. In some cases images that record the demise of original materials are preserved rather than the object itself.

Other concerns arise when the deterioration process creates toxic by-products or unpleasant odors that affect staff and the visiting public. Putrefied

organic materials can attract pests that infest other objects in the collection, and recycled building materials may contain asbestos, as in some works by Gordon Matta-Clark. The San Francisco Museum of Modern Art took action to reduce the odors from Joseph Beuys's *Untitled (Vitrine with Four Objects/Plateau Central)*, which contains a deteriorating sausage covered with zinc ointment, a galvanized box with fat, and a glass jar with a dry battery cell and copper sulfate crystals (fig. 4). Charcoal absorbers placed behind the objects now effectively eliminate the odors.[29]

RECENT DEVELOPMENTS IN CONSERVATION

Conservators and conservation scientists address the needs of contemporary art on many fronts. Researching the behavior of new art materials and technologies can involve a number of institutions as well as artists and their foundations. For instance, six different institutions joined forces to investigate patterns of surface irregularities on highly polished metal sculptures of artists such as Donald Judd.[30] A growing body of literature chronicles this genre of technical research on modern materials. In 2001 Harvard University created a Center for the Technical Study of Modern Art.[31] The Center will assemble an archive of art and conservation materials together with information received from artists.

Conservators must rethink their standard methodology in the face of new materials, new technologies, and conceptually driven art. New models for conservation include active participation by artists and other stakeholders and are not necessarily motivated by the ethic of preserving the "authentic" object. One model with a high tolerance for incorporating change according to artists' intentions comes from the Foundation for the Conservation of Modern Art in Amsterdam.[32] As described by the authors, this model follows standard conservation methodology in its emphasis on documentation, material-condition research, and identifying the meaning, or artist's intent. The model forces a discussion of two types of discrepancy. The first is whether the current condition of a work conflicts with its intended meaning—does the aging, damage, or decay warrant conservation intervention? As the authors suggest, a scratch in a floor plate by Carl Andre confirms the artist's meaning, whereas a similar scratch on a pristine Donald Judd negates the artist's intent.[33] Similar scratches may lead to very different conservation decisions, based on artists' expressed goals for their work. The second point for discussion of discrepancy is in considering options for conservation. The conservator gathers relevant information from a range of sources, such as material analysis, industrial literature, and documented artist's intent. She then formulates passive and active options for

conservation. Stakeholders discuss these options, as well as others they bring to the table. A central question is whether conservation intervention helps unite the object with its intended meaning. Polishing or refinishing a scratched Donald Judd may do just that, whereas similar treatment of a Carl Andre floor plate would contradict his objectives.

Collecting and archiving artists' intent is tricky business. Some artists are readily approachable and easily express their thoughts on acceptable patterns of aging. They define their tolerance for shifting colors, cracking resins, soiling, and physical damage. Others choose not to address the future of their work. To reduce needless or unwanted contact with artists, conservators first consult published and unpublished documents from prior interviews or written exchange. These documents often exist in museum registration files or on collection databases.

Museums increasingly ask artists to fill out questionnaires or participate in an interview when a work enters their collection. Some institutions prefer structured survey forms and questionnaires, whereas others draw on ethnographic methods, using unstructured interview techniques. The Tate Gallery in London developed a model database for recording information on acquired collections.[34] When possible, they interview the artists in front of their acquisitions, with a questionnaire tailored to suit each artist and his or her work.

Carol Mancusi-Ungaro of the Whitney Museum of American Art in New York and Harvard University conducts videotaped interviews with artists. She argues against long surveys for acquiring detailed information. Her videos and their transcriptions are frequently not edited: "An unedited film can convey an artist's uncertainty or doubt which the finished printed word, by its very nature, cannot."[35] She adds that unedited interviews contain information that could seem irrelevant today, but may prove critical in the future.[36] Since artists do change their minds and respond differently to different conservation problems, frequent dialogue and documentation of responses help construct more advanced understanding of their concerns.

Museums work collaboratively to share their archived data on artists' materials and intentions. Two recent initiatives illustrate this trend in information sharing. The first is the International Network for the Conservation of Contemporary Art (INCCA),[37] funded by the European Commission and organized by the Netherlands Institute for Cultural Heritage with the Tate Gallery. INCCA's mission is to establish a virtual archive of information on artists' intent. The primary tool is a meta-database of references to unpublished documents held by member institutions, such as video interviews, notes from conversations, and analysis of materials used by individual artists. Because of restrictions on copyright and confidentiality, the documents themselves are not posted online. Once an authorized researcher locates a document from an online search, she contacts

the owning institution for permission to view or obtain a copy of the document. An additional project of INCCA is an online literature database for publications on contemporary art conservation, along with conference postings, guidelines for conducting artist interviews, models for conservation decision-making, a conservation vocabulary list, and links to related websites. Fortunately, this aspect of their work is accessible online to non-members.

A second model devised to document and share information from artists is the Variable Media Network, funded by the Daniel Langlois Foundation for Art, Science, and Technology and coordinated by the Solomon R. Guggenheim Museum in New York.[38] The Variable Media Network is a shared database for museum staff designed primarily to house information about the reinstallation of nontraditional artwork. Launched in 2003, it consists of a website and an online database accessible to the general public. The network discards traditional, medium-specific categories such as painting, sculpture, and video, since media are often mixed and can even change over time through migration and emulation. Instead, works are assigned to categories of installation, such as "interactive" (for those that museum visitors interact with), "networked" (for works distributed across the Internet), and "contained" (for more traditional art such as paintings and sculpture).

These new initiatives reflect new modes of working in order to conserve the increasingly diverse interests of artists. These interests can extend beyond conceptual concerns to concrete political action.[39] In activist art, social intervention takes precedence over physical longevity. The artist Judy Baca, of the Social and Public Art Resource Center (SPARC) in Los Angeles, works with disenfranchised populations to create murals in public spaces. She insists that the process of instilling neighborhood pride is inherent to her work, and consequently her murals cannot be conserved without involving future generations of community representatives. "Outside" professional conservators alone cannot conserve the murals: "It isn't just a question of consolidating a surface, it's consolidating the community and reactivating it."[40] It may be argued that conservation of activist art can be achieved only through continued activism. This may cause problems for conservators and owners with different political orientations, or in changing social circumstances that render action on old issues obsolete.

The models suggested in this chapter for conserving contemporary art challenge standard beliefs in preserving the authentic object. They also point to greater collaboration and sharing of conservation authority. The multidisciplinary nature of creating contemporary art leads to a conservation that is more diffuse at its borders. Not only do traditional divisions of conservation (e.g., paintings, sculpture, and paper) break down, but conservation research and

decision-making also reach into new technical and social arenas. While striving to hold onto a strong sense of professional ethics, conservation is forced outside of museum walls to become a more participatory practice that is shaped by new technologies and new currents in contemporary culture.

NOTES

1. For example, see Code of Ethics and Guidelines for Practice of the American Institute for Conservation, 1994, http://aic.stanford.edu/geninfo/; the Professional Guidelines of the European Confederation of Conservator-Restorers' Organizations (ECCO), 1993, at http://palimpsest.stanford.edu/byorg/ecco/library/ethics.html; and the Code of Ethics of the International Council of Museums—Conservation Committee, 1984, http://icom-cc.icom.museum/About/CodeOfEthics/ (all accessed 19 November 2003).

2. Miriam Clavir, *Preserving What Is Valued: Museums, Conservation, and First Nations* (Vancouver: UBC Press, 2002).

Catherine Sease, "Codes of Ethics for Conservation," *International Journal of Cultural Property* 7, no. 1 (1998): 98–114.

3. Philip Ward, *The Nature of Conservation: A Race against Time* (Marina del Rey, Calif.: Getty Conservation Institute, 1986).

4. American Institute for Conservation, *Directory: The American Institute for Conservation of Historic & Artistic Works* (Washington, D.C.: AI Conservation, 2002), 21.

5. International Council of Museums—Conservation Committee, 1984, http://icomcc.icom.museum/About/DefinitionOfProfession/ (accessed 27 July 2004).

6. Suzanne Keene, "Objects as Systems: A New Challenge for Conservation," in *Restoration: Is It Acceptable? Occasional Paper No. 99*, ed. Andrew Oddy (London: British Museum, 1994), 19.

7. United Kingdom Institute of Conservation, *Guidance for Conservation Practice* (London: UKIC, 1983), 2.

8. Cesare Brandi, "Theory of Restoration, I, II, & III," in *Readings in Conservation: Historical and Philosophical Issues in the Conservation of Cultural Heritage*, ed. Nicholas Stanley-Price, M. Kirby Talley, and Alessandra Melucco Vaccaro; trans. Gianni Ponti and Alessandra Melucco Vaccaro (Los Angeles: Getty Conservation Institute, 1996), 231; originally published 1963.

9. Cornell Law School, 1967, http://www.law.cornell.edu/treaties/berne/overview.html (accessed 23 July 2004).

10. Ivan Hoffman, *The Visual Artists Rights Act*, 1990, http://www.ivanhoffman.com/vara.html (accessed 15 November 2003).

11. Annemarie Beunan, "Moral Rights in Modern Art: An International Survey," in *Modern Art: Who Cares?* ed. IJsbrand Hummelen and Dionne Sillé (Amsterdam: Foundation for the Conservation of Modern Art and the Netherlands Institute for Cultural Heritage, 1999), 222–32.

12. Ibid.

13. Ibid., 227–28, and Roy S. Kaufman, *Art Law Handbook* (Gaithersburg, N.Y.: Aspen Publishers, 2000), 983–84.

14. Kees Herman Aben, "Conservation of Modern Sculpture at the Stedelijk Museum, Amsterdam," in *From Marble to Chocolate: The Conservation of Modern Sculpture Tate Gallery*

Conference 18–20 September 1995, ed. Jackie Heuman (London: Archetype Publications, 1995), 104–109.

15. Michele Derrick, Dusan Stulik, and Eugena Ordonez, "Deterioration of Cellulose Nitrate Sculptures Made by Gabo and Pevsner," in *Saving the Twentieth Century: The Conservation of Modern Materials*, ed. David W. Grattan, (Ottawa: Canadian Conservation Institute, 1993), 169–82; and Christopher W. McGlinchey, "The Physical Aging of Polymeric Materials," in ibid., 113–19.

16. William A. Real, "Toward Guidelines for Practice in the Preservation and Documentation of Technology-based Installation Art," *Journal of the American Institute for Conservation* 40 (2001): 211–31.

17. Howard Besser, "Longevity of Electronic Art" paper presented at the conference of the International Cultural Heritage Informatics, 2001, available from http://www.gseis.ucla.edu/~howard/ (accessed 1 November 2003); and Pip Laurenson, "The Conservation and Documentation of Video Art," in *Modern Art: Who Cares?*, 263–71.

18. Howard Besser, director of the Moving Image Archiving and Preservation Program, New York University, communication with author, 8 April 2003.

19. Mitchell Hearns Bishop, "Evolving Exemplary Pluralism: Steve McQueen's *Deadpan* and Elija-Liisa Ahtila's *Anne, Aki and God*—Two Case Studies for Conserving Technology-Based Installation Art," *Journal of the American Institute for Conservation* 40 (2001): 179–91; and Timothy Vitale, "Techarchaeology: Works by James Coleman and Vito Acconci," *Journal of the American Institute for Conservation* 40 (2001): 233–58.

20. Constance M. Lewallen, senior curator for exhibitions, Berkeley Art Museum, communication with author, 12 December 2003.

21. John G. Hanhardt, "Nam June Paik, *TV Garden*," in *The Variable Media Approach: Permanence through Change*, ed. Alain Depocas, Jon Ippolito, and Caitlin Jones (New York: Guggenheim Museum Publications and the Daniel Langlois Foundation for Art, Science, and Technology, 2003) 70–77.

22. Martha Buskirk, *The Contingent Object of Contemporary Art* (Cambridge, Mass.: MIT Press, 2003).

23. Carol Stringari, "Installations and Problems of Preservation," in *Modern Art: Who Cares?*, 272–81.

24. D.H. van Wegen, "Between Fetish and Score: The Position of the Curator of Contemporary Art," in *Modern Art: Who Cares?*, 201–209.

25. William Bartman, Tim Rollins, Jan Avgikos, and Susan Cahan, "Interview with Felix Gonzalez-Torres," in *Felix Gonzalez-Torres* (New York: Art Resources Transfer, 1993), 9.

26. Ralph Rugoff, "Dark Art: A New Generation of British Sculptors Is Finding Inspiration in the Morbid and Macabre," *Vogue* 182, no. 9 (1992): 352–58.

27. Caroline Tisdall, *Joseph Beuys* (New York: Solomon R. Guggenheim Museum, 1979), 7.

28. Lynda Zycherman, conservator of sculpture, Museum of Modern Art, New York, communication with author, 18 December 2003.

29. Michelle Barger, associate conservator of objects, San Francisco Museum of Modern Art, communication with author, 1 December 2003.

30. Researchers suspect that these patterns originate from lubricants such as oils, waxes, and silicones used in industrial production prior to purchase by artists and fabricators. From Eleonora Nagy, project director and sculpture conservator at the Solomon R. Guggenheim Museum, communication with author, 5 November 2003. The collaborating institutions are the Guggenheim, the Chinati Foundation in Marfa, Texas, the Museum of Modern Art in

New York, Orion Analytical in Williamstown, Massachusetts, the Philadelphia Museum of Art, and the Whitney Museum of American Art in New York.

31. More information on the Center for the Technical Study of Modern Art can be found at http://www.artmuseums.harvard.edu/press/released2000/mancusiungaro.h (accessed 18 November 2003).

32. Wilma van Asseldonk et al., "The Decision-Making Model for the Conservation and Restoration of Modern and Contemporary Art," in *Modern Art: Who Cares?*, 164–72.

33. Ibid.

34. Marja Peek and Agnes W. Brokerhof, "Documentation and Registration of Artists' Materials and Techniques: Proceedings," in *Modern Art: Who Cares?*, 388–90.

35. Carol Mancusi-Ungaro, "Original Intent: The Artist's Voice," in ibid., 392–93.

36. Carol Mancusi-Ungaro, director of the Center for the Technical Study of Modern Art at Harvard University and director of conservation at the Whitney Museum, communication with author, 8 December 2003.

37. See International Network for the Conservation of Contemporary Art (INCCA) at http://www.incca.org/ (accessed 1 October 2003).

38. See the Variable Media Network at http://www.guggenheim.org/variablemedia/ (accessed 1 October 2003).

39. Tom Finkelpearl, *Dialogues in Public Art* (Cambridge, Mass.: MIT Press, 2000); and Suzanne Lacy, ed., *Mapping the Terrain: New Genre Public Art* (Seattle: Bay Press, 1994).

40. Judith Baca, "The Public Role in Preservation," in *Conservation and Maintenance of Public Art*, ed. Hafthor Yngvason (London: Archetype Press, 2002), 21–29.

Acknowledgments

This book originated in conversation with Nancy Grubb, whom I thank for giving me the opportunity to publish under the imprint of my alma mater. Her fine collaboration and support were essential to the success of this project. I also thank the staff of Princeton University Press, especially Hanne Winarsky, Kate Zanzucchi, Carmel Lyons, and Sara Lerner, as well as Alison Pearlman for her copyediting from afar.

The critical factor in a book on this subject is the intelligence, knowledge, and practical experience of its authors, and I must admit that I was surprised that almost everyone on my initial wish list agreed to write for *Collecting the New*. Those who know the nature of current museum work understand just how busy curators and directors are, and those who know these individuals will realize how fortunate I have been to assemble this particular group of museum professionals. I am pleased to have provided an opportunity for them to engage these issues in print, and I thank them all for incisive contributions to the ongoing discussion of museum collecting of contemporary art.

Bruce Altshuler

Index

Note: Page numbers in italic type indicate illustrations.

Photography Credits

The photographers and the sources of visual material other than those indicated in the captions are as follows (numerals refer to figures).

The Right to Be Wrong, Howard N. Fox
© Chris Burden. Photograph © 2004 Museum Associates/LACMA (1)

© Anselm Kiefer. Photograph © 2004 Museum Associates/LACMA (2)

© Rachel Lachowicz. Photograph © 2004 Museum Associates/LACMA (3)

© Bill Viola. Photograph © 2004 Museum Associates/LACMA (4)

Breaking Down Categories, Christophe Cherix
© Mel Bochner, New York (1)

© Cabinet des estampes, Geneva (2, 3)

© Actinic, Geneva (4)

© John Miller, New York (5)

Keeping Time, Chrissie Iles and Henriette Huldisch
Photograph by David Allison (1–3)

Photograph by Geoffrey Clements (4)

Photograph by Greta Olafsdottir. © Liisa Roberts (5)

Collecting New-Media Art, Steve Dietz
Screenshot by Steve Dietz (1–4)

Beyond the "Authentic-Exotic," Vishakha N. Desai
Courtesy of Ravinder G. Reddy (1)
Courtesy of North Dakota Museum of Art (2)
Inside Out: New Chinese Art, P.S.1 Contemporary Art Center. Photograph by Hiro Ihara (3)

The Unconscious Museum, Pamela McClusky
Courtesy Stephen Friedman Gallery, London (1)
Photograph by Paul Macapia (2–4)

The Accidental Tourist, Gabriel Pérez-Barreiro
Rick Hall (1–5)

Collecting the Art of African-Americans at the Studio Museum in Harlem, Lowery Stokes Sims
Photograph by Adam Reich, courtesy of the Studio Museum in Harlem (1)
Courtesy of the Studio Museum in Harlem (2)
Photograph by Adam Reich (3)
Courtesy of Keith Duncan (4)

Challenges of Conserving Art, Glenn Wharton
Hirshhorn Museum and Sculpture Garden, Smithsonian Institution (1, 2)
Glenn Wharton & Associates, Inc. (3)
© Artists Rights Society (ARS), New York/VG Bild-Kunst, Bonn (4)